Photographic Multishot Techniques

Photographic Multishot Techniques

High Dynamic Range, Super-Resolution, Extended Depth of Field, Stitching

Juergen and Rainer Gulbins

rockynook

Juergen Gulbins, jg@gulbins.de
Rainer Gulbins, rainer@gulbins.de

Editor: Gerhard Rossbach
Layout and Type: Juergen Gulbins
Translator: Gerhard Schneibel
Copyeditor: Jeremy Cloot
Cover Design: Helmut Kraus, www.exclam.de
Cover Photo: Helmut Kraus
Printer: Courier Corporation
Printed in the USA

ISBN-13: 978-1-933952-38-3
1st Edition © 2009 by Juergen Gulbins and Rainer Gulbins

Rocky Nook Inc.
26 West Mission Street Ste 3
Santa Barbara, CA 93101
www.rockynook.com

First published under the title
"Multoshot-Techniken in der digitalen Fotografie"
Copyright © 2008 dpunkt.verlag GmbH, Heidelberg, Germany

Library of Congress Cataloging-in-Publication Data
Gulbins, Jürgen.
 [Multishot-Techniken in der digitalen Fotografie. English]
 Photographic multishot techniques : super-resolution, extended depth of field, stitching, high dynamic
 range imaging, and other image enhancement techniques / Juergen and Rainer Gulbins. — 1st ed.
 p. cm.
 Includes bibliographical references and index.
 ISBN 978-1-933952-38-3 (alk. paper)
 1. High dynamic range imaging. 2. Imaging systems—Image quality. I. Gulbins, Rainer. II. Title.
 TR594.G85 2009
 771--dc22

 2008053325

Distributed by O'Reilly Media
1005 Gravenstein Highway North
Sebastopol, CA 95472

Contents

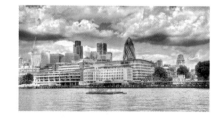

Introduction

1

Digital cameras first became widely available in 2002. Since then, technical advances have not only rapidly increased image sensor resolution, but have also brought great improvements to camera technology in general. The problem of image noise has been addressed, dynamic range has been increased, and cameras are constantly being equipped with ever-faster image processors. Faster processors have simplified the use of "bracketing" techniques, which allow the photographer to automatically shoot sequences of shots with varied exposure settings.

Parallel to these developments, image processing software has also been improving rapidly. RAW conversion is now a simple process, and can be combined with many automatic and manual image correction functions. Modern digital lens correction functions also achieve high-quality results. Combined with appropriate shooting techniques, such technical advancements make previously unimaginable image processing possible. One of the most powerful new options available to the digital photographer is the ability to create a high-quality image by combining multiple shots. This book addresses the use of the following multishot techniques:

1. *Super-Resolution, used to increase overall image resolution*

2. *Focus Stacking, used to increase depth of field*

3. *Stitching, used to create panoramic photos*

4. *HDRI Techniques, used to increase the dynamic range of an image*

5. *Plus other techniques for reducing image noise, and the general optimization of the multishot images you have generated*

This book is intended as an introduction to these techniques and demonstrates how to apply them practically using widely available applications.

We will keep theory to a minimum throughout this book, although the technical aspects of the processes described are sometimes very complex. We will also limit the number of software applications we demonstrate. Introducing all the applications available on today's market would not benefit most users, and new programs and program functions are constantly being introduced anyway.

1.1 Why Use Super-Resolution and Other Multishot Techniques?

The basic approach to multishot techniques (which many professionals have long used in simplified form) is as follows:

▸ Once we've found the right angle, lighting and composition for a shot, we make several exposures of the same scene, each with different exposure settings, and hopefully in sharp focus. Taking multiple pictures doesn't cost the digital photographer any extra money. When shooting such bracketed sequences, the aperture should remain the same while the shutter speed is increased or decreased at set intervals.

▸ You can then simply view the whole sequence at home and choose the best-exposed shot for further processing. At this point, we're often ready to move directly on to the image optimization stage.

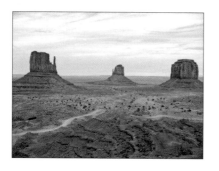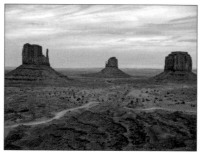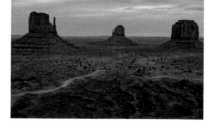

Figure 1-1: A series of three images taken at Monument Valley in the United States. The exposures were varied using different shutter speeds. We think the picture in the middle turned out the best, so we used this one for processing and optimization.

However, the applications described in this book offer a number of other options for processing your image sequences, including:

1. If image resolution isn't sufficient, for example, for large-format printing, we can use the techniques described in chapter 3 to combine multiple images to make a single image with increased resolution. To achieve this, we need at least four images – the more the better.

2. If poor light forces us to shoot at high ISO speeds, we can combine images to reduce noise. This can be achieved using PhotoAcute (described in chapter 3) or using an HDRI program such as *Photomatix Pro* or *FDR-Tools*. The latter is described in chapter 6.

3. If the exposure range of an image isn't broad enough to capture the dynamic range of a high-contrast scene, it's possible to increase the dynamic range of your best image by augmenting it with data from the other images in the series. This can be achieved using the *PhotoAcute* method described in chapter 3, using the HDRI programs described in chapter 6, or using a simple layer mask technique in Photoshop. HDRI stands for *High Dynamic Range Imaging*.

Figure 1-2: Here we see a scaled-down version of the original picture along with two detail images. The center detail was taken from the original image, and the one to the right was taken from a super-resolution image created using PhotoAcute.

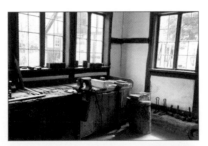
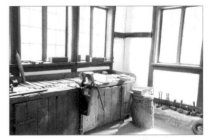

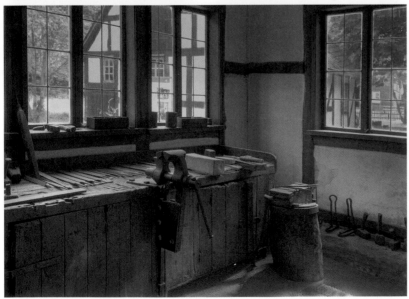

Figure 1-3: Above are three shots of an old-fashioned carpenter's workshop. They were taken using different exposure settings. Because the light outside the windows is drastically different than the light inside the building, it's impossible for a camera to capture the entire dynamic range of the scene and to properly expose both sections of the image. The image on the left shows a combined image created using HDRI. The image was also post- processed to correct perspective distortion.

Varying the image crop or depth of field, instead of changing the lighting, also gives us various new image processing options.

Figure 1-4: Because the desired depth of field for the shot above couldn't be attained in a single exposure, we took six shots with different focal settings and used focus stacking to combine them into a single image with extended depth of field. The result is pictured here.

4. In some cases a particular focus setting can't capture the entire depth of field the photographer would like to portray. This is sometimes the case when shooting architecture, and almost always the case with macro shots. To counteract this problem, we take several shots, changing the focal point from shot to shot. Later, we'll use software to merge these images into a single new image with extended depth of field. An example is of this technique is shown in figure 1-4. This process is called *focus stacking* and is described in chapter 4.

5. If a scene is too large (too wide, too tall, or both) to capture in one shot with the lens at hand, we can create multiple, overlapping shots of the entire scene which can be joined together later using specialized software. This process is called *stitching* and is commonly used to create panoramas. There are, however, a number of other photographic situations in which stitching can be used, including increasing overall image resolution.

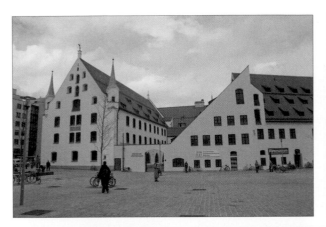

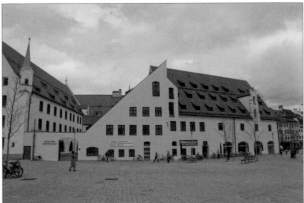

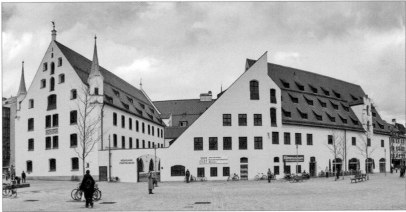

Figure 1-5: These two pictures of the city museum in Munich were easily turned into a panorama using Photoshop and a little post-processing.

All of these techniques require multiple, varied exposures of a scene – hence the term "multishot".

Once you've decided to proceed with one specific technique, the next step will be to plan a little. While shooting, it is always necessary to consider which multishot technique you will be applying to your images. Shots taken for a panoramic image call for different camera settings than those taken for use with a focus stacking process. We will describe in detail, the specific requirements for shooting, and give advice on where to find more information in each chapter.

After creating a merged multishot image, you will most likely need to further optimize your results. This can involve smoothing the seams between the individual, merged images, or improving local contrast to make your final image more dynamic, and to give it more presence. Because most of these optimization techniques are applicable to nearly all multishot techniques, we will save the majority of the post-processing discussion for chapter 7 at the end of the book. Other post-processing steps, such as distortion or perspective correction, will be addressed throughout the book where appropriate.

Figure 1-6: A Joshua Tree in the Joshua Tree National Park. The illustration above shows our initial picture and below is the same image with increased local contrast. The difference is (intentionally) subtle, but nevertheless visible. The results are quite different from those which can be obtained using traditional sharpening techniques.

Some of the techniques we describe will probably be new to you, at least in part. Examining them in great depth quickly becomes complicated, but it is nevertheless possible to achieve great results by combining trial-and-error with a moderate amount of know-how. We want to encourage you to learn and to experiment. We are certain that once you have worked your way through this book, you'll want to use these techniques on a regular basis. This will enrich your photographic routine and give you new possibilities and perspectives to work with. We don't recommend that you always use the techniques described here, but only where they are appropriate and can be used to enhance the quality of your work.

1.2 Who Is this Book Aimed At?

This book is written for ambitious amateurs, as well as for professional photographers. Our goal is to expand your photographic repertoire. We assume you have a good working knowledge of your camera and understand the basic principles of digital image processing.

The basic tool used throughout this book is Adobe Photoshop (in the CS2, CS3, or CS4 version). Photoshop CS3 and CS4 occasionally offer version-specific enhancements, and we will mention these where appropriate. Many of the techniques we will describe can be applied using earlier versions of Photoshop, but sometimes with only limited functionality. Throughout this book we also assume that you are familiar with your computer and its operating system, and that you are using a relatively new system version (Windows 2000 and higher, or Mac OS X Version 10.4 or newer).

The Right Camera

Different shooting techniques will require different camera functionality. This book assumes you will be working with a bridge camera (a digital single lens reflex camera with a built-in lens) or a digital single lens reflex camera (DSLR) with interchangeable lenses. Your camera should have two functions which are necessary to work successfully with this book: It should be capable of taking bracketing sequences (i.e., sequences with automatically varied exposure settings), and should allow you to make manual adjustments to aperture, shutter speed, and focus settings. Some compact digital cameras also have appropriate functions, and stitching techniques can often be successfully applied to images made using even the simplest compact digital camera.

How to Read This Book

This book is designed to be read sequentially from beginning to end. We use the early chapters to discuss techniques which will be applied again in later chapters. Chapter 2 focuses on a general workflow for taking pictures, and merging and post-processing them. This information is common to all four of the major techniques described.

After working through chapters 2 and 3, you can skip to a chapter that you're specifically interested in, although you may have to return to an earlier chapter at some point to find a reference to a particular technique or specific information. Because PhotoAcute covers nearly all of the techniques we will be discussing (with the exception of stitching), we will address the program's basic use in chapter 3 before we move on to more specific topics in later chapters.

Generally, we have allotted one chapter to each major technique. Chapter 7 focuses on making improvements to local contrast and post-processing in general.

"Make or Break" – The Fine Line Between Success and Failure

The techniques described in this book require planning, manual intervention by the photographer, and experimentation. The programs which support these techniques are rapidly improving, but success is never guaranteed. There is a fine line between success and failure. One small change to your shooting technique, your image processing technique, the program used, or the options and parameters you set can mean the difference between success or failure. Don't be discouraged by early mistakes. Adjust your workflow, and try different settings or a different program. We will also provide alternatives for all of the techniques we describe.

→ *The techniques described here are relatively new and are subject to constant development. Consequently, comprehensive experience in their use is still rare. Most of the programs' authors are grateful for feedback, and often build suggestions into one of the many software versions released every year.*

If you don't have much experience processing digital images, some of the techniques demonstrated in this book might appear quite laborious. We've put a lot of effort into making each step comprehensible, but the work at the computer may seem tiring at times, especially in the case of larger, more complex projects. For this reason, we suggest starting with small, simple processes. A panorama doesn't necessarily have to be composed of five images – two are often fine, and a simpler panorama can be more easily processed. Also, HDRI sequences don't necessarily have to be created using five or more images – two or three can suffice to greatly increase the dynamic range of a scene. Start small and work your way up. Use simple projects to gather experience before moving on. This will reduce the potential for frustration, and you won't spoil your own fun with overly large projects and major setbacks.

1.3 Conventions Used in this Book

The majority of the usages in this book should be self-explanatory. The combination Filter ▸ Sharpening ▸ Unsharp Mask, for example, represents the menu sequence Filter followed by Sharpening and finally the menu item Unsharp Mask. Keystroke combinations are designated using the Ctrl-A notation. The hyphen means both keys should be pressed simultaneously. Menu entries and action buttons are written using the File or *OK* typefaces, and list elements to be selected are written in *italics*.

* *The* ⌥ *key also typically carries the* Alt *label.*
** *This is also called the Command Key and also carries the* ⌘ *symbol.*

The Windows and Mac OS X versions of the programs included with this book almost always use the same keystroke combinations, although the Windows Alt key is replaced by the ⌥ (option)* key in Mac OS. The Windows Ctrl key is replaced by the ⌘ key in Mac.** ⇧ means shift in both systems (⇧-A is a capital A). The ↵ represents the return or enter key. The Ctrl/⌘ combination signifies use of Ctrl in the case of a PC, and ⌘ for a Mac. The same logic applies to the Alt/⌥ notation.

We will occasionally mention functions which require a right mouse click to activate a popup menu. Macintosh users who use a single-button mouse should hold down the Ctrl key and click once to simulate a right click.

We've cropped some of the screenshots in this book in order to keep them down to a manageable size, and we have also reduced extra whitespace in some places to help keep things clear.

→ *We recommend that Mac users invest in a two- or three-button mouse, with a scroll wheel if possible. This investment – which doesn't have to be a large one – will help you a great deal when using this book.*

Enjoy Your Photography

This book inevitably includes large amounts of technical information – and you've already had a first taste. Try to keep in mind the goal of creating an interesting and appealing image. We are simply trying to show you new ways to that achieve that goal, and we hope the techniques demonstrated in this book will help you produce pictures which you and others can enjoy.

In many areas we make suggestions which reflect not only our experience, but also our personal taste. Remember, these are only pointers and are not intended to influence your own personal style or working methods. And don't let the technical aspects of this book get in the way of your continued efforts to experiment, to gather experience with your camera, and to take great pictures.

→ *It's impossible to describe everything here, and that isn't our aim. We hope to present a useful introduction which will stimulate your curiosity.*

We simply hope you'll get a lot of enjoyment out of experimenting and realizing your own photographic vision.

The Multishot Workflow

2

The basic steps – or workflow – are quite similar for all the different multishot techniques described in this book. The main differences are the actual applications or techniques used for merging images. A typical workflow will have four main phases:

1. *Shooting the images*

2. *Preparation of the images for the merging process*

3. *Merging the original images into a single, new image*

4. *Post-processing. Here you will fine-tune your results, remove artifacts that result from the merging process, and finally (optionally) increase local contrast.*

This chapter will provide an overview of a typical multishot workflow, and will introduce the applications we will be using to apply the various multishot techniques. We will also discuss file formats – the ones your camera produces as well as the ones we will be using as input for the merging process.

Finally, we will introduce you to the Adobe DNG Converter. Some of the applications we describe require you to convert your RAW files to a format (TIFF or JPEG) before they can be processed.

2.1 Common Steps in a Multishot Workflow

Although each individual technique described in this book has its own workflow, there are a number of commonalities between them that we would like to touch on at this point. The typical workflow for all of these multishot techniques consists of four phases which are represented in figure 2-1:

1. Shooting the image sequence
2. Image preprocessing
3. Merging the images into one
4. Post-processing (optimizing) the merged image

Each of these phases may consist of several steps that form their own sub-workflow. The following paragraphs will discuss each major step individually.

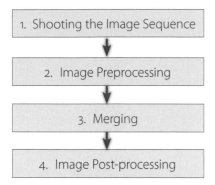

Figure 2-1: *Major phases of a multishot workflow*

1. Shooting the Image Sequence

This first phase in the process offers a number of opportunities to make decisions which will later allow you to achieve optimum results. While technical aspects (such as the camera's shutter speed and aperture settings) differ from camera to camera, other aspects of basic technique are generally the same for all multishot techniques. You can assume, for instance, that for all of the techniques we describe, the use of a tripod will improve your results – even if it is possible to shoot Super-Resolution, HDRI, and panorama sequences without one. It's difficult to shoot focus stacking sequences without a tripod, and it is basically impossible to effectively shoot macro photos hand-held.

While shooting photos for use with all of these techniques, it is best to use a preset white balance setting. This is less important if you are shooting in RAW format, because RAW allows you to adjust the white balance later when converting your images into other formats. Here, you can adjust the color temperature without sacrificing image quality.

It is important to note that when a camera is set to automatically meter the color temperature of a shot, it embeds the resulting information directly into the image data (with RAW files it is embedded into the EXIF data). Later, when you process your images using a RAW converter, you have to remember to set them all to the same color temperature (unless you're using the same program to both convert and merge your images).

It's also crucial to all of these multishot techniques that the focal distance remains consistent throughout the image sequence[*] – and you can only be sure that this is the case if you focus manually. If your subject is sufficiently far away, and there are no objects in the foreground to confuse the camera's systems, you can sometimes use autofocus to shoot for panoramic or HDRI sequences. It is also important to retain a constant ISO speed setting throughout each sequence, and we recommend using a preset ISO setting and not the Auto-ISO feature built into many newer cameras.

Figure 2-2: *Workflow steps and settings for the shooting phase*

Naturally, this is not the case when shooting for focus stacking.

Recommended Settings for Various Multishot Techniques				
Technique:	**Super-Resolution**	**Focus Stacking**	**Panorama**	**HDRI**
Shutter speed	variable	fixed	fixed	variable
Aperture	fixed	fixed	fixed	fixed
Camera exposure program	manual or Av bracketing*	manual (or Av)	manual	Av bracketing*
ISO speed	fixed	fixed	fixed	fixed
Subject distance	fixed	manual	fixed	fixed
Focal length	fixed	fixed	fixed	fixed
White balance	fixed	fixed	fixed	fixed
Tripod	optional	always	preferable	preferable

** Using bracketing varies one of the camera's shooting parameters during a sequence of shots. Av bracketing varies the shutter speed for a fixed aperture, according to your AEB (Auto Exposure Bracketing) settings.*

Manual exposure settings are usually the best choice when shooting for multishot processes. There are, of course, exceptions, such as shooting for HDRI, or using Av bracketing to vary the shutter speed automatically. Av bracketing can also be used to shoot images for super-resolution applications. Av mode (or "A" mode, as some camera manufacturers call it) can also be used for Super-Resolution.

When taking shots that require slow shutter speeds, it is necessary to use a tripod. Mirror lockup is also a useful tool built into many DSLR cameras, and prevents motion blur caused by the mirror's movement. Mirror lockup is not suitable for high-speed bracketing sequences, but some cameras allow mirror lockup for entire bracketing sequences, and you should use this feature if your camera has it.

Figure 2-3: To shoot images for HDRI and Super-Resolution applications, use your camera's aperture priority (Av or A) setting.

2. Image Preprocessing

Download Your Images to Your Hard Drive and Rename Them

The first step to take after downloading your images to your computer is to give them simple and relevant names. The file names automatically assigned by the camera are usually neither unique nor particularly descriptive. Most cameras automatically restart the image numbering sequence from zero once 9999 has been reached. When creating multishot images, it is important that each image has a unique name that is not repeated in any other folder or on any other local drive.

The majority of image processing programs (i.e., Photoshop with Adobe Bridge) and photo management programs nowadays have download functions which support renaming files during the download process. The shooting date followed by a text section describing the shoot and a number assigned by the camera gives each of your images a unique and easily understandable name.

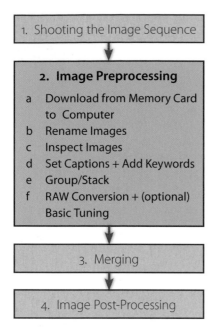

1. Shooting the Image Sequence

2. Image Preprocessing

a　Download from Memory Card
　　to　Computer
b　Rename Images
c　Inspect Images
d　Set Captions + Add Keywords
e　Group/Stack
f　RAW Conversion + (optional)
　　Basic Tuning

3. Merging

4. Image Post-Processing

*Figure 2-4: Some more image processing
details, used before merging*

➔ *Some downloaders (such as the ones
included in Adobe Bridge, Adobe Lightroom,
and Apple Aperture) allow IPTC data to
be attached to batches of files as part of
the download process. The data is either
embedded in the image file, saved in a sidecar
file, or stored in the image database itself.
Adding metadata as you import will save time
later on.*

When recording the date, we recommend using the international standard YYYYMMDD format (Year, Month, Date; with two or four digits for the year and two digits each for the month and the day). This results in filenames which are chronologically and numerically ordered. When working with multiple cameras, we also add in the name and the type of camera.

The RAW filename for a shoot in London on June 16th, 2008 with a Canon 40D ends up looking like this:　*20080616_40D_London_1283.CR2*

Inspection

The next step is to visually inspect your images. You should tag unusable images before re-examining and deleting them later. How you tag your images will depend on which management software you are using. Rotating portrait format images during your first inspection helps you to retain a clear overview of your image stock.

Assigning Keywords

Immediately following inspection, you should assign IPTC metadata to your files. This will help you to locate or group specific images according to your own user-defined criteria (such as themes or events). Metadata entry methods vary from program to program, but it is generally best to first assign keywords that apply to large batches of files before assigning specific information to individual images.

Grouping Your Images into Sequences

Apple Aperture, Adobe Bridge, Adobe Lightroom, and a number of other image processing and image management applications allow you to automatically group images into virtual stacks, making it easier to view your stock in an image browser. This feature is especially useful for multishot techniques, as it enables you to quickly combine usable images into sequences. The criteria for grouping images into stacks are varied and can be manually configured, although one common preset is a maximum given time delay between shots.

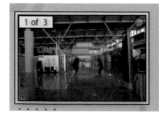

*Figure 2-5: Image sequence consisting of three shots for an HDRI merge. On the left are the images shown in an unfolded stack,
on the right you can see the collapsed stack (screenshot of a stack in Adobe Lightroom).*

You should always put your best shot (your reference shot) at the top of a stack. Automatic grouping according to the time intervals between shots usually works well for images used for super-resolution, HDRI and, for the most part, panoramas. If you are using focus stacking, however, it is sometimes necessary to manually rearrange your shots to achieve the best results.

We have found that manually recording the image numbers from a group of images in the image description can help when organizing your photos. For example, this technique can be applied to all images in a single panorama or a stacking group, and ends up looking like the example in figure 2-7.

For panoramic and focus stacking shoots, where you will often find yourself working with a variable number of shots rather than fixed group sizes, it is common practice to take a shot of your hand between sequences (see figure 2-6). This creates a simple partition, which can be deleted later. An empty, black frame can also serve the same purpose.

This practice also works well for most other techniques, but is impractical when you are shooting bracketing sequences.

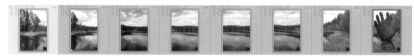

Figure 2-6: Sequence of shot for a panorama. The right-most image showing the hand indicates the end of the sequence.

Image Processing

How you go about preparing images for merging depends on which format your camera uses to save images, and which formats your application supports.

If your program can import RAW images directly, you won't have much initial processing to do. However, if you shoot in RAW and your image processing program only supports TIFF or JPEG files, then you will have to convert the RAW data (to either TIFF, JPEG, or DNG) before further processing.

The standard process for converting RAW files involves converting all the images in a sequence using the same basic settings. The most important settings to consider when converting are white balance, aberration correction, and vignetting. It can also be helpful to adjust the exposure slightly at this point (but not for HDR images). If, for example, the horizon is slanted in a panorama sequence, it would also make sense to correct this now. Most merging applications, however, only support the merging of images with identical pixel dimensions. So, if you decide to straighten and crop your RAW files before merging, make sure that all the files have the same pixel size. For most multishot techniques, it is usually better to crop and straighten your images after they have been merged.

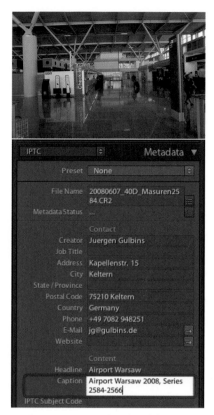

Figure 2-7: Image thumbnail showing part of the IPTC data. Here, we included the image numbers from a HDRI sequence in the Caption (shown here in Adobe Lightroom).

** At this stage you should only sharpen the image slightly, if at all. If the merging program automatically sharpens the image (as do PhotoAcute and most focus stacking programs) then it is better to leave sharpness unchanged.*

When converting sequences of RAW images to TIFF or JPEG, start by optimizing the reference shot, and subsequently apply the same changes, where appropriate, to the rest of the sequence. Such settings usually include white balance, cropping, noise reduction, and slight sharpening.* It is usually better to make corrections to panoramas in general, to lighting or color saturation, and to contrast after the photos have been merged.

Your *reference shot* should be the one which is most similar to your desired result. In an HDRI sequence, this will be the one with normal (medium) exposure values, for a panorama it will be the shot in the center of the subject, and for a focus stacking sequence, it will be the shot with the central element of your subject in sharp focus.

The method for transferring the settings used for the reference shot to the other images in a sequence varies according to which RAW converter you are using. With some converters – Adobe Camera Raw or Adobe Lightroom, for example – you simply select the remaining images and click the *Synchronize* button. In the dialog boxes which follow, you can select which aspects of the reference shot should be transferred (see figure 2-8). Make sure the color temperature and image size (crop) are transferred – most merging applications require all images in a sequence to have the same pixel dimensions.

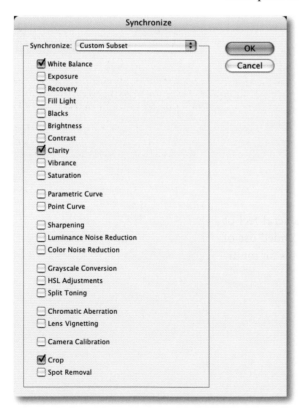

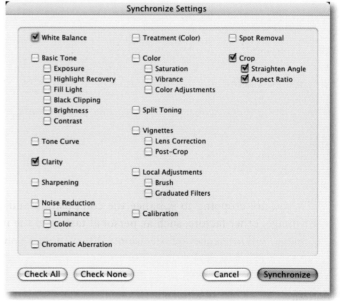

Figure 2-8: The dialog boxes for synchronizing your RAW conversion settings in Lightroom 2 (above) or Adobe Camera Raw (left). Here, you can select which settings to transfer to the other (currently selected) images in the sequence.

Everything we have said about optimizing RAW data using a converter also applies when optimizing JPEGs or TIFFs in an image editor, although transferring settings to multiple images can be more difficult.* For TIFF and JPEG files, we recommend holding off on image optimization until all the shots have been merged into a single image. Only make corrections which are absolutely necessary, such as removing dust spots, aberration corrections, or vignetting before merging your images.

** Some applications (such as Apple Aperture, Adobe Lightroom, Nikon Capture, or LightZone) allow you to apply the same procedure that is used for RAW files.*

If you perform these adjustments using the Layers function in Adobe Photoshop, it is possible to apply the same changes to other images by dragging the adjustment layers from the layer palette of your reference image to other open images. Simply select the applicable adjustment layers, hold down the Alt or ⌥ key, and drag the layer entry in the layer palette to the image you want to modify. Unfortunately, this doesn't work with all filters.

3. **Merging Your Images into One**

This phase varies greatly depending on which multishot technique you are applying. You will find detailed descriptions in individual chapters relating to each technique (chapters 3 through 6).

4. **Optimizing Your Merged Image**

As a rule, merged images generally need to be further optimized after the merge has taken place. This phase usually includes cropping, either in order to remove the parts of the final image which are poorly defined, or to aid overall composition.

Some of the programs described here – especially those used for focus stacking – are capable of automatically cropping the images in a sequence to include only the image areas that are present in all the images used. It is usually necessary to select the areas to be cropped by hand when stitching panoramas.

If you are cropping to enhance the composition and general feel of your image, other factors, such as personal taste and the intended use of the image, will influence your decisions. When shooting photos for multishot sequences, it is always important to shoot a larger area than you wish to appear in your final image, in order to compensate for potential shifts and distortions, and for any cropping you do while post-processing.

Depending on the technique you are using, a number of different anomalies can occur. These can include rounding errors caused by compression and expansion or rotation and distortion, or blurring caused by the averaging of highlight values. Most optimization scenarios will require a local contrast improvement** and a final sharpening of your image. It might also be necessary to burn or dodge some parts of the final image. You will find descriptions of the necessary techniques on page 114.

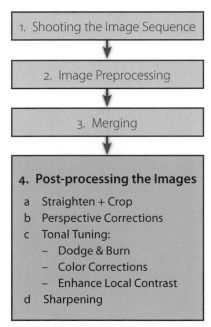

Figure 2-9: More post-processing details

*** Improving local contrast is described in detail in Chapter 6.*

Lens distortions can be corrected before or after merging using the Photoshop Lens Correction filter (Filter ▸ Distortions ▸ Lens Correction). The filter also supports correction of vignetting, chromatic aberrations, and perspective distortion. If you are shooting in RAW format, it is usually preferable to correct vignetting and aberrations directly in your RAW converter rather than later using Photoshop.

It is also better to correct perspective and lens distortion before enhancing contrast or image sharpness. Up until now, this was only possible using select RAW converters (such as Bibble, by Bibble Labs [57]). These types of correction functionality are, however, becoming increasingly common in popular RAW conversion software packages.

2.2 Which Camera? Which Settings?

Many of the techniques described in this book can be applied to images shot using inexpensive compact digital cameras. PhotoAcute even has a function designed specially to enhance images shot using cell phones or point-and-shoot cameras.* However, to achieve high-quality results, you will need a camera whose settings you can adjust yourself. The best choice is a camera which allows you to set both shutter speed and aperture manually, but the minimum requirement is at least manual shutter speed adjustment. For macro and panorama shots, it is important to be able to switch off autofocus and focus manually. Almost all bridge cameras and certainly all DSLR cameras offer this kind of flexibility, while compact cameras rarely do.

This functionality is available in the Professional version of PhotoAcute.

DSLR = "Digital Single Lens Reflex"

Another invaluable piece of equipment is a good tripod. You won't need to use it for every shot, but having one with you at all times is a great advantage. Your camera should have its tripod socket as close to the optical axis as possible – a feature not offered by many compact cameras. A third factor which will influence the quality of your results is the image data storage format.

2.3 Which File Format Should I Use?

All modern digital cameras can produce images in the JPEG format, which has the advantage of producing compressed, and therefore compact, image files. JPEG files are often compressed by a factor of 10 or 20, and sometimes as much as 100. It is, however, important to remember that JPEG compression also causes image data loss, so it is always better to set your camera to the minimum possible compression level if you wish to retain as much image detail as possible – even if this results in larger image files.** Regardless of whether you shoot in JPEG, TIFF, or RAW, you should always set your camera to shoot at the highest possible resolution.

*** A decompressed JPEG image will never have as much detail as an image that has never been compressed.*

Higher-quality cameras will allow you to shoot in RAW (or, occasionally, TIFF) format. TIFF has the advantage of storing non-compressed images, and can also be compressed losslessly. A general loss of image quality is therefore not an issue for TIF-format images, and makes TIFF preferable to JPEG in this respect.

For the majority of the applications discussed here, RAW is the optimum shooting format. When cameras store JPEG and TIFF files, they pre-process the data registered by the camera's image sensor. The camera automatically interpolates and smoothes the image, and usually enhances contrast and sharpness as well. RAW files, in contrast, reproduce as exactly as possible the data collected by the image sensor, and only adds information regarding camera settings[*] to the file before saving it losslessly to the camera's memory card. The actual preparation of a usable image that is suitable for further optimization is only performed later using a RAW converter on a computer. This process can deliver JPEG, TIFF, or PSD files, according to your own personal preferences.

* E.g., EXIF data and white balance settings.

This conversion step causes additional work, but using RAW images has a number of advantages:

1. The user has a high degree of control over the conversion process, and can make adjustments to suit his/her personal taste and the intended use of the final image. The ability to adjust the white balance of an image using a RAW converter is one example of this extended control.

2. As a rule, cameras pack more data into a RAW file than into a JPEG file. This means a modern camera can store RAW image data at a level of 12- to 16-bits per pixel, while a JPEG file can only store 8-bits per RGB channel and pixel. When shooting in JPEG, some of the data registered by the image sensor is automatically discarded by the camera. Often, it is exactly this detail which can be used later to rescue under- or overexposed images.

3. In many of the techniques described in this book, images (or image segments) are distorted, straightened, compressed, stretched, or interpolated. All of these operations result in some loss of image quality, so the reserve detail provided by a 16-bit image can often be more useful than the detail provided by an 8-bit image.[**]

** The 8- and 16-bit color depths mentioned are valid for each RGB color channel.

4. Working on RAW data in a RAW converter is non-destructive. Whatever mistakes you may make, you can always return to the original, unchanged version of your image.

The advantage of the JPEG and TIFF formats is that images can be downloaded from the camera in a near-complete state and often look better than their unprocessed, non-optimized RAW counterparts. Images shot directly in JPEG format are automatically processed to adhere to a generalized consumer taste and usually appear lively and crisp, with contrast and sharpness

being automatically enhanced by the camera. One disadvantage of RAW files (apart from the obligatory conversion step) is the sheer number of RAW formats on the market. Not only do all camera manufacturers have their own, proprietary RAW formats, but they also assign each camera model its own version of that format.

Until recently, most image processing programs only supported regular formats such as TIFF, JPEG, BMP, or PSD. All RAW files downloaded from a camera had to be converted to some such format before they could be manipulated. These days, increasing numbers of image processing applications are RAW-compatible, but use their own, built-in converter. Photoshop, for example, uses the Adobe Camera Raw (ACR) module. However, since the continual development of RAW converters is very labor-intensive, most of the programs described in this book address the problem using one of two simple tricks:

A. They use the open-source converter *dcraw*, which works quite well and is regularly updated to support new formats as they become available. *dcraw* is a command-line-based RAW converter and is generally not integrated into the user interface.

B. They support a single RAW format: DNG. This is a well-documented, universal, open format created by Adobe.* Other RAW formats are converted to DNG from the source RAW format by the DNG converter before further processing takes place. This is, for example, the technique is used by PhotoAcute.

If you choose to shoot RAW images (which we recommend), for the sake of simplicity, we suggest that you convert your image to the DNG format, as described in section 2.5.

If you manage your photo workflow with an all-in-one program such as Apple Aperture or Adobe Lightroom, you can use the built-in DNG conversion function instead of a stand-alone converter to convert your images during download from the memory card or during export to your hard drive.**

Keep in mind, though, that any corrections you might make to a RAW file using Lightroom will be saved in a sidecar file (with standard RAW files) or will be embedded in a *private* area within the DNG file. This means that you can only review your changes using Lightroom itself, or Adobe Camera Raw, but not using other third-party programs. Other manufacturers' programs will only recognize the parts of a DNG file that were originally saved by the camera. If you are lucky, third-party programs will recognize metadata added at a later stage, such as IPTC data (e.g., captions, copyright notes, keywords, etc.).

** "Open" in this context means not only that DNG is well documented, but that it allows the embedding of "private data". "Private data" is data that is only interpreted by a specific program, but is ignored by all others.*

*** The Lightroom import dialog supports this functionality, for example.*

2.4 About the Programs Used in this Book

The goal of this book is to broaden the scope of your capabilities as a photographer by teaching you new techniques, not by boring you with theory or too many overviews and comparisons.* The simple act of shooting images and enhancing them creatively is central to what this book is about, which is why we shall focus specifically on only a few, proven software programs. Not only is this easier on your wallet, but it will also give you more time to experiment. We will use a broad spectrum of tools, including the Photoshop *Merge to HDR* command and the *PhotoAcute*, *FDRTools*, and *Photomatix* packages to apply High Dynamic Range (HDR) techniques; *Helicon Focus* and *CombineZM* for focus stacking; and the *DOP Detail Extractor* for improving local contrast. All of these programs run on Mac OS X as well as in Windows, with the exception of *CombineZM*, which only runs in Windows. Free trial versions of all programs mentioned are available and can be downloaded via the URLs provided at the end of the book as well as on a dedicated web page at the publisher's site.** With the exception of Photoshop – which is really a necessity for any serious digital photographer – they all cost less than $100. Each program has its own particular uses, and they can all be used in conjunction with each other or as stand-alone applications.

All of the techniques and programs presented here are relatively new, and are developing rapidly. All of these programs are updated several times a year, so what we are providing here is only a snapshot, intended to illustrate the potential which lies therein.

Processing multishot images requires a lot of processing power and main memory, so it's best to use a system with plenty "under the hood", and, if possible, one with multiple processors. Your minimum requirement should be a system with 2 GB RAM and a Pentium 4 processor running at at least 2 GHz. Here, more is always better.

A large monitor will also be an advantage when you are processing your images. A sensible minimum should be a 19-inch unit with a resolution of at least 1,280 x 1,024 pixels (this doesn't, of course, apply to laptops). A calibrated and profiled monitor is also an advantage for a more demanding user, regardless of whether it is being used for the techniques described here or for other applications.

** Although it's inevitable that we will sometimes use some technical terminology for the sake of clarity.*

*** See www.rockynook.com/tools.php*

➜ 32-bit versions of Windows do not allow single applications to address more than 2 gigabytes of RAM, but this limitation is changing as 64-bit systems become more commonplace.

➜ A good value calibration tool was described in FotoEspresso 2/2006 (see [6]).

The Photoshop "Merge to HDR" and "Photomerge" Commands

There isn't really much we can say about Photoshop that hasn't already been said in other books. The program's Merge to HDR command can be found under File ▸ Automate or in Adobe Bridge under Tools ▸ Photoshop. The command has been in use since the CS2 version of the program, but was significantly improved for CS3, and is really easy to use. We will be using it to create HDRI images.

We will also be using Photoshop's Photomerge command (File ▸ Automate) to stitch panoramas, and we will also be using Photoshop for simple focus stacking as well as for a number of other overlay and optimization techniques. Simply put, Photoshop is our basic image processing tool.*

* In CS4 "Photomerge" was enhanced again.

With the introduction of the CS4 version, Photoshop provides a more advanced focus stacking functionality, which we will describe in section 4.8.

PhotoAcute

PhotoAcute Studio is manufactured by Texas-based Almalence Incorporated [19]. It is a stand-alone application for Windows and Mac OS X, and its user interface can be easily mastered with the help of this book (the program's own online manual is not as comprehensive as it could be). PhotoAcute is something of a jack-of-all-trades with many different functions:

➜ PhotoAcute's other functions can be used even if your camera /lens combination isn't supported.

1. Profile-based correction of specific errors. This includes chromatic aberration and lens distortion (but not perspective distortion). These corrections are called *profile-based* because a specific camera/lens-profile is used to establish which particular errors can be corrected automatically for the camera/lens combination being used. An ever-increasing number of profiles for many camera/interchangeable lens combinations is bundled with the software, and new profiles can be downloaded from the internet as they become available. If you wish to take the trouble, you can even have Almalence create a special profile based on shots you take yourself using a special test-card. You can upload the results to Almalence Inc., which will then create your profile and make it available for download.

2. Super-resolution

3. Increased depth of field – also known as *Focus Stacking*

4. Basic HDRI functionality

5. Elimination of camera shake from merged images

6. Noise reduction in images shot at high ISO speeds

We recommend that you use RAW images as a basis for most of the techniques described in this book. If you decide to follow this recommendation, you will need a copy of the Adobe DNG converter.**

** Available as a free download from Adobe [20].

PhotoAcute offers a broad spectrum of functions, but a limited range of settings for fine-tuning your optimized images. It is not necessarily a market leader in any of the areas it covers, but it is inexpensive and easy to use. Like all the programs mentioned, PhotoAcute is being rapidly and continually developed.

FDRTools

FDRTools was created by Andreas Schömann [24]. He currently offers three variants of the package, all of which are available for Windows and Mac OS X. *FDRTools Basic* is a powerful freeware package, and is an excellent way to try out HDR techniques. The extended version is called *FDRTools Advanced*, and costs approximately $49. Both versions are stand-alone programs.

The third component is a Photoshop plug-in called *FDR Compressor*. It has a multi-language user interface and can be used for tone mapping, as well as for other applications external to the HDRI sphere – such as optimizing RAW images exported to Photoshop as 16-bit TIFFs. At the time of writing, the plug-in was only available for Photoshop CS2, but not for CS3 or CS4.*

* *The author plans to provide an updated version in the near future.*

Photomatix Pro

Photomatix Pro is a product of the Belgian company HDRSoft SARL [13]. It is available for Windows and Mac OS X with a user interface sporting several languages. Photomatix's specialty is HDRI, and it is among the fastest and most sophisticated programs of its kind. Like PhotoAcute, this is a stand-alone program with a user-friendly interface. The program supports batch processing to ease the strain that processing HDRI sequences puts on the user and the computer.

➜ *In addition to the commercially-available Photomatix Pro and Tone Mapping Plug-In, HDRSoft offers the freeware program "Photomatix Basic" for Windows. It can be used to create HDR images.*

Photomatix Pro also provides a simplified HDR-creation function called *Exposure Blending*, which skips the creation of a tone-mapped 32-bit HDR file, and produces 16- or 8-bit low dynamic range images.

In addition to the Photomatix stand-alone program, HDRSoft offers a Photoshop plug-in called *Tone Mapping*. This can be used to improve localized contrast for PSD images saved with 16- or 32-bits per color channel. Tone mapping for HDR images in Photoshop can also be achieved using a plug-in, as described in section 6.6.

➜ *Photomatix provides similar HDR functionality to PhotoAcute and FDRTools, although Photomatix and FDRTools are superior to PhotoAcute for pure HDR applications.*

CombineZM

The freeware program *CombineZM* [21] was created by Alan Hadley, and can be used to merge images of a single subject taken at differing focal distances. This process is known as *focus stacking*. Of all the programs we will be discussing, this is the only one that is only officially available for Windows, although it can be run on a Mac using an appropriate emulator. CombineZM has a somewhat complicated user interface but gets the job done well. The only real alternative to this program, *Helicon Focus [17]*, is significantly more expensive. There is also a very similar new application, created by the same author, called *CombineZP*. However, we will only cover *CombineZM* in this book.

➜ *CombineZM has its own Yahoo group with current information and updates. Visit: http://tech.groups.yahoo.com/group/combinez/*

Helicon Focus

HeliconSoft's [17] *Helicon Focus* program is primarily aimed at focus stacking and, after testing the software, we had to break our promise to keep the list of programs we want to discuss short. The program's user-friendliness and the results it delivers convinced us to include it in this book, even though a Pro license is not necessarily cheap. For those of you who are more cost-conscious, with a little patience, you can achieve similar results using the freeware Lite version of the program.

The program is available for Windows (2000, XP, Vista and Vista x64) and Mac OS X, although the Windows version is obviously being more rapidly developed than the Mac version. The Windows version can process a whole spectrum of RAW data files (including, notably, Canon RAW formats), and while the Mac version supports different formats (JPEGs and 16-bit-TIFFs, for example), it only supports RAW formats for Mac OS X 10.5 and higher. Even then, it can only read the RAW formats already supported by the operating system. The program's batch processing and image post-processing functions are so far only available in the Windows version.

DOP Detail Extractor

Super-resolution or enhanced depth of field images usually benefit from an increase in local contrast. This is also true of many "normal" digital images. This enhanced local contrast is also known as *microcontrast*. Improving the microcontrast in an image makes fine textures visible and often makes an image generally more eye-catching. There are many microcontrast-enhancing programs and filters available (more on that later), but our personal favorite is the *DOP DetailExtractor* Photoshop plug-in written by Uwe Steinmueller. This plug-in enhanced the presence of most of our images using moderate settings. The effects you can achieve using the software can be quite startling, as we will demonstrate in chapter 7.

The plug-in is available for Windows and Mac OS X, and a single license purchase includes both versions. Full licenses and a trial version can be downloaded from the internet [11].

There is also a simplified version of *DOP Detail Extractor* available (for Mac OS X and Windows), called *DOP EasyD Detail Resolver*. This version offers less settings, and is designed to keep your images smooth while enhancing sharpness.

2.5 Converting RAW to DNG Using the Adobe DNG Converter

DNG was originally envisioned by Adobe as an open and universal RAW format, and has now been accepted by the ISO (*International Standards Organization*) as a proposed standard. The format is fairly well documented (which unfortunately isn't the case for most other RAW formats), and is already supported by a broad range of third-party programs. Using DNG gives programmers the opportunity to offer RAW compatibility without having to support the ever-growing list of proprietary RAW formats available on today's market. PhotoAcute and Photomatix both use this approach when processing RAW image data.

Adobe's RAW-to-DNG converter[*] for Windows and Mac OS X is available for free download. It is capable of converting practically all the RAW formats which Adobe Camera Raw and Adobe Lightroom support, and the list of formats it can process is updated promptly when new cameras/formats become available. The converter is a stand-alone program designed to batch convert all RAW files in a given folder (and, optionally, all subfolders). The program performs this task quickly and reliably.

** You can download it from:
www.adobe.com/products/dng/*

The DNG converter can also be controlled externally, enabling other programs (such as PhotoAcute) to convert otherwise unsupported RAW formats to DNG, and to interpret the resulting DNG file.

To manually convert RAW files to DNG after installing Adobe DNG Converter, simply double click the program icon. The dialog box in figure 2-10 will appear.

In section ❶ choose the source folder containing the RAW files to be converted.

In section ❷ select the target folder in which you wish to store your converted DNG images. We recommend using a folder other than the source folder in order to avoid mistakenly overwriting your original image files.

In section ❸ set the convention to be used for naming the converted files. We keep it simple by using the same name as source file and simply replacing the extension with ".DNG". That way the new files are linked by name to their source files.

In section ❹ the Preferences menu enables you to set the actual parameters for conversion (see figure 2-11).

JPEG-Preview • The converter can embed a relatively good quality preview image into the DNG file. We recommend doing this because many programs use this image to create their own previews.

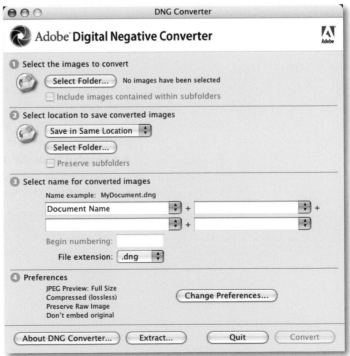

Figure 2-10: Adobe DNG Converter – main dialog

Compressed • This option should be generally activated, as it uses lossless compression to produce DNG files which are 10–65% smaller than the original image files.

Image Conversion Method • There are two possible conversion methods:

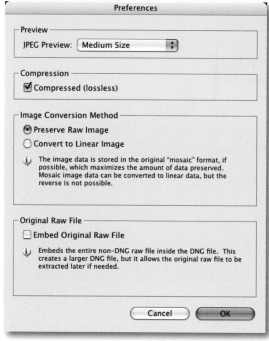

1. *Preserve Raw Image*
 For most camera sensors, this means data output by the sensor following the Bayer Pattern. This option keeps the sensor data intact in the DNG file. This is the best option for our purposes.

2. *Convert to Linear Image*
 In this case the image data is converted before saving to DNG. The original data from the sensor is no longer a part of the file, which can be a disadvantage at a later stage.

The first option is the best option for use with the techniques described in this book. You will most likely profit from this choice later, as newer converters offer improved processing of Bayer Pattern data. The improvements made in this field in the last few years lead us to expect further positive developments in the near future. Data interpretation takes place during conversion to linear formats, and causes RAW data to lose some of its potential detail. Additionally, a linear file is 60 to 300% larger than a camera image, due to the fact that linear formats store all three RGB components for each pixel (RAW only stores a single, grayscale value for each pixel).

Figure 2-11: Adobe DNG Converter conversion settings

Embed Original Raw File • This option embeds the original RAW data in the DNG file, allowing the original image to be extracted at a later stage. This doesn't suit our purposes and will double the size of each DNG file – here, two separate RAW versions are saved in a single file.

Should you want to extract the original RAW image from a DNG file which has been saved this way, simply click on *Extract* (see figure 2-10).

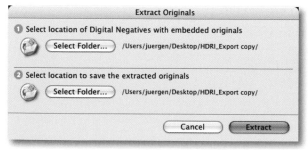

This will bring up the dialog box shown in figure 2-12.

This only works for DNG files which were saved with the original RAW image data embedded.

Click on *convert* (figure 2-10) to start the batch conversion of your RAW files to the DNG format. The converter itself is fairly fast, but you will need a fair amount of processing power, depending on the number of images you are converting. The conversion progress is shown in a separate window (figure 2-13). You can use the *Stop Conversion* button at any time to interrupt (or cancel) the process.

Figure 2-12: Dialog for extracting the original RAW data from a DNG file

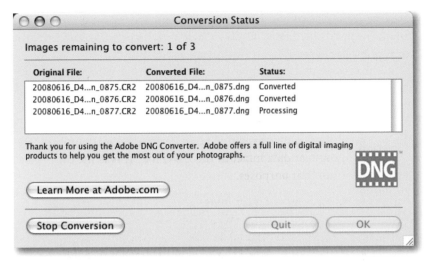

Figure 2-13:

The converter shows the conversion status while converting RAW files to DNG.

Once a file has been converted to DNG, it can be opened like any other file in programs which support the format. If you open a DNG file in Photoshop or Bridge, Adobe Camera Raw is automatically activated. The DNG file also automatically includes all metadata (such as EXIF and IPTC) saved with the original RAW file.

2.6 Installing Photoshop Plug-ins, Filters, and Scripts

Several of the tools described here are available not only as standalone programs but also (or even exclusively) as Photoshop plug-ins, filters, or scripts.

Installing these tools is generally simple, but you will need to have administrator privileges to implement system-wide changes. It is best to log in to an administrator account before installing any of these modules. Many of the modules install themselves automatically, but others require a little computer know-how during the process.

The basic Photoshop CS3 folder structure into which we will install our tools is almost identical for Windows and Mac OS X, and is shown in figure 2-14. The illustration shows only the folders relevant to this particular task.

The illustrated file structure is sometimes present in two places. The first folder tree (figure 2-14) is the Photoshop installation, located by default in Windows at:

C:\Program Files\Adobe\Adobe Photoshop CS3\

The standard location in Mac OS X is:

Applications/Adobe Photoshop CS3/

In both cases these folders are located on the system drive and the modules and settings contained within them are available system-wide.

A second, parallel file system stores all of your user-specific settings and extensions. In Windows this is located at C:\Documents and Settings\ *User Name*\Application Data\Adobe\Adobe Photoshop CS3\.

In order to be able to see these settings files, use the Windows Explorer to go to Tools ▸ Folder Options ▸ View ▸ Advanced Options ▸ Hidden Files and Folders. Now activate the option Show all files and folders.

In Mac OS X, this structure is located in the individual user's *Library* folder, for example, at ~*user*/Library/Application Support/Adobe/Adobe Photoshop CS3/, where "~*user*" represents the user's home directory.

Both structures are generally self-explanatory, once you are familiar with them. Script-based add-ons such as *DOP Detail Extractor* are copied into the *Scripts* folder (a subfolder of *Presets*) of either the system-wide or user-specific directory tree. Filters like the filter-plug-in *FDRCompressor* are copied into the *Filters* folder.

It is always safer to close Photoshop before installing any of the described add-ons, and any modules you do install will only be available once Photoshop has been restarted anyway. You will find your new add-ons in varying locations, depending on their type:

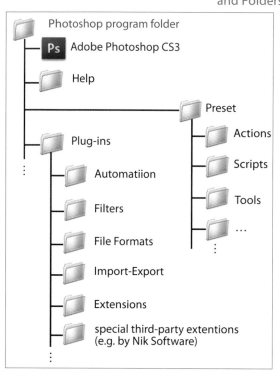

Figure 2-14: The Photoshop CS3 folder structure.

Filter will show new filters at the bottom of the menu list. Many filters are registered primarily here – usually under their manufacturers' name. The actual filter is often located in a sub-menu which extends from the company name (e.g., Filter ▸ Akvis ▸ Enhancer).

File ▸ Automate is where automation modules are located (e.g., File ▸ Automate ▸ Photomerge for stitching multiple shots into a panorama).

File ▸ Scripts is where scripts (such as *DOP DetailExtractor*) are located.

File ▸ Export is where specialized export modules are located.

Some add-ons are designed to extend existing Photoshop commands, and will therefore appear in those modules' dialog boxes. For example, additional formats can appear in the export dialog of the Save as command, while the Open command can be extended to support importing new formats (like JPEG2000), or a specific scanner could be linked to the program, which will then appear in the File ▸ Import menu.

Unfortunately, there are some disadvantages to installing add-ons directly in Photoshop's folders. If you have to reinstall Photoshop, the add-ons will be deleted, and whenever you update the program they will be ignored. To work around this, we recommend installing your add-ons (actions and scripts) in folders other than the ones Photoshop provides (the

ones described in figure 2-14). You can set Photoshop to look for add-ons in different location by choosing the menu Prefrences ▸ Plug-Ins and using the check box *Additional Plug-Ins Folder* to point Photoshop to the folder tree where you've stored your add-ons. That way, when you update Photoshop (from CS2 to CS4, for example), all you have to do is reset that path.*

* *Remember to check if the add-ons still work in a new version of Photoshop.*

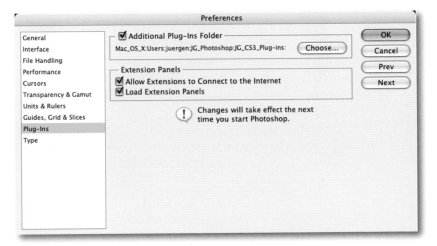

Figure 2-15:
In Photoshop's Preferences, you can define an additional Folder for your own plug-ins.

Actions can also be stored in a separate folder and loaded from the Action panel using Load Actions from the fly-out menu under the ▸ icon at the top left of the Actions panel.

Super-Resolution – More Pixels

3

Sometimes you will need an image with extremely high resolution. Although camera manufacturers are constantly competing with each other to produce the highest image sensor resolution, this is not always a productive approach. An increase in the number of pixels in a sensor will always reduce the size of each individual sensor element, making the sensor increasingly sensitive to image noise. An alternative to ever-increasing camera resolution is to use software such as PhotoAcute, which merges several images into one image with greater resolution than each of the originals. This technique has many practical applications, but is not a catch-all solution for images with insufficient resolution.

Making this type of merged image involves a fair amount of effort, but has a number of advantages:

1. You can use just about any camera, including bridge and compact cameras

2. The technique can be used not only to increase resolution, but also to (optionally) reduce image noise

3. If you merge images with differing exposure values, this can have the side-effect of producing a Dynamic Range Increase effect (DRI)

This chapter explains all the preparatory and practical steps you need to take to produce great super-resolution images. We will also discuss the general use of PhotoAcute for subsequent reference.

3.1 Super-Resolution Shooting Technique

Similarly to shooting for panoramas and HDRI images, there are several points to keep in mind when you shoot the individual basis shots for a super-resolution (SR) image. Sharp, well-exposed images are the ideal starting point.

As with HDRI, when we construct a high-resolution image out of several (almost) identical shots, any movement of the objects in the scene can cause problems. Algorithms exist which help to resolve the problem, but they can never completely eliminate blurring. Therefore, it is important to shoot your images as quickly as possible one after the other. A camera with a built-in burst mode is helpful here, as it allows you to shoot a sequence of images simply by pressing and holding the shutter button.

Because the primary goal here does not involve improving dynamic range, you should only use a small shutter speed bracketing interval with the camera set to Av (or Manual) + AEB. Experience has shown that a ½ EV step[*] is ideal. Smaller intervals can also be used if you are shooting a longer sequence. The range of contrast in your scene plays a role when deciding which bracketing steps to use – a high-contrast scene demands slightly larger steps, while a low-contrast scene works better with smaller steps. If the camera you are using is capable of capturing the entire range of contrast in a scene, you can simply leave out the bracketing procedure. Small bracketing steps (or no bracketing) have the advantage of avoiding longer exposures and the associated risk of camera shake. If you are not particularly interested in increasing the dynamic range of your image, burst mode is just fine, and can help you to shoot longer sequences more easily. Many DSLRs today can only bracket sequences of up to three shots. Newer, high-end models are often capable of more.[**]

Because PhotoAcute is capable of reducing noise (by averaging) while merging images, it is possible to work with ISO speeds between about 400 and 800, and therefore shorter exposure times, faster shooting speeds, and a reduced risk of camera shake. The best ISO setting depends on how well your particular camera handles noise.

PhotoAcute combines several technologies when merging images, and produces images with not only higher resolution, but also with a larger dynamic range (similar to DRI). The program averages the exposure values of the shots involved, and can thus also reduce noise in the final image.

Most HDRI applications require you to shoot from a tripod in order to avoid discrepancies between shots. PhotoAcute makes it possible to shoot SR sequences hand-held, which can be a great practical advantage.

How much resolution can actually be gained using PhotoAcute and the Super-Resolution process? PhotoAcute doubles the resolution along both the X- and Y-axes, resulting in an image that is four times larger than

EV = "Exposure Value", i.e., the shutter speed or aperture value being used. In this case, we are referring to the shutter speed. AEB = "Auto Exposure Bracketing". Using this setting, the camera automatically varies the shutter speed up or down according to a preset interval value.

*** Including the Nikon D200, D300, D700, and the Canon 1Ds Mark III.*

the originals. For this reason, the software manufacturer recommends that you use at least four images as a basis for your new image, although you can use less if that is what is available. However, more is often better, and five or six originals can produce better final results.

An Introduction to PhotoAcute

The following sections deal with the general usage of PhotoAcute, with relation not only to SR image creation, but also to the other functionality the program provides. We will be referring to these sections later in the book.

3.2 Preparing Images for Use with PhotoAcute

Depending on whether you shoot your images in RAW or JPEG format, you will have to prepare your material slightly differently for processing with PhotoAcute. The only RAW format that works well in PhotoAcute is DNG. Because very few digital cameras shoot directly in DNG format,[*] some pre-processing and conversion to the DNG format will be necessary if you are shooting RAW. Depending on which RAW converter you use, you have three basic options:

Leica cameras are some of the very few that support shooting in DNG format.

A. You can use the Adobe DNG Converter to convert a camera-specific RAW format into DNG (see section 2.5)

B. You can use your RAW converter to perform basic preprocessing before exporting your image as a 16-bit TIFF file. If you use this method, remember to use the settings (exposure compensation, white balance, cropping, rotation, etc.) applied to your best image for all the others in the sequence. How you go about doing this depends on which RAW converter you use. We have already briefly described this process for Adobe Camera RAW and Adobe Lightroom in section 2.1 (page 16).

C. You can leave the image files in their original RAW format and import them directly into PhotoAcute. This, however requires that:
 1. You have a locally installed copy of Adobe DNG Converter
 2. Your DNG converter supports your particular RAW format
 3. You have configured PhotoAcute to recognize the path to your Adobe DNG Converter. Here, PhotoAcute automatically opens the RAW file in the DNG converter and automatically loads the resulting DNG file.

If your source images are in a format that is not supported by PhotoAcute, we recommend converting them to TIFF format for processing, although PhotoAcute also supports JPEG.

3.3 PhotoAcute: Basic Usage

If this is the first time you are using PhotoAcute, you will need to carry out the following setup and registration steps before proceeding:

Registration

After starting PhotoAcute for the first time, you will need to activate it, either by entering a registration code or selecting trial mode.

Start by selecting the program's preferences (Photo-Acute ▸ Preferences). In the following dialog box, click *Registration*. This will display the dialog box shown in figure 3-1. You can then enter your name and registration code, or simply click on the *Trial / Reg* button before clicking OK to proceed.

The *Licensed* box indicates which version has been registered (there is also a program version designed specifically for camera phones available, but that doesn't interest us here). The standard version of the program only supports compact cameras – the following sections describe the Pro version.

Figure 3-1: When using PhotoAcute for the first time, you will have to either enter a license key or choose Trial / Reg mode.

Settings

Figure 3-2: This shows the standard settings with the tab "General".

To begin with, you should adjust the program's settings to match your working environment (PhotoAcute ▸ Settings).

General Here, you should set the *Scratch Folder* option to point to a folder where the program can store temporary files. The default setting will point to your main hard drive, but if you're short on space there, you should set this option to use a different drive, or a partition with plenty of spare space.

Make sure the path *Location of Adobe DNG Converter* is set correctly, using the *Browse* button to locate the correct folder if necessary.

The tool-tips which pop up automatically when you start the program can be useful at first, but can get annoying after a while. You can deactivate them by deselecting the *Show tips at startup* option. You should keep the default JPEG quality setting.

View The *View* tab governs the user interface settings (see figure 3-3). *Tiled mode* controls the behavior of the preview thumbnails. You are sure to want to deactivate *Show welcome page* once you have seen it once. The *View interpolation* section allows you to select which algorithm PhotoAcute uses to scale the preview display on your monitor (which, by the way, has nothing to do with the scaling of actual image). *Nearest neighbor* is the fastest method, *Bicubic* and *Background bicubic* require more processing power and are slower.

Figure 3-3: Setting up PhotoAcute's image viewing settings.

Background bicubic initially displays a simply interpolated image while performing the bicubic interpolation for subsequent display. We will be using this option.

Camera Use this tab to specify your favorite camera/lens combination (see figure 3-4 Ⓐ). This is really only for cases in which Photo-Acute cannot find appropriate EXIF data in the image files – some older lenses cannot transmit lens data to the camera; and some lens adapters have the same problem. You will also need to make these settings if PhotoAcute supports your camera, but has no profile for the specific lens used for a particular shot.

It is also a good idea to activate the *Autodetect camera type from EXIF data* option (Ⓑ). EXIF data are usually automatically embedded into the image file by the camera, and include information regarding the type of camera being used, the ISO speed setting, the lens being used (if the interchangeable lens in use can communicate this information), and the focal length setting. We will thus also activate the *From EXIF* setting Ⓑ (see figure 3-4).

Figure 3-4: Use this tab to define the camera/ lens combination you use most often, and whether the camera and lens data should be extracted from the EXIF data (if available).

Advanced Use option Ⓐ in the *Advanced* tab (figure 3-5) to ensure that the program uses the RAW camera profile, even if your source files are in JPEG or TIFF format. This usually results in better quality image corrections.

Option Ⓑ controls the export of exposure data from the EXIF data into the image file. You should always leave this option activated.

Option Ⓒ allows you to restrict the size of your resulting image to a maximum pixel value. We recommend that you deactivate this option.

PhotoAcute automatically does a slight sharpening of your final image. You can use the slider Ⓓ to control exactly how much. The slider's labeling is, however, somewhat misleading – moving the slider all the way to the left will increase the sharpening effect, while setting the slider all the way to the right will result in virtually no sharpening at all. The default *Normal* setting will produce satisfactory results in most cases.

Figure 3-5: Define the profiles to be used for image processing and the degree to which PhotoAcute sharpens your results.

About The *About* tab (figure 3-6) includes information about the program version in use and your registration/licensing status.

Now click *OK* and you will find yourself back in the main program window. Some of the settings shown here (e.g., those for your camera and your lens) can also be found in the *Settings* dialog for individual merge processes. We will be addressing this option later.

Figure 3-6: Here, you will find information regarding your PhotoAcute version and your registration and licensing status.

Displaying Preview Images

PhotoAcute offers two modes for displaying preview thumbnails and the final image. *Tiled* mode displays all the images curently in use, distributed across the application window – otherwise, the program only displays a single image from your list. We use *Tiled* mode for most multi-image scenarios, but you can easily switch beteween the two modes by activating or deactivating the *Tiled* option in the *View* settings (see figure 3-7 Ⓑ).

3.4 Creating Super-Resolution Images

→ *PhotoAcute's "Super Resolution" function only works if the program recognizes your camera and supports it with an appropriate profile. Camera recognition takes place either via an image's EXIF data or via settings made in the "Camera" tab of the program's settings dialog.*

Although PhotoAcute can perform several optimization functions simultaneously, as described in section 2.4, we will start by concentrating on maximizing resolution, and the settings associated with this function. The logic involved in the merge itself should become self-evident during the process.

The first step is to open the images you wish to work with using one of the several methods PhotoAcute offers.

Figure 3-7: The PhotoAcute application window with loaded images displayed in Tiled mode. Here, you can use the "Settings" button to change the settings for the current process that would otherwise be made using the "Preferences" dialog.

A. Go to File ▸ Open (or click on the *Open*-button in the PhotoAcute window) and use the resulting dialog box to navigate to a folder containing your source images. Instead of opening each file individually, you can open multiple images either by using the ⌃Ctrl/⌘-key while selecting, or by holding down the ⇧-key to select an entire group.

B. Drag and drop the required files into the PhotoAcute window directly from Windows Explorer or from the Mac Finder.

C. Drag the images from a drag-and-drop-capable image browser (Adobe Bridge, for example) and drop them into the PhotoAcute window.

You may have to exercise some patience during this process, as PhotoAcute can be slow when handling large images. Once processed, the images appear (usually cropped) in the preview tiles, as shown in figure 3-7.

Normally, you will have to set the display ratio to its smallest size (25%) to display your images adequately. The *Fit* setting (which can be found in the Ⓐ menu) scales your images to fit them into the individual tiles, but stretches them to a degree that often makes this view unusable. You can move the selected image detail displayed in the navigation window using your mouse, which will be displayed along with its EXIF data (such as aperture, shutter speed, and focal length; see figure 3-7).

When working with RAW files, don't be irritated by the somewhat colorless and lifeless preview images. Along with the stretched preview images already mentioned, this problem simply underscores the weaknesses of PhotoAcute's preview system.

The next step is to select the images you want to merge using the check-box next to each image's name. Only selected images will be processed. The last selected image is automatically selected as your preferred image, and is marked in gray. This image will then be your reference image for the processes that will be applied to all the other images in the sequence, so it is important to select the image with the best tonal range for this purpose. The final, merged image will be saved in a new file, and your original images will not be changed during the merge process.

If the settings you have made previously are not suitable for the current run, click *Settings*. This will call up the familiar dialog box (see the description on page 35). You can now adjust your preferences as desired.

Now click *Start*. In the resulting dialog box (see figure 3-9), you can choose either a preset merge process using the Ⓐ menu, or you can make your merge settings manually.

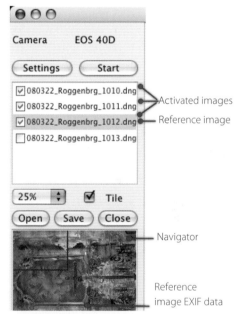

Figure 3-8: You need to select the images to be merged by hand. The image marked blue is the reference image.

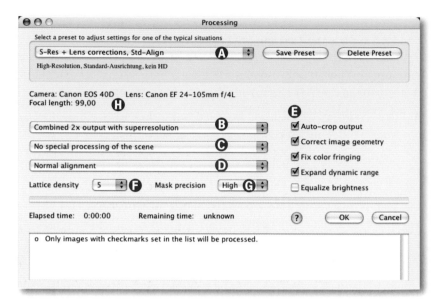

Figure 3-9:
This is where you can specify how your
images will be processed. Your settings can
be saved as a new preset and selected in
Menu Ⓐ.

Manual settings are made mostly in menu Ⓑ (see figure 3-10), where you can specify the primary goals of your merging process:

Figure 3-10: Here, you select the required merge process.

▸ Merge the source images into a new image with twice the original resolution

▸ Merge the source images into a single, normal-resolution image with reduced image noise

▸ Re-align and display the source images (without merging)

In our first example, we will be using four images to create a new super-resolution image. Accordingly, we select the first menu item. Alternatively, we could simply reduce image noise, or align and export our images for further processing (in Photoshop, for example).

In menu Ⓒ (figure 3-11), you will find additional, special processes that can be applied to your images:

▸ No special processing

▸ Remove moving objects from the scene

▸ Remove moving objects from the first image only

▸ Merge the source images using focus stacking

Figure 3-11: Use this menu to define additional special processing steps.

We don't need any specialized treatment in our first example, so we will select the first option.

We then use menu Ⓓ to define how the images in the sequence are aligned (see figure 3-12):

▸ Normal alignment (this is our standard setting)

▸ Only small shifts (to be used for images shot using a tripod)

▸ Wide distortions (recommended for hand-held shots)

▸ No alignment at all (usually only applicable for images made using a microscope)

Figure 3-12: Here, you define how the source images will be aligned for the merge process.

Because the shots used in our example were taken hand-held, but supported on a solid base, we will use the first option, *Normal alignment*.

The final step involves activating options in menu Ⓔ, which determine the remaining corrections which are to be applied to our image. These options include:

Auto-crop output We recommend activating this option, which automatically crops the final image to include only sections which were present in all of the source images. We therefore also recommend that you shoot your images with a generous border, in order to compensate for any parts of the image that may be auto-cropped later.

Correct image geometry PhotoAcute uses this option to correct lens errors (distortion). This option can only be used if Photo-Acute has a profile for the camera/lens combination that was used to shoot the original image (see section 3.5 for more information).

Fix color fringing This corrects chromatic aberration in your source images before merging. This function also requires the presence of a complete camera/lens profile.

Expand dynamic range This combines the tonal values of the individual source images to expand the dynamic range of the resulting image (DRI). This is particularly effective if the source images come from a homogenous sequence. The resulting image is, however, an LDR image (and not an HDR image), although the program version 2.8 (and higher) allows you to save a real HDR image. An LDR image is saved in either a 16-bit or an 8-bit format.[*]

Equalize brightness This option calculates the brightness of the final image by averaging the brightness values of the individual source images. Here, PhotoAcute reduces shadow noise in order to make shadow details more visible. Our experiments with this function sometimes delivered unsatisfactory results, but it is nevertheless worth giving it a try.

Lattice density This sets the limits for the density of the elastic distortion lattice in the alignment algorithm. High values make it possible to compensate for more complex distortions (due to the use of a fish-eye lens, or the visual effects of hot air rising, for example) but can lead to artifacts and incorrect matching if moving objects are present in the scene.

Figure 3-13: Optional additional corrections that can be applied during merging.

[*] *For more information about the difference between HDR and LDR images, see chapter 6.*

Figure 3-14: This parameter controls the density of the elastic distortion lattice in the alignment algorithm.

Mask precision | High **G** ‡

Figure 3-15: This parameter controls the degree of precision PhotoAcute will apply when looking for moving objects.

Mask precision This parameter controls the precision of focused areas and detection of moving objects. A higher value leads to longer processing times, but may achieve better results. *Medium* usually works fine.

The settings you use can be saved as a preset (click *Save Preset* in menu Ⓐ). These will then appear as a separate item in the drop-down menu Ⓐ under the name you specify (see figure 3-9). You can use fairly long preset names to describe your settings accurately. You also have the option of writing an abbreviated description which will later appear in the drop-down menu Ⓐ.

In section Ⓗ (see figure 3-9 on page 38), PhotoAcute displays information about the camera and lens used for the shot and the focal length (if a zoom lens was used). This information is taken either from the reference image EXIF data or from the preferences set by the user.

Finally, click *OK* to start processing. The progress bar at the bottom of the window will track progress, which can be slow if you are working with a large number of images, or if you are applying a number of complex corrections.

The result will be a new image, stored initially only in your computer's memory cache, and displayed in the program's preview window along with its size (measured in pixels). The program will automatically suggest a name for the new image, consisting of the name of the reference image and a suffix. You can inspect this virtual result in the navigator window along with the reference image. Again, don't let the rather lifeless (RAW) display image bother you. A little post-processing in a RAW converter or in Photoshop can work wonders.

Figure 3-16: PhotoAcute offers several different file formats for saving your final image. If your input files were RAW files, your output format should be DNG.

If the result is acceptable, you need to save it as a file with its own unique name (either the suggested name or one of your own invention). PhotoAcute offers several export formats (see figure 3-16). If the source images were DNG or RAW files, then they should be exported to DNG to allow for more flexible processing later on. Although the option exists, we do not recommend using PhotoAcute's DNG to TIFF or JPEG conversion, or that you use any output format other than DNG.

When creating an SR image, the difference between the source images and the resulting super-resolution image may be hard to detect at first. Apart from the fact that the image file is larger, in most cases, the differences in resolution and detail will only become apparent at the printing stage. PhotoAcute cannot, of course, work miracles and make details appear which weren't part of the source images to begin with. However, the merged image will always show noticeably better texture once it has been interpolated for printing using Photoshop or a similar tool. Figure 3-17 shows two magnified image details – the one on the left was printed directly from the source image, while the one on the right is the result of PhotoAcute's super-resolution processing.

Figure 3-17: The image on the left is a merged super-resolution image. The center image is a detail taken from one of the source files. The image on the right is a detail taken from the super-resolution image.

You can also apply other corrections when merging images, which we will describe in the following sections. These corrections are applied to the source images before merging, and will not modify the actual source files. Reducing image noise is usually the most important of these additional corrections.

3.5 Additional PhotoAcute Image Correction Functions

As previously mentioned, PhotoAcute can carry out a number of automatic corrections before merging images. These functions include the removal (or, more accurately, reduction) of chromatic aberration and lens distortion correction. Unfortunately, the program cannot correct vignetting.

All of these corrections are profile-based, which means that the properties of a camera and a specific lens are measured against special test exposures and are stored in a profile. These profiles do not, by the way, have anything to do with conventional ICC color profiles.* The profile data is then used to make appropriate corrections to your images. In order for this procedure to work effectively, the specific camera/lens combination you are using has to have its own, unique profile.*

If your camera (or lens) is not supported, the program's manufacturer (Almalence Incorporated) will make you one for free and make it available to all other users online. In order to do this, you will need to make a series of test shots and send them to Almalence. The exact procedure is described at the URL listed in the margin.

** You can find a list of the currently available camera and lens profiles at: www. PhotoAcute.com/studio/downloadwin. html#profiles_list*

➔ A description of how to establish a profile for a specific camera or lens can be found at: www.PhotoAcute.com/studio/ downloadwin.html#profiles_list

"Correct Image Geometry" – Correcting Lens Distortion

Wide-angle lenses and zoom lenses in particular tend to produce distortion (especially when used at their shortest and longest focal lengths). The effects produced are usually pin-cushion ▦ or barrel ▦ distortion of straight lines. The degree of distortion depends on the lens (or focal length) being used and the subject distance. The closer you are to your subject, the more visible distortion will be. The distance between the subject and the center of the lens also plays a role – the further a straight line is from the center of the image, the more pronounced any distortion will be.

Such distortion is usually barely visible in most landscape images, but can be bothersome in architectural images or others which contain clear, straight edges (see figure 3-19).

These days, most high-quality photo editing software will allow you to correct these types of aberrations. In Photoshop, the Lens Correction filter has been available since the CS2 version (Filter ▸ Distort), but requires you to find the appropriate settings using the preview window and trial-and-error. A profile-based solution is more elegant, and is offered by other programs, such as *DXO Optics Pro* [35], *PTLens* [15], or *LensFix* [16].

These programs all offer additional, manual error correction for camera/lens combinations that are not already profiled, whereas PhotoAcute only allows profile-based error correction.

To make the corrections described on pages 38–40 using PhotoAcute, activate the *Processing* dialog, and check the *Correct image geometry* option (see figure 3-18). Figure 3-19 shows the result of such a correction. We used an image which isn't particularly appealing, but which clearly shows evidence of lens distortion. Corrections made to most other images will be much more subtle.

This type of image correction (like the ones we will describe later) can be used on single or merged images, and can also be applied to images al-

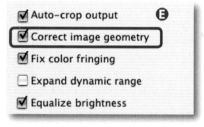

Figure 3-18: The "Correct image geometry" option can be used to correct lens-based distortion.

Figure 3-19: The image on the left shows strong distortion caused by the wide-angle setting of the zoom lens we were using. The image on the right shows the results of using PhotoAcute's distortion correction. There is some obvious over-compensation, and perspective distortion has not been addressed.

ready processed using other tools, such as *Photoshop, Photomatix Pro, Helicon Focus, CombineZM,* or *FDRTools.* For applications that do not support profile-based image correction, you can use PhotoAcute for preprocessing. Simply load your images into PhotoAcute, activate the desired corrections (see figure 3-18) and choose the *Output individual aligned images option* in menu Ⓑ as shown in figure 3-20. This operation requires you to have an established profile for your camera/lens combination, and to load at least two images for processing.

PhotoAcute sometimes over-compensates while performing geometric corrections, and we recommend that you check thoroughly how well the program handles your camera/lens combination. If PhotoAcute isn't up to your standards, we recommend using the relatively inexpensive *PTLens* [15], which is easy to use, supports a large number of cameras and lenses, and only costs about $25.

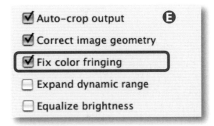

Figure 3-20: These settings allow you to export corrected images without merging them.

"Fix Color Fringing" – Correcting Chromatic Aberrations

"Chromatic aberration" describes color fringing, which results from deficiencies in the construction of a lens – different wavelengths of light are refracted to slightly different degrees by the elements of the lens, causing their images to be formed in a staggered pattern on the camera's image sensor. This type of aberration is often particularly evident in high-contrast portions of an image, and at well-defined edges. Stopping your lens down (reducing the aperture) while shooting helps to reduce this unwanted effect.

The term *color fringing,* which is used in PhotoAcute, is generally correct, but is also (somewhat confusingly) used elsewhere to describe the *blooming* effect that occurs when the pixels that make up certain highlights in an image become irreparably over-exposed. Here, we are referring exclusively to chromatic aberrations.

Activating PhotoAcute's *Fix color fringing* reduces chromatic aberrations. There are no additional settings for this function, and it only works properly when an appropriate camera/lens profile is used.

If the color fringing isn't completely gone after processing, you can make additional corrections later using a RAW converter.[*]

Figure 3-21: "Fix color fringing" will reduce chromatic aberrations in your image.

** Only, of course, if your input format is RAW and your output format is DNG.*

Figure 3-22:
Highly magnified details: The left-hand (source) image shows a clearly visible magenta color fringe between the cherub and the dark background. On the right is the processed image, in which the effect is visibly reduced. We also activated the "Equalize brightness" function during processing. The final image was constructed from three source images.

Most good RAW converters (including Adobe Camera Raw, Lightroom, and Capture One) offer this type of functionality, but these are not generally profile-based.

PhotoAcute does not yet have the necessary functionality to perform the corrections described (distortion, chromatic aberrations, etc.) on single images which can then be separately saved to files, for example as components of a panorama sequence. PhotoAcute requires you to always load at least two images. Other programs or plug-ins, such as *PTLens* [15] or *LensFix* [16], and RAW converters like *Bibble* [57] or *DXO* [35] can correct images based on profiles and then export the corrected image. If you are shooting with a Canon DSLR, you can also use Canon's *DPP* (*Digital Photo Pro*) software to perform these types of corrections.

Reducing Noise

The smaller your camera's image sensor, the higher your camera's resolution; the older your camera, and the higher your ISO speed setting, the greater the degree of noise your image will display. Images brightened after shooting will also show increased noise, especially in darker image areas.

Noise manifests itself in the form of discrepancies in brightness and contrast between neighboring pixels, which are, in turn, caused by the technical inadequacies of the digital photographic process, and not by real artifacts present in the subject. When discussing noise, we differentiate between color noise and luminance noise, and most RAW converters offer noise reduction filters for both types of noise. There are many different ways to reduce noise, starting with the camera itself.

Apart from when we are using extremely long exposures, we prefer to reduce noise later rather than in-camera, due to the processing power and the degree of control a computer gives us. Reducing image noise always involves striking a compromise between the level of noise present and the sharpness of the final image.

Activating noise reduction during shooting can also significantly reduce your potential shooting speed. The camera's image processor simply needs time to reduce noise, and for most multishot techniques, a fast shooting speed is a better choice.

→ *Several of the tools we will be discussing also allow you to reduce image noise by averaging the pixels found in multiple images of the same scene. The "Fusion" method in Photomatix Pro also provides an "Average" option, and FDRTools also has an averaging function. Both programs are discussed further in chapter 6.*

Many of our techniques allow you to reduce noise in a relatively natural way. DRI and HDRI images only use portions of the images which are correctly exposed anyway, although some tone mappers (explained in section 6.1) can increase the effects of noise when increasing microcontrast. PhotoAcute reduces noise by averaging the exposure values of the pixels in the source images, thus almost entirely eliminating the random deviations that cause noise in the first place. Here, the more shots you use – hopefully without much shake – the better your results will be.

To activate this function, use menu Ⓑ (see figures 3-23 and 3-9) and activate the option labeled *Combined 1x output (no superresolution, noise*

reduction only). Additionally, you can also activate *Equalize brightness* from menu Ⓔ (see figure 3-24).

Figure 3-25 shows two image details demonstrating the difference between a source image and the image resulting from using PhotoAcute's active noise reduction. The final image was merged from six separate source images.

If you choose to use DNG as both the import and export format, you will be able to perform more noise reduction later (if necessary) using your RAW converter. You can also further reduce noise for all other formats using Photoshop (Filter▸Noise Filter▸Reduce Noise). For even better results, you can use special Photoshop plug-ins, such as *Neat Image* [36], *Noise Ninja* [37], *Noiseware* [38], or Nik Software's *Define* [23].

Whichever route you decide to take, images shot at high ISO speeds can always benefit from an application of PhotoAcute's noise reduction feature.

Figure 3-24: When this option is activated, PhotoAcute will average the brightness values of the pixels of all source images.

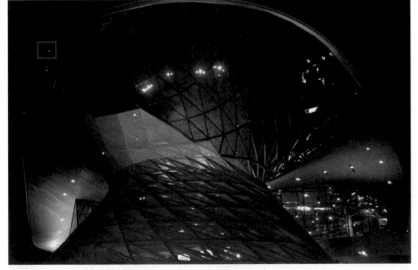

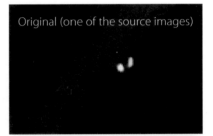

Figure 3-25: The image on the left shows one of the source files. The upper right image is an enlarged detail from this image. The lower right image shows a detail of the noise-reduced image. Six images were shot using a Nikon D200 at ISO 1600 and merged using PhotoAcute.

Eliminating Moving Objects

It is not uncommon for objects in a scene to move between shots, creating a problem for the photographer when combining a sequence into a merged image. This applies just as much to superimposed super-resolution images as to stitched panoramas. If you have enough source images (PhotoAcute recommends that you use at least five images, and doesn't function with less than four), then the program is capable of digitally removing moving objects from a scene. With a little bit of luck and sufficient object movement, the program can produce perfectly acceptable results.

Here, we use either the option *Remove moving objects from the scene* (see figure 3-26), or *Take moving objects from the first image* before we begin the merge process.

Our example scene shows a construction site fence. At no point during the shoot was the scene empty of passersby, so we used PhotoAcute to "clean" the image. We could have achieved the same effect using one of the Photoshop stamp tools, but this way is faster. Figure 3-27 shows our six source images, and figure 3-28 shows the scene after we used PhotoAcute to eliminate passersby and merge the images.

Figure 3-26: The second and third options help you to remove moving objects from your image.

Figure 3-27: Our six source images showing the passersby that we want to remove from the scene.

Figure 3-28: The merged image after an attempt to remove the moving objects from the scene. The results still leave something to be desired, and even the leaves at the top of the frame show a movement that hasn't been completely eliminated.

The results aren't perfect, but can certainly serve as a basis for some further stamp-based corrections.

The problem of moving objects is one of the more prominent aesthetic problems that can occur when using multishot techniques, although it is always less of an issue for panoramic shots. Although each of the programs we will be discussing has some kind of correction feature for this type of issue, and although the quality of these functions is always improving, we have yet to find an effective all-around solution. The best solution is still simply to avoid capturing moving objects when shooting your source images.

When shooting images for multishot processing, you simply have to be patient and wait for the wind to die down, for the grass to stop moving, for tree branches or flowers to stop waving, or for your scene to become people-free. Simply getting up early is often an effective way to find the scene you are looking for, and using a camera with a fast burst mode is often a great help too. If nothing else helps, you may have to retouch your individual shots by hand before merging, or after the merge, which can be even more painstaking. Remember – some scenes are simply not suitable for use in a multishot merge.

Focus Stacking

Focus Stacking describes a technique which enables the user to construct a single image out of multiple images of a single scene shot at different focus distances. The resulting image will have a much greater depth of field than each of the source images. The use of PhotoAcute for focus stacking purposes is explained in chapter 4.

3.6 Batch Processing

Working directly with a command prompt has pretty well gone out of fashion (with the exception of Unix and Linux and some IT administrators), but the method does have some advantages. Processes which take a long time to complete, or which need to be repeated regularly, can be executed in the background if they are started at a command prompt level. PhotoAcute offers a command line interface which enables the user to control all of the program's functions (except, of course, the actual visual inspection of images). A very elegant way to approach working with the command line is to create scripts (text files) containing several commands, which are executed one after the other when the script is run. Once a script has been started, you can return to doing other tasks in your computer's graphical user interface.

Information about how to start the PhotoAcute command prompt can be found in the program's online help. Once you understand PhotoAcute's

graphical interface, switching to the command prompt is a very simple step. This is especially true if you are already familiar with other types of shell scripts or scripting languages. You can create scripts in any text editor, and a single command line in a script might look something like this:

PhotoaAcute @Church -m2 -oChurch_x_2 -p2 -r0 -e2 -f1 -a1 -g1 -c2

This command opens all the files that are part of a list contained in the file *Church* (@Church). It tells PhotoAcute to merge them into a single super-resolution image (-m2), to use DRI to optimize the tonal range (-e2), and to average the brightness and correct chromatic aberration (-f1). It also tells the program to align the individual shots as if they were taken using a tripod (-a1), to perform distortion correction (-d1), and to crop the final image. The option "-oChurch_x_2," then saves the final image as *Church_x_2*.

3.7 Import and Export Formats

PhotoAcute supports a number of different input and output file formats.

The program's input formats include JPEG, TIFF, and numerous RAW formats. For the majority of the functions described here, you will achieve the best results with image files that contain as much image data as possible. If your camera supports a RAW format – as most modern DSLRs and bridge cameras do – you should use this format for shooting images for super-resolution merging. RAW files usually provide between 12- and 16-bits of image data per color channel, while a JPEG or a TIFF image taken directly from the camera's memory card will only contain 8-bits of data per channel. Even if a 16-bit TIFF image appears to contain more information, it can nevertheless only contain as much data as the camera can capture in the first place (typically 12- or 14-bit per RGB color channel).

If your camera only supports JPEG, you should set it to shoot at the highest possible resolution and use the lowest possible compression setting. If your camera offers you the choice between using JPEG and TIFF, we recommend that you use TIFF, as this format is not susceptible to the formation of compression artifacts.

If you import JPEG or TIFF images into PhotoAcute, you will be limited to those same formats as export options. If, for example, you import an 8-bit TIFF image, then an 8-bit format is the only format you can export after processing. If you import a RAW (or DNG) image, you can (and should) export to DNG.

We have found that Adobe Camera Raw can not always interpret PhotoAcute's DNG output correctly. It this happens to you, you will have to revert to using the TIFF format (preferably 16-bit TIFF).

If you wish to import RAW images generated by your camera, Photo-Acute will automatically use Adobe DNG Converter to create a working DNG file. In order for the converter to function correctly, it has to be

installed either at its default location in the operating system folder, or at a location whose path can be set in the PhotoAcute preferences dialog (see figure 3-2 on page 34).

If you are importing DNG or any other RAW format, you should always use DNG as your export format. PhotoAcute's RAW-to-JPEG or RAW-to-TIFF conversion capability is not the best available, and the program warns users accordingly. Several of the other programs we have mentioned are not capable of exporting any RAW formats at all – in these cases we recommend exporting to 16-bit TIFF.

We don't want create the impression that PhotoAcute only works well with RAW or DNG files. The program supports JPEG and TIFF perfectly well, and these formats have their own advantages – you can preprocess them in a photo editor, adjust white balance and vignetting, or even crop in advance to save time later during additional processing steps. However, if you plan to make corrections to the image geometry or to any lens-based aberrations, it is better not to crop your images in advance.

Optimizing Images During Preprocessing

Please note: When you optimize an image using a RAW converter, you must export it to TIFF or JPEG before merging, as nearly all of the programs discussed here do not recognize optimization data embedded in RAW files.

One exception to this rule is if you use Photoshop in combination with Adobe Camera Raw or Lightroom. Photoshop can interpret embedded adjustments in DNG files made using ACR or Lightroom, and can also interpret data that other RAW formats store in XMP sidecar files.

3.8 Post-Processing Your Images

As already mentioned, the best starting point for super-resolution images are source images saved in RAW or DNG format. PhotoAcute can, in turn, also save your results as DNG files. These DNG files will, however, require some post-processing in order to convert them to a regular image format. When using 16-bit TIFF files for input, the preferred export format is also 16-bit TIFF, as this offers the most margin for further image enhancements, such as white balance correction, tone balance correction, tone mapping, global and selective color correction, and also scaling and sharpening. 16-bit image files are also better suited for microcontrast enhancements. If your input images are based on an 8-bit format (TIFF or JPEG), PhotoAcute can only output an 8-bit format.

If you are using RAW source images, you will need to decide which of your planned corrections you want to perform during the image preprocessng

stage, before the actual merge process takes place. Classic examples of pre-processing steps are white balance and exposure compensation corrections. If you decide not to post-process your image's microcontrast in Photoshop, you can still adjust local contrast using a good RAW converter. These days, even (careful) global increases in color saturation are best performed using a RAW converter. While most RAW converters offer a sharpening option, they are not usually capable of processing selectively, and can only target an entire image. Because sharpening is often an important factor influencing overall image quality, it is usually better to adjust image sharpness at the post-processing stage using Photoshop, especially if you have access to a sharpening plug-in.

These days, most RAW converters can also convert images to monochrome (black-and-white) to a high standard. You can then optimize your monochrome tonal structure later using Photoshop, or other similar tools.

Defining the order of your workflow steps when using a RAW converter isn't always easy: Should you preprocess your RAW image and export the results to TIFF, or should you simply post-process the entire image using Photoshop? Most perspective or distortion correction cannot be performed using a RAW converter, and will require use of an image editing program rather than regular post-processing.

Regardless of which PhotoAcute export format you choose, the resulting images will not need to be sharpened as much as other images, as PhotoAcute always sharpens images automatically. This effect can be controlled using the *Oversharpening protection* slider in the *Advanced* tab in the program's *Preferences* and *Settings* dialog (see figure 3-29). If you are using JPEG or TIFF source files, you should sharpen your images as little as possible at the shooting stage. This will help avoid over-sharpening and the creation of unwanted image artifacts.

Figure 3-29: This setting allows you to control PhotoAcute's sharpening effect.

Alternative Methods of Increasing Image Resolution

An alternative method of increasing image resolution is to stitch several individual, overlapping images together to form a single, merged image. Here, each individual source image captures a different part of the overall scene. This technique is also described in more detail in chapter 5. Depending on the number of images used, this method can increase resolution by up to 4x or more. Additionally, this process also allows you to work outside the constraints of your camera's normal format without losing resolution due to cropping or trimming.

Both of these processes – merging multiple images using PhotoAcute or using stitching software – are capable of delivering much higher image quality than interpolation using Photoshop (and/or plug-ins) can deliver.

Figure 3-30:
It's also possible to increase the resolution of an image by merging a series of overlapping source images. Once merged, you can then correct perspective errors and even out exposure differences to produce a seamless result. These final steps can be performed by hand or using appropriate software.

For those of you who aren't satisfied by these methods and who want images with even higher resolutions, we recommend that you visit the Gigapxl Project at www.gigapxl.org.

Focus Stacking – Maximizing Depth of Field

4

Despite the rapid technical advances digital photography has seen in recent years, depth of field in digital images has not increased significantly. To maximize the depth of field, the smallest possible aperture is usually selected. However, this method works only up to a certain point, beyond which the laws of optics cease to improve the image: while depth of field continues to increase beyond a given aperture, the general sharpness of the resulting image begins to diminish. This effect is caused by the physical diffraction of light as it passes through the aperture opening. The f-stop at which diffraction sets in depends on the lens, its focal length, the distance between the lens and the object, and on the size of the sensor and its individual light-sensitive elements (we will discuss this topic further later on).

Maximizing depth of field is another area in which "digital optics" – i.e. computer-based digital post-processing – can lend a hand. New software can be used to merge a series of shots that were taken at differing focal distances into a single image with enhanced depth of field.

A number of programs are capable of performing this type of process. However, to keep our list of tools as short as possible (and to keep our expenses down!) we will start by using PhotoAcute, which refers to the function as "Focus Stacking". We will also discuss the freeware program CombineZM, which, unfortunately, is only available for Windows. Another program that will be covered is Helicon Focus, an elegant and user-friendly (although rather expensive) alternative. Photoshop can also be used to perform simple focus stacking.

4.1 Why Use Focus Stacking?

Controlled depth of field is often used as a compositional tool – for example, to emphasize the face in a portrait shot by blurring the background. It is also conceivable that the photographer simply wants to use the maximum achievable depth of field, or simply more depth of field than the available equipment can provide. Depth of field is generally determined by the distance between the subject and the lens, the focal length of the lens being used, the aperture setting, and the size of the image sensor (which affects the effective focal length). This means it is possible to achieve greater depth of field when photographing an object up close with a wide-angle lens than it is with a normal lens. Some compact digital cameras can deliver more depth of field (at some apertures) than typical DSLRs. In absolute terms (disregarding the crop factor)[*], compact camera lenses are generally of a more wide-angle nature than those found on cameras with larger image sensors (APS-C or full-format 24 × 36 mm).

The size of the individual sensor elements also plays a role, and also helps to determine how far you can stop the aperture down before diffraction begins to reduce image quality.

Greater depth of field is often an advantage when shooting architectural, landscape, or macro images. When shooting macro (or micro) shots, the depth of field is always relatively small due to the unusually exaggerated relationship between subject distance and focal length. In the case of photomicrography (i.e., shots taken with a camera attached to a microscope), this distance may be no more than a fraction of a millimeter.

Under normal circumstances, you can maximize depth of field simply by setting the aperture as small as possible.[**] The effectiveness of this procedure is, however, limited by the diffraction that takes place at the edges of the aperture opening. Closing the aperture down further simply reduces sharpness, and with it the usable depth of field. This is because a reduction in contrast between neighboring pixels has the effect of reducing overall image sharpness. The optimum aperture setting – known as the *usable aperture* – achieves the best possible compromise between depth of field and overall image resolution. It is determined by the focal length of the lens, the subject distance, the size of the image sensor, and the size of the individual sensor elements (or sensor resolution).

In the case of a digital camera with a 10-mexapixel APS-C sensor, the usable aperture is somewhere between f/9 and f/11. Higher resolutions (for the same sensor size) further reduce this value due to the even smaller distance between the individual sensor elements. Due to the small image sensors they use, most compact digital cameras have a maximum aperture setting of between f/5.6 and f/8.

Physically longer lenses (for example, macro extension rings or bellows) reduce the usable aperture value because the physical lengthening of

[*] *The crop factor tells us the equivalent focal length of a lens used with a digital camera compared to the focal length the same lens has when used with a 24 x 36 mm full-frame 35mm camera (sensor). A typical DSLR with an APS-C sensor has a crop factor of 1.5 (for most Nikon APS-C DSLRs) or 1.6 (for Canon APS-C -DSLRs).*

[**] *A smaller aperture is indicated by a larger numerical aperture value (e.g. f/11 or f/16).*

the lens increases the effective aperture. The effective aperture is calculated based on the following formula:

Effective aperture = nominal aperture × (magnification power + 1)

The "nominal aperture" is the aperture the lens is named with. Increasing the distance between the aperture and the film (or image sensor) leads to a higher effective aperture value.

If you reduce the aperture beyond its effective point, the depth of field still increases, but overall contrast (and with it the perceived sharpness of the image) will decline.

You can find a web page for calculating effective apertures (with relation to reproduction ratios) at the address listed at [43]. Keep in mind when using this calculator, though, that the results are based on calculations made for a full-frame (24 × 36 mm) image sensor. You can read more about this topic in the article listed at [42].

If you find yourself in a situation that requires more depth of field than your current combination of camera, lens, and subject distance can provide, focus stacking is often the solution to your problem. The process hinges around taking several (otherwise identical) shots of a scene using differing focal distances. With the help of appropriate software, these images are then merged into a single, new image with maximized depth of field.

You can even conduct this type of merge "by hand" by assigning your images to individual Photoshop layers and using layer masks to isolate the areas of each image which are in sharp focus. The other problem here, is that adjusting the focal distance also slightly alters the magnification of the final image. You therefore need to scale and align each individual image accordingly. If you are only dealing with two or three shots, this technique can be quick and reliable – we will demonstrate exactly how it is done later on.

If you are handling large numbers of images, the Photoshop approach can be very cumbersome, and it is usually better to use specialized software tools. Apart from our old friend PhotoAcute, we have only found two other readily available tools that we recommend: the *CombineZM* freeware program[21] by Alan Haley, and the rather more expensive Helicon Focus [17], which costs about $70 for a one-year Pro license, or about $250 for an unlimited Pro license. There is also a Lite version of the software available, which is considerably less expensive and perfectly suitable for most users.

With the introduction of Photoshop CS4, Adobe has also introduced an effective focus stacking tool, which we will describe in section 4.8.

Although the focus stacking tool included with Photoshop CS4 is a big improvement, it can still be useful to use Photoshop layers to align and crop your images (as explained on page 62), before exporting them individually for merging using *Helicon Focus* or *CombineZM*.*

Magnification Ratio

Magnification ratio is written in the format

$$x{:}y \quad \text{or} \quad \frac{\text{Image size on the sensor}}{\text{Size of the original object}}$$

and signifies the relationship of the size of an object on film or sensor to the size of the object in real life. A magnification ratio of 1:2 means the image at the sensor is half the size of the original object. A ratio of 3:1 means the image at the sensor is three times larger than the subject itself.

This explains why compact cameras – which have small sensors – have large magnification ratios. The size at which such an image can be effectively printed is an entirely different issue.

See also the description of this workflow on page 61.

4.2 What to Consider While Shooting

➜ *"Depth of field" is often abbreviated as DOF.*

Taking good, sharp photos with adequate depth of field is an important initial step. You also need to differentiate between four basic types of subject distance:

1. Middle to far distance (about 15 feet to infinity)
 In this type of situation, you will usually only need to shoot a single image using a relatively small aperture (large aperture value). If this does not achieve the desired depth of field, two or three shots are usually sufficient to bring the objects in both the foreground and background into focus.

2. Near to middle distance (about 2–15 feet)
 Here (depending on the lens you are using and the subject), two, three, or four shots are usually sufficient.

3. Close-ups (½ inch to approximately 1 foot)
 Shooting at these distances requires the use of specialized macro equipment (when using a DSLR)[*] and usually between 3 and 6 shots.

*Compact cameras can often zoom in to distances of 1 inch or less without using special accessories, although you might have to activate the camera's macro function to achieve this.

4. "Real" macrophotography (from ½ inch right down to the photomicrographic level)
 Here, you may have to take a large number of shots, as depth of field shrinks rapidly with increasing magnification. Here, the depth of field involved can be as little as a fraction of a millimeter.

If you are working with a DSLR, you should have a good idea of the usable aperture your camera (or camera/lens combination) provides.

Establishing the "Optimum Aperture" Using Test Shots

Two Aspects of the "Optimum Aperture"

Two factors to consider when selecting your optimum aperture are:

A. At of which aperture will neighboring sensor elements be affected by diffraction effects?

B. At of which aperture will diffraction effects be visible in my print (in the case of a standard-sized 4 x 6 or 8 x 10 inch print)?

Value A is usually noticeably lower than value B.

Here, you will simply need to experiment to find the ideal setup. To eliminate the risk of camera shake, you should take all of your test shots using a stable tripod, a remote or cable release (or a timer), and if possible, mirror lock-up. Start at around f/5.6 and take several shots, decreasing the aperture each time until you reach the limit your lens permits at the zoom setting you are using.

You can now download your test images to your computer and perform any necessary RAW conversion while taking care not to sharpen your images manually during the process. You can then compare your images (ideally at 100% magnification), and identify the aperture (to be found in the EXIF data associated with each image) at which depth of field no longer increases and contrast (and therefore perceived image sharpness) begins to decrease. This is the point at which your optimum aperture lies, and is usually found at around f/11 for an 8-megapixel APS-C camera, and at around f/9 for a 10-megapixel APS-C camera. The value should increase to approximately f/16 for an 11-megapixel full-frame camera, such as the Canon

1Ds, and should be around f/8 in the case of a 21-megapixel full-frame camera, such as the Canon EOS 1Ds Mark III.

You will need to repeat these steps for various subject distances, as the reproduction ratio also plays a role in determining sharpness and depth of field. We recommend that you use a purpose-built test chart (like the one shown in figure 4-1). In order to achieve accurate results, the chart needs to be exactly parallel to the image sensor while you are making your test shots.

A good explanation of diffraction and its effects on image contrast and resolution can be found at [42].

Figure 4-1: Heavily scaled down image of a test chart used to determine sharpness and the associated "optimum aperture" of a camera/lens combination.

Optimum Aperture for a Standard Print

If you are only considering the point at which diffraction effects become visible in a standard (8 × 10 inch) print, you will most likely achieve results similar to those listed in table 4-1. The table was calculated based on the following formula:

$$Optimum\ aperture = \frac{u}{1.22 \times \lambda \times (m + 1)}$$

Whereby:

u = Circle of confusion diameter (assumed to be 0.03 mm for the 35 mm format)

λ = Wavelength of the light involved (550 nm is the assumed average)[*]

m = Magnification ratio

[*] Blue light has a wavelength of about 465 nm, green light of about 540 nm, and red light of about 650 nm. A typical digital camera can register a spectrum ranging from approximately 450 to 680 nm.

This table takes neither sensor resolution nor the size of the individual sensor elements into account. At higher resolutions, the optimum aperture value is further reduced (as demonstrated above) for as long as you use higher resolution to make larger prints.

Table 4.1: "Optimum aperture" (OA), calculated for various magnification ratios and sensor sizes

Magnification ratio:	1:2	1:1	2:1	3:1	4:1	5:1	7:1	8:1	10:1	Circle of confusion
OA Medium Format (57 × 57 mm)	49.7	37.3	24.8	18.6	14.9	12.4	9.3	8.3	6.8	0.050 mm
OA Full Format (24 x 35 mm)	29.8	22.4	14.9	11.2	8.9	7.5	5.6	5.0	4.1	0.030 mm
OA Crop Factor 1.3	22.9	17.2	11.5	8.6	6.9	5.7	4.3	3.8	3.1	0.023 mm
OA Crop Factor 1.5	19.9	14.9	9.9	7.5	6.0	5.0	3.7	3.3	2.7	0.020 mm
OA Crop Factor 1.6	18.6	14.0	9.3	7.0	5.6	4.7	3.5	3.1	2.5	0.019 mm
OA for ⁴⁄₃"-Format (CF = 2)	14.9	11.2	7.5	5.6	4.5	3.7	2.8	2.5	2.0	0.015 mm
OA ²⁄₃"-Sensors	7.9	6.0	4.0	3.0	2.4	2.0	–	–	–	0.008 mm
OA ¹⁄₁.₈"-Sensors	6.0	4.5	3.0	2.2	–	–	–	–	–	0.006 mm
OA ¹⁄₂.₄"-Sensors	5.0	3.7	2.5	1.9	–	–	–	–	–	0.005 mm

4.3 Shooting for Focus Stacking

As described above in the section about test shots, you will need to avoid camera shake as much as possible when shooting focus stacking sequences. This is best achieved by using a tripod, a cable (or remote) release, and, if possible, mirror lock-up. Mirror lock-up prevents vibrations caused by the mirror's travel from being transmitted to the tripod. If you are taking true macro shots, we recommend the use of a focusing rail instead of your camera's focusing ring (see figure 4-2 for an example). If you are using bellows, the rail is usually already built in.

Figure 4-2:
A macro focusing rail helps with
precision focusing when shooting close-ups
or macro photos. (The illustration shows the
Novoflex "Castel-Mini".)

When taking macro shots of nature subjects, it is useful to have a tripod that can be set up to work close to the ground. The best option here is a boom tripod like the one shown in figure 4-3.

You should also switch to manual focus in order to focus accurately, and it always an advantage to use the camera's depth of field preview button to ascertain in advance how many shots you will need to take and where to focus for each. To begin with, we will only focus roughly, and we will fine-tune our settings later using the bellows or the focusing rail. Start with the foremost focus distances and work your way backwards.

When shooting landscapes or architectural shots, we usually use the focusing ring on the camera's lens.

Figure 4-3: Boom tripod
(here, a Gitzo "Explorer 2").

If you are working with a cable or remote release and an SLR camera, you will often not be using the viewfinder. This can cause stray light to reach the lens through the viewfinder, making your image duller than it otherwise might be. You can avoid this problem by covering the viewfinder eyepiece. The neck straps included with some Canon DSLRs include a rubber cover specially designed for this purpose.

Your subject will, ideally, not move between shots, but minor movements can be compensated for later using appropriate software. It is also important to take your shots in rapid succession to avoid any changes in lighting that affect your results. As far as we are aware, there is currently no camera that has a focus bracketing function. Remember to adjust your focus settings in one, consistent direction – i.e., from front to back or back to front, and do not switch direction mid-sequence.

If you are shooting in JPEG or TIFF format, you should used a fixed preset white balance value in order to keep the color temperature consistent for your whole sequence. The aperture and exposure time also need to be consistent, so it is best to work in manual mode as often as possible. Most focus stacking programs (especially Photoshop) can compensate for some exposure discrepancies between shots.

The number of shots you need to take will depend on the subject, the subject distance, the lens you use, and its optimum aperture; and on your own personal standards. We recommend that you start by taking three- or four-shot sequences in order to gain some experience. Macro shots with high magnification ratios will require you to take additional shots in order to achieve high-quality results. It quickly becomes obvious when there are blurred gaps between the in-focus regions of an image; the in-focus areas of the individual shots should always overlap.

When taking close-ups using a macro lens and a focus rail, we only use the camera's focusing ring for the first shot. All subsequent shots are focused using the focusing rail in order to avoid the changes in lens length (and the resulting change in effective aperture) that focusing a macro lens causes.*

The focus stacking applications mentioned in this book can all handle large numbers of images in a stack, although dealing with large numbers of images in Photoshop can quickly become tiresome. It is, therefore, a good idea to take too many rather than too few shots. This way you avoid the risk of having gaps in the focus of your final image. The first step in a merge process will always be to load your images and to discard any shots that are too similar or that are not in focus.

As already mentioned, the depth of field preview button can help to ascertain exactly how much depth of field you will be able to achieve for a certain shot. Most DSLR cameras have this functionality, as do some bridge cameras. However, in instances where the aperture is small, the image in the viewfinder will quickly become dark, making it hard to evaluate depth of field. In this case, experience helps.

In most cases, this can be compensated for by using software.

Figure 4-4: The file names you give your images should reflect the order of the stacking sequence.

Preprocessing

Regardless of which program you choose to use, we recommend renaming your images so that they maintain their sequence when sorted numerically. It is also a good idea to save the images from a single focus stack in their own folder as illustrated in figure 4-4. Alternatively, some image database software (such as Apple Aperture or Adobe Lightroom) allows you to group your files into a stack.

Your shooting format and the program you use will determine whether you have to preprocess your images before merging. Photoshop and *CombineZM* cannot process RAW files, so if you shoot RAW images, the first step will be to convert the file format. *CombineZM* requires 8-bit images as input, but Photoshop can also handle 16-bit (per color channel) images. *PhotoAcute* and the Windows version of *Helicon Focus* can process RAW as well as 16-bit TIFF and 8-bit JPEG files. You can find out whether using RAW input files suits your purposes simply by experimenting.

Make sure you subject all your images to the same preprocessing steps (white balance, exposure compensation, vignetting, and other color and tonal corrections). We will perform all other fine-tuning, including sharpening and perspective correction, once the images have been merged.

To begin with, apply the same changes to all of your images. Most currently available RAW converters (e.g., Adobe Camera Raw, Adobe Lightroom, Apple Aperture, or Capture One) allow you to optimize the first image in a stack and then apply your settings to all subsequent images using a built-in synchronization function (as described in section 2.1 on page 16). This will give all the images in your sequence a similar (or identical) distribution of luminance and color tone.

In all other cases, export your images at the highest possible resolution to TIFF or JPEG. If you choose to shoot JPEG images directly, use the highest image quality and the lowest compression setting possible. When exporting images from a RAW converter, you should always export to TIFF, because the quantization automatically applied during JPEG conversion can spoil the merge process later on. (Quantization creates groups of pixels within single-color image areas so they can be coded more efficiently into the resulting image file.)

Should you want to publish your merged image online, or send it as an e-mail attachment, you should only perform any necessary scaling or compression on the final, merged image, not on your source images.

4.4 **Focus Stacking Using Photoshop**

The workflow we describe in this section may appear highly technical to some of our readers. Those who prefer to use more automated processes can skip directly to section 4.5 on page 66.

Photoshop versions up to and including CS3 do not offer an automated focus stacking tool. You can, however, still use Photoshop to perform this task manually. The required steps – loading, aligning, rotating, scaling, and merging (also called *blending*) – are described here in detail. The individual steps also apply to the other programs we have mentioned, although the process is automated to varying degrees in *PhotoAcute, CombineZM,* and *Helicon Focus.*

1. The first step is to load the source images. Because Photoshop cannot process RAW images directly, these will be loaded through Adobe Camera Raw into Photoshop as TIFF, PSD, or JPEG files (16-bit TIFF and PSD files are preferable).
 Once loaded, the individual images should be stacked in individual layers in order of focus distance.

2. The layers are inspected individually, and any unusable images are removed by deleting or disabling the appropriate layer.

3. Align each image horizontally and vertically in order to achieve the best possible coverage. Some of the images may need to be rotated or even scaled (enlarged or shrunk). We will show you later how to automate the first three steps in Photoshop CS3 using scripts.

4. Use layer masks to suppress the areas of each image (or, in Photoshop, the layers) that are not in focus.

5. Finally, crop the image to remove any margins created by rotation and scaling, and to leave only the areas in sharp focus.

6. You can now (optionally) merge your layers into a single image layer.

Don't let Photoshop's complex methodology intimidate you – the program has comprehensive help files, and many of the steps described are automated in PhotoAcute, CombineZM, Helicon Focus, and more recently in Photoshop CS4.

The following example demonstrates the process. We have two source images of a street, both of which cannot encompass the necessary depth of field to show the entire scene in focus (see figures 4-4 and 4-5). Both images contain detailed elements all the way from the near foreground to the far background (or "infinity").

Figure 4-5: This picture is sharp from the foreground up to about the middle of the view.

Figure 4-6: Here, detail from the middle distance to infinity is sharp.

The technique used in Photoshop versions up to CS2 involved opening both images and selecting (using Ctrl-A or ⌘-A) and dragging (by holding down ⇧-Alt) the entire second image (focused towards the rear of the scene) to cover the first.

You then need to align the two images. In our example, we will only move the upper image using the ⊕ tool and the arrow keys on the keyboard.

If we need to rotate and scale the result, we first need to increase the canvas size using the crop tool ⍰. Next, we activate the upper layer, select all (Ctrl-A), and use Ctrl-T or ⌘-T to activate the free transform and scaling tool. We then scale and rotate the layer until satisfactory coverage is achieved. During this last step, it is often helpful to set the layer mode to *Difference* (see figures 4-7 and 4-9).

Figure 4-7: Our layer palette with the blending mode "Difference" activated to check the alignment of our two layers.

As of the CS3 version, Photoshop handles most of this process using a specially developed script, which can be found under File ▸ Scripts ▸ Load Files into Stack.

In the script's dialog box, we select all of our source files and select the option *Attempt to Automatically Align Source Images* (see figure 4-8). It may still be necessary to scale the images later.

As already mentioned before, the level of coverage can be made visible using the *Difference* blending mode. Figure 4-9 shows that we have fairly good coverage, with only slight overhang resulting from the two different focal distances.

The next step involves masking the unsharp areas of the uppermost layer (or all layers if you are working with multiple images). This is fairly straightforward for our simple architectural example.

Figure 4-8: Photoshop CS3 includes a script called "Load Files into Stack". It allows you to load several images into separate layers and to align them.

To get started, we click the layer mask icon ◙ at the bottom of the Layers palette to create a new, white layer mask, making sure this new mask is active by clicking on the layer mask icon:

Our layers palette now appears as illustrated in figure 4-10.

The blending effect here is obtained by applying a simple black-to-white color gradient to the layer. The section of the image covered in black will be masked and where the mask is gray, we will have a semi-transparent layer. In this case, we want to mask the unsharp parts of the upper image in order to expose the sharp elements of the image beneath.

To do this, we first click on the foreground color icon in the Photoshop toolbar and press ⒟ to activate black-and-white mode for the foreground and background colors. We then select the gradient tool ▣, which is sometimes hidden behind the ◈ icon for the paintbucket tool.

To create the gradient, click on the left edge of the image and hold down the mouse button while dragging the cursor across to approximately the center of the image area, then release the mouse button. This will generate the gradient we need to create the mask, which should look something like the one shown in figure 4-11. If it doesn't look right, simply try again. In the area where the gradient fades to gray, the masking effect will correlate to the gray scale value, allowing the image beneath to show through more where the gradient is lighter and less where it is darker.

The result of the blending process can be seen in figure 4-12, and figure 4-13 shows the corresponding layers palette.

Figure 4-9:
Setting the layer blending mode to "Difference" will show how well the images in two layers fit. It shows the differences between the two layers in white.

Figure 4-10: The layer palette shows our two aligned images (layers). In the upper layer the layer mask is empty and activated.

Figure 4-11: Gradient layer mask used for the upper layer (created using the gradient tool).

Figure 4-12:
The merged image with increased depth of field.

Figure 4-13: Layer palette showing the two layers used in figure 4-12.

If you are working with a more complicated scene, a large, soft brush tool is more appropriate than the gradient tool. This will allow you to work around the contours of unfocused areas and mask them accurately with black, or to expose the sharp areas under a black mask using a soft, white brush. During brush work in masks, it is important to make sure that you are working on the mask (by clicking the mask icon) and not on your original image file.

An Example with Four Source Images

The process described above also works with more layers, and for images with varied depth of field. Our example uses the following four shots of a fern frond uncurling, whereby each shot has a different depth of field (see figure 4-14).

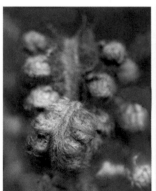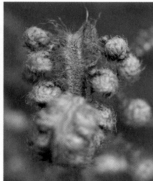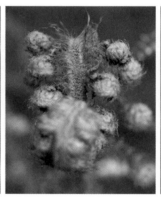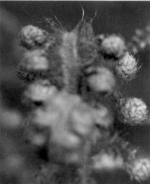

Figure 4-14: Our source images – greatly reduced.

Figure 4-15: Our four source images loaded and aligned, each with its own white layer mask.

Figure 4-16: Preview with active layer mask and all other layers hidden.

When working with multiple images, it is a good idea to create a white layer mask for all layers except the one at the bottom of the stack. The layer palette will then look something like the one shown in figure 4-15.

We then hide all but the uppermost layer by clicking on the eye icon 👁 next to the name of each layer in the palette. Now activate the layer mask for the top layer and mask all unsharp areas using a large, soft black brush. You can use a smaller diameter brush to work around the finer details.

The final image should look something like the one in figure 4-16, showing only the areas of the layer that are in focus, with all other layers hidden.

Once a layer is done, move on to the one directly below it. Unhide the layer, activate its layer mask, and repeat the process of masking all the unsharp areas in black. Finally, activate the bottom layer, but here, do not perform any masking. Figure 4-17 shows the resulting layer palette, in which the individual masks are visible.

It is helpful to occasionally hide the individual layers during the masking process (by holding ⬆ and clicking on the appropriate mask icon). This helps you to see if the mask is a good fit. If you have masked too much detail, you can go back and make corrections using a white brush. Zooming in and out while painting the mask also helps you to work more accurately.

Finally we applied some mild local contrast enhancement using *DOP Detail Extractor* (as described in section 7.1), and a little sharpening using the Photoshop USM filter to achieve the result you can see in figure 4-18.

Figure 4-17: The Layers palette showing all layers and their corresponding layer masks.

Figure 4-18:
The result of our Photoshop merge process. The source images were taken using a Canon 40D with the Canon 100 mm F2.8 macro lens. The subject distance was about 14 inches. We used the camera's built-in flash and a working aperture of f/11.

This process will possibly appear complicated and laborious, therefore the programs we will now describe will help you to achieve similar results in a simpler way. Nevertheless, with a little practice you can achieve satisfactory results fairly quickly using Photoshop. Processing our four-image example took about 20 minutes from start to finish.

In section 4.8 we will show you how to automate focus stacking processes using the new features included in Photoshop CS4.

4.5 **Focus Stacking Using PhotoAcute**

Figure 4-19: We photographed this old Leica using a Nikon D300 with a 60 mm macro lens set to f/9. Shot from close up, only a small part of the camera is in sharp focus.

For this example we photographed an old Leica camera. As figure 4-19 illustrates, the depth of field in a single shot is too shallow to encompass the entire camera body and extended lens. We therefore used our Nikon D300 with a Nikon 60 mm f/2.8 macro lens set at f/9 to take five shots, each with the focal distance pushed a little further back.

We used a stable tripod, and the camera was set to *Manual* in order to ensure constant exposure values throughout the sequence. Autofocus was deactivated and we focused each shot manually. We used a cable release and mirror lock-up to further reduce the risk of camera shake.

We used drag&drop to load our JPEG source files from Adobe Bridge into PhotoAcute, giving us a start scenario as depicted in figure 4-20.

Because PhotoAcute has yet to offer a profile for the Nikon 60 mm macro lens we used, we chose the most similar lens (a Nikon 50 mm 1.8) from the dropdown menu (see figure 4-21 Ⓐ).

A click on the *Start* button opens the *Processing* dialog box, where you can set parameters shown in figure 4-21. The most important setting is the *Focus Stacking* command located in dropdown menu Ⓑ, which tells the program to merge the images into a single image with extended depth of field.

Figure 4-20:
The five source images are first dragged to the open PhotoAcute window from Bridge (or whichever other image browser you are using). Don't forget to activate your source images! PhotoAcute automatically recognized the camera type, but we had to manually select a lens similar to ours, as PhotoAcute does not yet support the actual model we used.

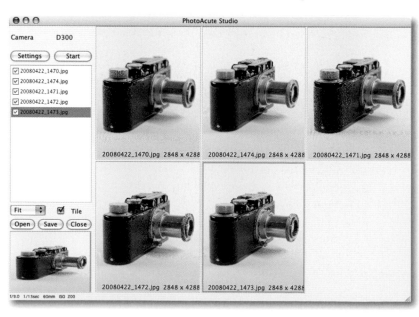

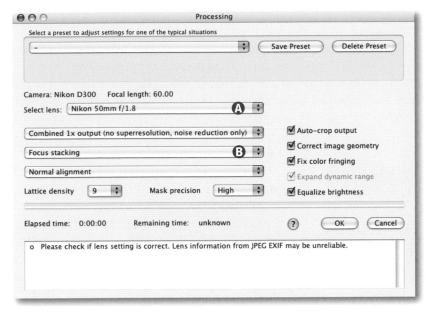

Figure 4-21:
Our Focus Stacking settings: The illustration shows PhotoAcute version 2.8.

Clicking *OK* will start the merge process. Processing five source images will take some time, even if you are using JPEG files and (as we did) a fast, four-processor Macintosh. The result of the focus stacking run can be seen in figure 4-22.

Figure 4-22:
The result of our PhotoAcute process.

Figure 4-23: We used the Photoshop Shadows/Highlights function to brighten up the dark regions of the image.

Figure 4-24:

The result of merging five source shots with differing focal distances, and then lightening some shadows using the Photoshop Shadows/Highlights tool.

** It would have been better to take the shots against a smooth background. This example shows that some preparation and careful consideration before shooting can save you a good deal of time and effort later on.*

At this point, the side of the camera closest to the viewer appears a little dark, as well as and the black metallic parts of the camera.

To brighten up these parts of the image, we used the Photoshop Shadows/Highlights tool. The settings we used are shown in figure 4-23.

In figure 4-24 we see the final image, which shows a degree of consistent sharpness that we couldn't have achieved with our standard equipment.

We then noticed the moiré effect caused by the cloth we used as a backdrop, so we decided to adjust the background using Photoshop.*

We used Photoshop's Gaussian Blur filter to create a soft-focus effect in the background cloth, while retaining sharpness for the camera itself. To achieve this we need to select a suitable area using Select ▸ Color Range. In the dialog box which appears (see figure 4-25), start by setting the drop-down menu Select Ⓐ to *Sampled Colors.*

Then activate the eyedropper Ⓑ, and click in a part of the image where the cloth is relatively bright. Use the Tolerance slider Ⓒ to set the camera apart from the background (it should be marked black). Details like the shadow under the camera's lens can be corrected later on.

Then, with our selection activated, we duplicate the background layer by clicking Layer ▸ Duplicate Layer. This new layer will automatically con-

tain a layer mask which protects the parts of the image containing the camera from being processed by the applied filters.

The layers palette will now look like the one in figure 4-26. At this point, we named the new layer *Gaussian Blur*.

Figure 4-26:

The Layers palette should look like this once you have created and activated the new layer.

We now select the desired filter via Filter ▸ Blur ▸ Gaussian Blur, select a moiré-affected area with the mouse, and use the *Radius* slider (see figure 4-27) to increase the filter effect until the moiré pattern is no longer visible in the preview window.

Figure 4-25: *Using the* Select ▸ Color Range *dialog helps us to create a new layer mask for use later on.*

Figure 4-27:

Increase the Radius value until the cloth pattern disappears.

The *Preview* option should be activated during this process, in order to make the effect of your adjustments visible in the entire image, and not just the preview thumbnail.

Because the layer mask wasn't perfect, and parts of the camera and lens weren't completely covered by it, we now click on the layer mask icon in the layers palette to reactivate the mask. We then use the brush tool (with the color set to black and sharpness set to soft) to rework the boundaries of the area which need to be excluded from the Gaussian Blur effect. As you paint into the mask, the active layer will be hidden under the black areas you create and the in-focus image in the layer behind it will become visible. We then continue to fine-tune the layer mask using black and white brushes until it fits perfectly around the camera in the image.

In addition to the unwanted cloth pattern, the image in figure 4-24 also shows a slight yellow color cast, caused by the color of the lamp used to light the scene. Ideally, we should have corrected this color cast by adjusting the white balance in a RAW converter, but we would then have had to adjust the levels for each individual source image.

We can correct the color cast using an adjustment layer, via Layer ▸ New Adjustment Layer ▸ Hue/Saturation. In the dropdown menu Edit in the resulting dialog box, we choose *Yellows* (see figure 4-28). We then use the eyedropper tool to select an area of the image with a relatively pronounced color cast – the upper edge of the lens barrel, for instance. We then reduce saturation using the *Saturation* slider until the color cast is no longer visible. In our example, this occurred at a saturation value of "-48".

We now select *Blues* from the Edit menu to correct the blue cast that is also affecting the camera lens in our image. Again, we use the activated eyedropper to select an appropriately colored area, and reduce saturation while adjusting *Hue* slightly towards green (see figure 4-29). At this point, the Layers palette should appear as illustrated in figure 4-30.

Figure 4-28: We reduced the yellow cast visible in figure 4-24 by reducing saturation for yellows.

Figure 4-29: Here, we have reduced the blue cast visible along the upper edge of the camera's lens in figure 4-24.

Figure 4-30: The Layers palette for the image in figure 4-31 showing all the fine-tuning layers we used.

As a final touch, we could also lighten the shadow under the camera's lens. Here, we use a Curves (or Levels) adjustment, coupled with a mask that covers almost the entire image save for the shadow area, which remains white.

Because PhotoAcute sharpens your images automatically, you only need to apply slight additional sharpening before printing. If you plan to present your results on a monitor, online, or in a slide show, no further sharpening will be necessary. RAW source images always require more sharpening at the presentation stage, as these are generally softer than images originally shot in JPEG format.

If the program's almost exaggerated automatic sharpening is too much for your taste, you can use the *Oversharpening Protection* slider to keep this effect in check. The slider can be found in the *Advanced* tab of the *Preferences* dialog (see also the description on page 35).

Figure 4-31:
The final image. The moiré pattern in the background cloth is gone, and the yellow color cast has been neutralized.

When shooting images for advertisements (especially with flash), reflections can often cause problems in the resulting images. This type of problem can be effectively reduced using a polarizer, and flash can usually cope with the 1 ½ to 2 stops of exposure darkening that a polarizer causes. A polarizer cannot, however, reduce reflections from metal surfaces, as our example shows. Here, you can use either softer lighting, or an anti-reflective spray (available at most specialty photo stores).

4.6 Maximizing Depth of Field Using CombineZM

CombineZM is currently freeware, and is designed to work with Windows 2000 (and newer) systems. The version we used for our example can be downloaded from the link listed at [21], or via our the publisher's link page at www.rockynook.com/tools.php. We recommend downloading the msi-version, as this is easiest to install. The installation automatically adds a program icon to the user's desktop.

CombineZM is a powerful program, and offers the user a much greater degree of control over the merging process than PhotoAcute. It can handle JPEG and TIFF files as well as a number of other formats, including BMP, PNG, and GIF. It cannot, however, process RAW or DNG files.

CombineZM is also limited to processing 8-bit images (8 bits per RGB color channel), but is, similar to PhotoAcute, also capable of more than just focus stacking. We won't however, be addressing the program's noise reduction or tone averaging functions at this point.

The power of CombineZM, which can also extract images from several video formats, comes at the price of increased complexity. Here, we will detail a simple application, so as not to move outside of our declared scope for this book.

➜ *When starting CombineZM for the first time, you should go to File ▸ Set Options and increase the memory, which the program allocates for processing. We recommend allocating 1024 MB of RAM if possible. These changes will take effect after you restart the program.*

CombineZM Terminology

CombineZM uses partially proprietary terminology, so we will explain the most important terms in the following sections.

The individual images which are to be merged are called *frames*. CombineZM can load, store, and process up to 255 frames, provided your computer has enough RAM. The appropriate frames have to be loaded into the program before any processing can take place.

As previously described in the Photoshop section, the individual images (frames) are also loaded into a focus stack – in CombineZM, called simply a *stack* – where alignment and further processing takes place.

The processing itself is controlled by commands or combinations of commands, which are stored in macros. CombineZM provides a number of standard macros to cover most standard processing situations, but you can also write custom macros for particular combinations of commands if necessary. These macros can be found in the Macro menu, and we will be concentrating mainly on using Do Stack and Do Soft Stack.

While merging multiple frames into a single image with enhanced depth of field, CombineZM creates a special depth of field map of the process, called a d*epth map*. The program uses the depth map to determine which parts of each source image will be used when piecing the final image together. This process is similar to the manual layer masks we used for the Photoshop-based focus stack.

➜ *The author of CombineZM provides some online help documentation, but not enough to develop a thorough understanding of the program. Most online CombineZM tutorials also lack depth. If a good manual or a comprehensive tutorial were available, the public would be able to get a lot more out of the program! Nevertheless, a good place to look for help is:*
http://tech.groups.yahoo.com/group/ combineZ/

CombineZM displays a macro's progress in the *Progress* window. As the individual steps making up a macro can be fairly time-consuming, the progress window also displays a moving, gray progress bar for each individual step (see figure 4-34).

Sample Merge Using CombineZM

For this example, we will once again use our old Leica. We shot our source images from closer than before, and from a different angle. Here, in order to obtain sufficient depth of field, we made eight different exposures.

Figure 4-32: Our favorite old Leica, this time shot from a different angle using a Nikon D300 and a Nikkor 60 mm f/2.8 macro lens set to f/8.

After starting CombineZM, we use File ▸ New to load our source images, by navigating to the folder where the images are stored, and then selecting them and loading them using the ⇧- or Ctrl/⌘ keystroke.

In the *File* dialogs in CombineZM and all the other programs we have described, the ⇧ key can be used to select multiple files which are grouped together, and the Ctrl key can be used to select multiple files which are not listed consecutively.

During the loading process (and all other processing steps), CombineZM temporarily closes the main window and displays a progress window

instead. As previously mentioned, you should give your images file names that adhere to the desired order of your stack – from front to back, or vice versa.

After the loading is complete, the main window will reappear, displaying the bottom image of our stack (figure 4-33).

Figure 4-33:
CombineZM's main window after loading
the source images into the stack.
The first frame in the stack will be displayed.

At this point you can once more inspect your images individually. Press the function key ⟨F3⟩ to open a window displaying all the images in the stack. Select the image you want to view and click *OK* – CombineZM will then display that image in the main window.

Next, we begin the focus stacking process by starting the *Do Stack* macro, which is located in the Macro menu. The program will now display the progress of each individual macro step in the *CombineZM Progress* window (see figure 4-34).

If you are working with large numbers of images or large image files, this process can take some time. The main window will, however, eventually reappear, displaying the resulting new, stacked image (figure 4-35).

You can pull up the progress window at any time by pressing ⟨F2⟩, in order to review the steps that have already been completed, to check the

parameters that have been set, or to check for any warnings or error messages.

Clicking the Minimize button at the bottom left of the window does just that, and the progress window will disappear.

If the results are to our satisfaction, we can save our new image using the command File ▸ Save Frame/Image As.

Figure 4-34: ▲ CombineZM hides the main program window, and instead displays this progress window during processing. It shows the progress of the individual steps being performed.

Figure 4-35:
Once the macro has been executed, CombineZM closes the progress window, reverts to the main window, and displays the resulting merged image.

Here, we can specify the format the image is saved to. If you think your image will need further processing, then TIFF is the best choice. Figure 4-36 shows the formats the program offers.

If, on the other hand, the merged image doesn't exactly match your expectations, the program offers various options for making a second attempt. The first option is to use the command *Do Soft Stack* instead of *Do Stack*.

It often helps the process to succeed if you select a reference image from the middle of your sequence, or at least an image in which the most important part of the subject is in focus. You can then use this reference image as your starting point for processing.

If you haven't managed to achieve satisfactory results after two or three attempts, it can help to simply close the program and start again from scratch. This rather brutal approach has helped us to get better results on a number of occasions.

Figure 4-36: CombineZM offers several output formats for your merged images.

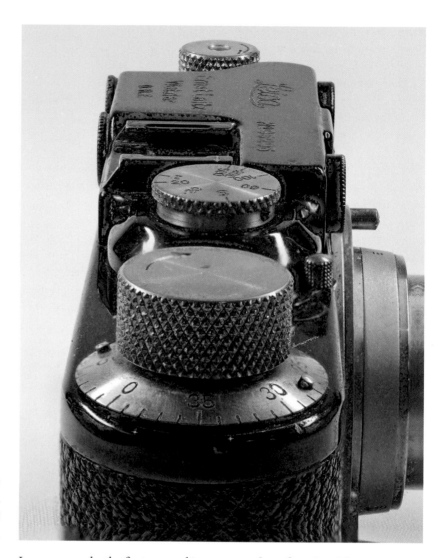

Figure 4-37:
Result of our CombineZM focus stacking
process, using eight source images,
the standard "Do Stack" macro, and
the program's default settings.

In our example, the first merged image turned out fine. As with our previous example (see page 70), we lightened the shadows using the Photoshop Shadows/Highlights tool, and we removed the slight yellow color cast present in the source images using a Hue/Saturation adjustment layer. The final result can be seen in figure 4-37.

All of the multishot programs we use require a substantial amount of processor power and RAM. It has happened – while processing many and/or large images in CombineZM – that our Windows system simply ran out of memory or swap space and froze.[*] If this happens to you, it might be necessary to scale your images to a smaller size before attempting to merge them.

That concludes our whistle-stop tour of simple focus stacking methodology using CombineZM. CZM is, however, capable of much more than that, and we encourage you to go ahead and experiment. Amongst the other functions the program offers, you can start by manually aligning the

** This effect may also be due to the fact that*
we run CombineZM in a virtual Windows
environment on a Mac Intel system with
accordingly limited RAM capacity.

images in your stack before merging, using Stack ▸ Site and Alignment. The program also applies masks to the individual frames in a stack to determine which parts of each frame will appear in the final merged image. These so-called depth maps can be saved separately, as can the rectangles for the individual frames in the stack, so you can use the same reference points later for a different merge.

CombineZM also enables the user to create custom macros, to load macros written by third parties, and to customize the macros provided with the program. This is easy to do – simply go to Macro ▸ Edit and select the macro you want to modify. This will open the selected macro in a macro editor, where you can, for example, build in new filters or entire processing steps.

In addition to the dialog-based version of CombineZM, there is also a batch-oriented version called *CZBatch* available. This version is used for merging multiple stacks into images with enhanced depth of field. To use the batch version of the program, you should save each stack that you wish to merge in a separate folder, and save these folders in a special batch folder.

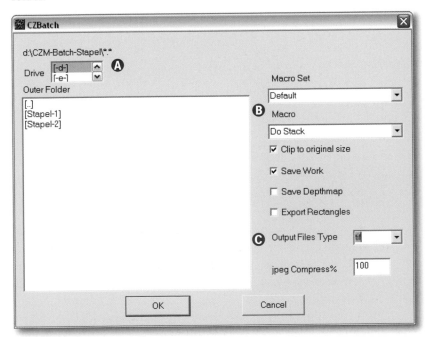

Figure 4-38:
CZBatch allows you to batch process multiple stacks. The merged images are saved in a folder called "CZMOutputs". The illustrated dialog box allows you to select which macro is to be used for processing, and which format your merged images will be saved to.

In the *CZBatch program window* (see figure 4-38), you can select the folder Ⓐ containing your sub-folders (stacks), select the macro Ⓑ you wish to apply, and Ⓒ select your desired export format.

CZBatch then runs through the individual folders, processing the images therein by passing the individual steps to CombineZM via a command prompt. The resulting merged images are exported to a folder called *CZMOutputs,* and are given the same name as the folder containing the source frames for the merge stack.

The online discussions conducted in various forums indicate that CombineZM is often used to merge multiple photomicrographs (shot using a microscope), with the aim of enhancing depth of field for this medium too.

Photomicrographic images often have a very shallow depth of field, and enhancing their depth of field can help to make them easier to interpret. The source images for such sequences are often taken using inexpensive webcams with sensor resolutions as low as 1.3 megapixels, and attached to the microscope using home-made adapters. Such low resolutions are not usually a problem when shooting photos through a microscope.

Given the large numbers of shots such procedures require, it is useful to control focus for the individual shots using a computer-controlled stepper motor. There are, these days, a number of macros available online written exactly for this purpose.

Figure 4-39:
This image was also created from eight
source images that were merged using
CombineZM.

4.7 Focus Stacking Using Helicon Focus

Our attempts at focus stacking using PhotoAcute worked smoothly, but didn't always produce optimum results. The focus stacked images we produced using CombineZM ranged from excellent to unacceptable. The surprising thing was that we managed to produce varied (and sometimes non-reproducible) results, even using exactly the same source images and program settings. This is why we decided to also test Helicon Focus (from HeliconSoft [17]), although this wasn't part of our original plan.

Helicon Focus is available for both Windows and Mac OS X, and can be used for stitching processes as well as the focus stacking functionality we will describe here. The program is available in both Lite and Pro versions. The Pro version has additional functionality, including a retouching brush which you can use to transfer whole portions of the scaled and aligned source image directly into the target image. The Windows version of the program also includes a batch processor, and allows you to export animated stacks. Both professional versions include a panorama function and support multiple processors, which can help increase your processing speed if you are working with large stacks or stacks containing large image files.

The Mac version is only available with an English language interface, while the Windows version (which we will describe later) has a multi-language interface, including German, French, and Spanish.

Helicon Focus can be bought with a limited, one-year license or an unlimited license, which is approximately 3½ times more expensive. An unlimited license includes free access to all future updates to the program.

We recommend starting with the free 30-day trial version. If you decide you want to continue using the program, you can then purchase the Lite version, which you can always upgrade later if you need the additional functionality offered by the Pro version.

➡ *A useful Helicon Focus support forum can be found at: http://forum.helicon.com.ua/*

Of the three programs PhotoAcute, CombineZM, and Helicon Focus, Helicon Focus has the best, most user-friendly user interface, making the program intuitive and easy to use.

You will need to set your basic preferences when you start the program for the first time. We used the settings illustrated in figure 4-40. We discovered that the Mac version took a very long time to find the folder containing our image editor (in our case, Photoshop CS3), but this setting only has to be made once, and was thus not a serious problem.

For our stacking example, we used the four images of a withered tulip which can be seen in figure 4-41 to produce a single, final image with maximized depth of field. The source images were shot in daylight using a 10-megapixel Nikon D200 and a Nikkor 60 mm f/2.8 macro lens set to f/9. We used manual focus and shot from a tripod.

Once again, the first step is to load the source images into the program using File ▸ Add Image, or by clicking on the *Open* icon and navigating to the directory that contains the source files.

Figure 4-40: You need to set your basic preferences when you start the program for the first time.

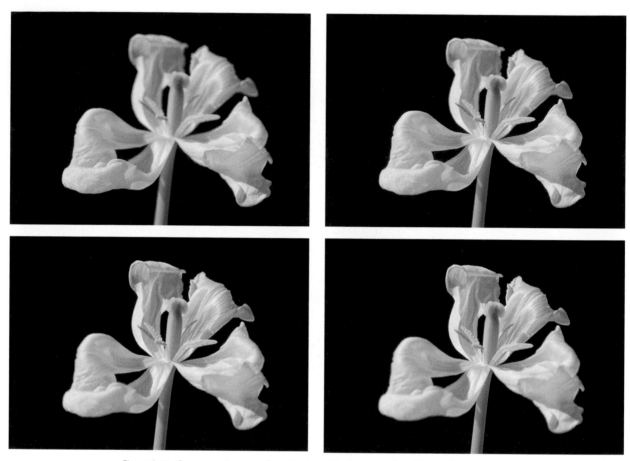

Figure 4-41: Our source images of a withering tulip, shot using four different focus settings.

Alternatively, Mac users can also drag and drop their source files from an image browser (such as Adobe Bridge, or the Mac OS X Finder). Dragging and dropping only works in the Mac version. In Windows you have to use the *Open* dialog to load your source images.

Once the images have been loaded, the program displays the currently selected image in a central preview window (see figure 4-42).

You can review the individual images using the *Source Files* list at the top left of the preview window. You can zoom in to each image using the ⌘-➕ keystroke, or by clicking the zoom-in button 🔍. Clicking 🔍 or using ⌘-➖ zooms back out. In Windows, the fastest way to zoom is using the size slider located beside the 🔍 icon.

Use the *Rotate Right* or *Rotate Left* button to rotate your images if needed.

As in our previous examples, you should make sure your images are loaded in the order they were shot and/or focused. And remember, only images with a checkmark will be processed.

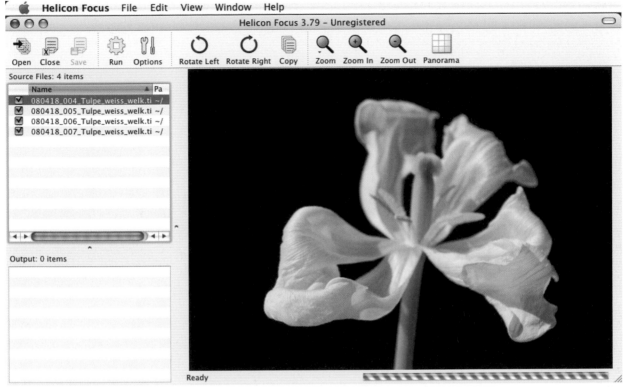

Figure 4-42: The Helicon Focus program window. The four source images are already loaded and activated (checked), and the program is displaying the first image in the preview window.

You can use the Options (⏧) button to set a number of other processing preferences (see figure 4-46 on page 83 and figure 4-47 on page 84). For a first attempt, the default settings should be fine.

A single click on Run ⚙, or using the Ctrl/⌘-R keystroke will start the Helicon Focus stacking operation. During the process, the progress bar at the bottom of the main window will help you to estimate the remaining processing time. Our quad-processor Mac and Helicon Focus Pro processed the job fairly quickly, in spite of the fact that we were using relatively large 16-bit TIFF files.

Once merged, the final image will appear in the program's output list and will be displayed in the preview window (see figure 4-43).

The resulting image (created using the standard settings illustrated in figures 4-46 and 4-47) is not as sharp as those created using PhotoAcute or CombineZM – but is by no means out of focus.

This fits into our personal workflow very well, as we prefer to sharpen our images later using Photoshop (using the USM filter, for example), and to a degree that is suitable for our chosen output medium. This helps us to avoid over-sharpening, and to apply selective sharpening effectively only where it is really necessary. We perform this final sharpening using a layer mask, as described in section 7.2.

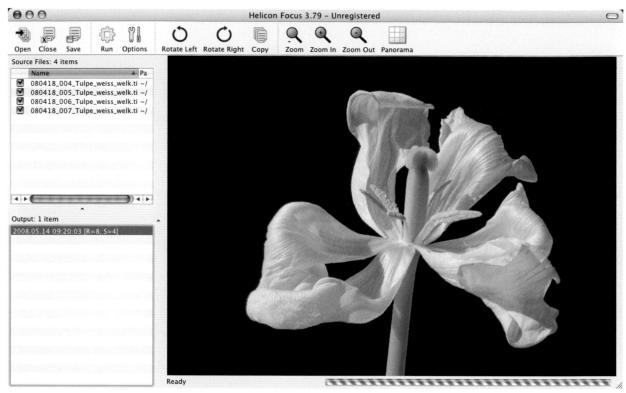

Figure 4-43: The stacked image with its extended depth of field appears automatically in the program's output list.

Figure 4-44: Helicon Focus offers a number of different output formats for your merged images.

If you want to increase sharpness from the outset, you can reduce the strength of the *Smoothing* parameter (found in the *General* tab of the *Options* dialog; see figure 4-46).

The final step is to save the image using File ▸ Save Image. Here too, you can select various output formats. If you are planning to do retouching using Photoshop, we recommend using the 16-bit TIFF format, as the lossless LZW compression algorithm used for TIFF images gives you the most leeway for applying selective sharpening or increasing local contrast later. Your input format will always determine your output format as far as this is possible – the TIFF and PSD formats support 16-bit input and output, for example, whereas JPEG can only be saved at up to 8-bit color depth. The Helicon Focus export formats include JPEG, JPEG 2000, PNG, TIFF and PSD (see figure 4-44).

Figure 4-45 shows our final image after it has been post-processed using the *DOP Detail Extractor* filter described in section 7.1. The extractor has helped to increase the image's microcontrast so that the delicate structures of the flower's petals stands out more. The image has also been slightly cropped.

Helicon Focus offers a number of options when processing focus stacks, which can be found under Options (or by clicking on 🍴).

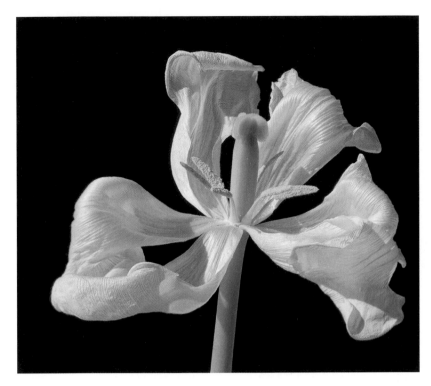

Figure 4-45:

The result of the Helicon Focus stacking process. We improved microcontrast and applied some slight sharpening at the post-processing stage.

One of the most important *Options* parameters is the *Radius* setting (see figure 4-46). This determines the size of the pixel radius that will be used to determine which parts of the source images are in focus, and will therefore be used in the final, merged image. The second important parameter is *Smoothing*, which controls the overlay mechanism function that merges the separate parts of the various source images. A low smoothing value leads to sharper images, but can cause some image artifacts to appear. A higher smoothing value results in smoother (but softer) transitions from image area to image area. The *Image Processing* method selection menu is only available in the Pro version of the program and currently contains two options, A and B. In our tulip example, the differences between the results produced by the two methods were virtually undetectable. For the stacked shot of our old Leica (see the illustration on page 73), *Method B* produced slightly better results with less visible artifacts.

The settings found on the *Auto Adjustment* tab (see figure 4-47) control how your images are prepared for the focus stacking process. These include how the source images should be aligned, to what degree they can be realigned, and the maximum allowable angle of rotation. The *Magnification* value specifies a percentage to which each image can be scaled, should this be necessary in order to achieve the required focus effects. The final parameter relevant to focus stacking is *Brightness,* which controls the degree to which Helicon Focus matches source image brightness, if at all.

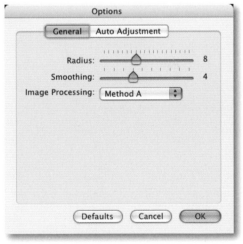

Figure 4-46: *Two important settings in the Helicon Focus "Options" dialog.*

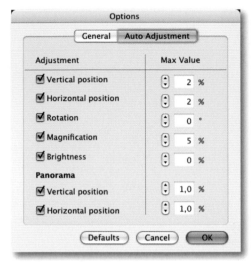

Figure 4-47: The parameters provided in the "Auto Adjustment" tab allow you to specify how the alignment of the source images should be done.

If you work with a tripod, the default parameters usually produce acceptable results. However, if you are shooting hand-held (never a good idea for macro shots), then it may be necessary to increase the values of the first four parameters.

Dust Maps

Helicon Focus also offers the special *Dust Map* function, which allows you to map the positions of any dead or hot pixels, or dust particles which may have been present on the image sensor during shooting. These erroneous pixels are then ignored by the program during processing and the resulting gaps are instead interpolated from neighboring pixels.

To use the function, you need to create a separate empty, white frame at the start or end of your sequence. Helicon Focus then uses this image to create the dust map. The frame should be shot against a white surface, out of focus, and at exactly the same size as your other source images (if you preprocess or convert your images before processing).

The dust map is loaded at the end of your sequence using File ▸ Add dust map. You can then start processing in the normal way.

Opacity Maps

Despite its generally effective functionality, Helicon Focus sometimes fails to merge a sequence correctly. This could be caused by several images having the same image area in focus, making the program incapable of deciding which image to take these pixels from. In such cases, you can have the program generate *Opacity Maps* for later use in Photoshop. You can also simply remove an image that might be causing problems from the input sequence and try again.

Helicon Focus for Windows

Helicon Focus for Windows is more highly developed than its Mac counterpart. This is evident from the version numbers (the latest Mac version is 3.79, while the Windows version is already at 4.60). Handling of both versions is very similar, except for the fact that the Windows version is capable of processing Canon RAW files. Figure 4-49 shows the main user interface for the Windows version of the program.

To start the process, load your source files into the program using the 🖼 function. As usual, multiple images can be selected by holding down the ⇧ key, or use Ctrl/⌘ to select non-adjacent files from the browser window.

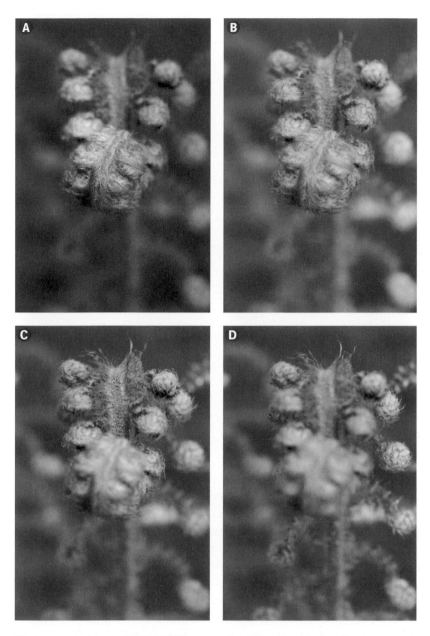

Figure 4-48:
Our four source images of a fern were taken using a Canon 100 mm f/2.8 macro lens, and using the built-in flash on a Canon 40D. The images were shot from the (minimum) distance of 12.5 inches at f/11.

If you are working with RAW files, you should expect the loading process to take longer than it would take for JPEG or TIFF files. We have found that Helicon Focus' RAW processing capability is not particularly powerful, so we recommend that you convert your RAW files to 16-bit TIFF before processing them using this program.

You can use the program's window icons to change the appearance of the user interface. You can choose between a single window (▢), two horizontal halves (▭), or two vertical halves (▯). Working with a split screen allows you to view the source images and the merged image simultaneously.

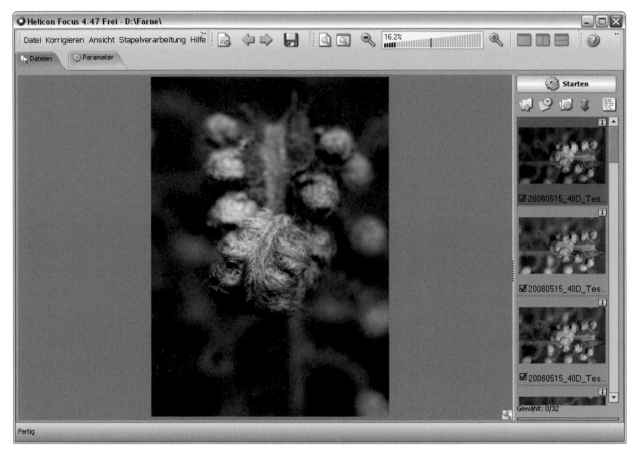

Figure 4-49: The Windows version of the Helicon Focus main window, showing the list of loaded and activated source images.

Figure 4-50: The "Parameters" tab includes the three most important merge settings.

Next, you can view your source images. If an image has been loaded in RAW format, it will only appear as a preview once you click on its listing.

Pressing Ctrl - R will rotate an image 90° to the right, and Ctrl - L will rotate it 90° to the left, although it is preferable to rotate your images before loading them. Clicking on the zoom scale allows you to quickly enlarge and reduce the preview image, and moving the mouse over the image causes a magnifier to appear, helping you to examine image detail. Clicking the icon displays a histogram and some of the EXIF data associated with the currently selected image.

We now check and set the processing parameters located in the *Parameters* tab (see figure 4-50) previously described on page 83. General preferences can be set by clicking on View ▸ Preferences (see figure 4-51). The palette will display four tabs: *General, Autoadjustment, RAW,* and *Cache*. We recommend deactivating option Ⓐ under *General* (see figure 4-51), because it speeds up processing. If you do not have much RAM available, it is also a good idea to activate option Ⓑ.

Figure 4-51:
These general preferences can be found under View ▸ Preferences. *We recommend using the program's default presets.*

In the *Automatic Correction* tab (see figure 4-52) you will find the correction parameters described on pages 83 and 84. Here is a quick summary:

The settings *Horizontal position*, *Vertical position*, *Rotation* and *Magnification* determine to what degree the individual images in the stack can be shifted, rotated, or scaled in order to achieve optimum image overlap.

The default values are well chosen, but you may need to raise them slightly if you are processing shots that were taken hand-held or in wind. Any increases will lengthen the time it takes to process the images. If you changed the lighting conditions while shooting, it is best to increase the *Brightness* value from 0 to about 5% or 8%. The two additional parameters are only relevant to micro-panorama sequences.

The settings listed in the RAW tab (see figure 4-53) allow you to determine how RAW files will be processed. One possible variant is to have Helicon Focus use the well-known *dcraw* converter, which is free, but doesn't quite produce the same quality of image that commercial programs such as Adobe Camera Raw, Lightroom, Apple Aperture, or Capture One can achieve.

Figure 4-52: *The image alignment settings.*

Whether you choose to activate *dcraw,* and which manufacturer's RAW format you are processing, dictates which options can be adjusted. The meaning of the varies options on offer requires some foreknowledge of the working of RAW converters. This is another good reason to work with 16-bit TIFF files or 8-bit JPEG files while using Helicon Focus.

Figure 4-53:
The RAW tab includes the settings for
processing RAW images. The available options
vary depending on which RAW format you
are using.

Figure 4-54: The "Cache" tab allows you to define where
Helicon Focus will save its cache files.

You can use the *Cache* tab to set the location of the program's cache files – we recommend using a disk with plenty of free space and fast read/write speeds. It is a good idea to periodically empty both cache locations, as these can quickly fill up with buffer data and preview thumbnails.

Don't forget to save the changes you make to the program settings by clicking the *Save* button 🖫. Changes made in any of theses tabs are only activated once they have been saved and the program has been restarted.

We can now begin the actual processing by clicking the Start button 🔅. Only selected images (indicated by a red check mark) will be included in the focus stacking process.

If your initial results are not as good as you had hoped, the first thing to change is the *Method*. In our example, *Method B* worked better than *Method A*. If this still doesn't help, you can also adjust the *Radius* and *Smoothing* parameters. If you are still not satisfied, you will have to make changes to the program's basic preference settings. Unfortunately, the Windows version of Helicon Focus cannot save individual preference configurations for later use.

Figure 4-57 on page 90 shows the first resulting image processed using the default parameters and *Method B*. The image has good depth of field in the foreground, but the merging process for the unsharp background has not really produced satisfactory results. The original was actually better (see figure 4-48 Ⓐ on page 85).

To remedy this, we copied some of the soft-focus areas from the first image in our stack to the merged image using a large, soft retouching brush tool. This tool is currently only available in the Windows version of Helicon Focus and is located in the *Retouching* tab (see figure 4-55).

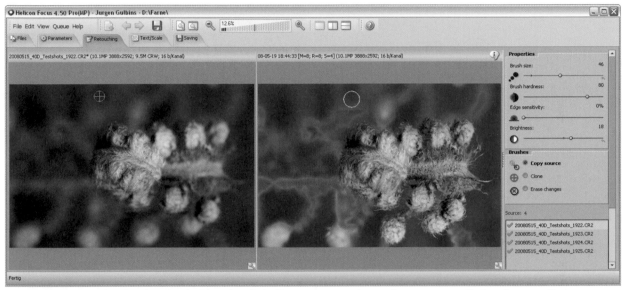

Figure 4-55: The editor found in the "Retouching" tab allows you to copy elements from your source files into the merged image.

The brightness of the merged image was automatically adjusted by the program. Therefore, we set the *Brightness* slider to 5%, making it necessary to match the brightness of the source image with that of the merged image when copying. This is achieved using the *Brightness* slider shown in figure 4-55.

We could also have carried out this correction using the Photoshop Clone Stamp tool 🔏, but the images in Helicon Focus are already rotated and scaled, and the program supports the matching of image brightness. Figure 4-58 shows the final image, generated and corrected exclusively using Helicon Focus.

Clicking on the 💾 icon will then initialize the *Save* dialog. Because we almost always perform our post-processing using Photoshop (described in sections 7.1 and 7.2), we choose either TIFF (compressed using the LZW algorithm), or Photoshop's native PSD format. Helicon Focus automatically includes the *Method*, *Radius*, and *Smoothing* parameters in its file names, which can be helpful while you are learning to use the program. If your input files are 16-bit data, your output file will also be 16-bit data.

Figure 4-56: The Windows version offers more output formats than the Mac version.

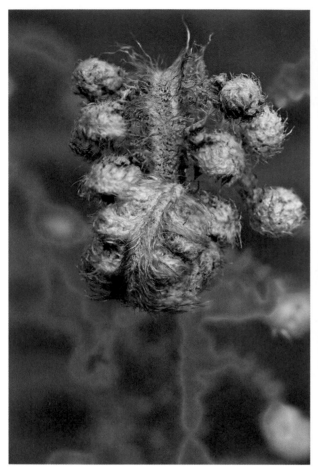

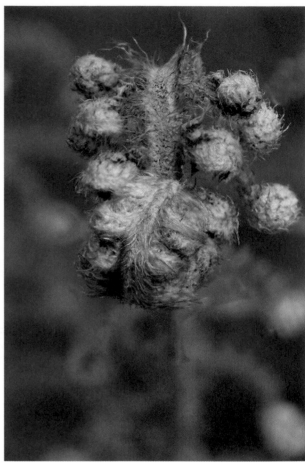

Figure 4-57: Our initial merged image, created from the source images shown in figure 4-48.

Figure 4-58: Our image after editing using the Helicon Focus retouching tools. The artifacts visible in figure 4-57 are almost gone.

Figure 4-59: The "Save" tab offers options for printing, mailing, or animating your results.

Clicking on the *Save* tab displays the options shown in figure 4-59. The *Create animation* option allows you to save a film showing the actual merging process taking place, which can be viewed in a web browser.

The Windows version of Helicon Focus transfers the EXIF and IPTC data from the first image in a stack to the merged image. This feature is not available in the 3.79 version for Mac.

The automatic transfer of IPTC data does not work with RAW files. This is because no currently available image management program is capable of writing this data directly into the image file. These data are usually either saved separately in the image database, or, in Adobe's case, in an XMP "sidecar" file. Most third-party programs (including Helicon Focus) cannot access this data.

Batch Processing

Instead of immediately processing a stack of selected images using the current settings by clicking *Start*, you can also use *Add to the queue* (at the bottom right of the *Parameters* tab) to queue the stack for batch processing.

Pressing F7 will display the batch queue (see figure 4-60) along with a choice of export formats and save locations. Here, you can also delete individual entries from the current queue.

Figure 4-60:
Pressing F7 *displays the Helicon Focus batch processing queue.*

Clicking the S*tart* button causes the queued stacks to be processed one after another, while you take a well-earned coffee break. Performing other tasks on your computer while Helicon Focus is batch processing can be difficult, as the program will use most of the computer's available memory and processor power for the job.

4.8 Semi-Automatic Focus Stacking Using Photoshop CS4

We had the opportunity to try out Photoshop CS4 shortly before this book went to press, so we are including a section describing the new CS4 functionality here.

As described in section 4.4, the first step is to load your source images into separate layers and align them. This is done using File ▸ Scripts ▸ Load Files into Stack. If you archive your images using Adobe Lightroom, it is easier to use Photo ▸ Edit in ▸ Open as Layers in Photoshop. In the dialog that follows, activate the *Attempt to Automatically Align Source Images option* (see figure 4-8 on page 62).

This time, we will use the three source images of a withered iris shown in figure 4-61. Each of the three shots shows very different lighting conditions, making the entire process more difficult.

Figure 4-61: Three shots of a withered iris used as source files for a semi-automatic focus stacking run in Adobe Photoshop CS4.

Figure 4-62: The Layers palette with our aligned images on three layers.

Figure 4-64: The Layers palette after the blending process has finished.

We now crop our images so that only detail-rich areas remain. Our layer palette now looks like the one illustrated in figure 4-62.

Next, we select all layers (not only the top layer) and use Edit ▸ Auto-Blend Layers. Photoshop will display a dialog (see figure 4-63) in which we select the type of blending we wish to use. In this case, we select *Stack Images*. We also activated the *Seamless Tones and Colors* option.

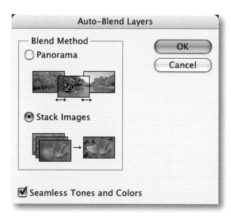

Figure 4-63:
Select your desired
blending method.

Clicking *OK* starts the blending process, which is actually quite fast in Photoshop. Figure 4-64 illustrates the layer masks thus created – the images are still there in their own layers and not yet merged to a single layer. This can be quite useful, as it allows you to fine-tune your image by further refining the individual masks.

Our Photoshop CS4 results were not quite as good as those produced by Helicon Focus. The merged (blended) image shown in figure 4-65 still shows a number of artifacts (the white leaf at the left, for example, still

shows some ghosting), and it is obvious we should have shot additional photos covering the very front of the scene. This type of blending functionality is still in its infancy in Photoshop, but it is nevertheless well worth trying for some scenes.

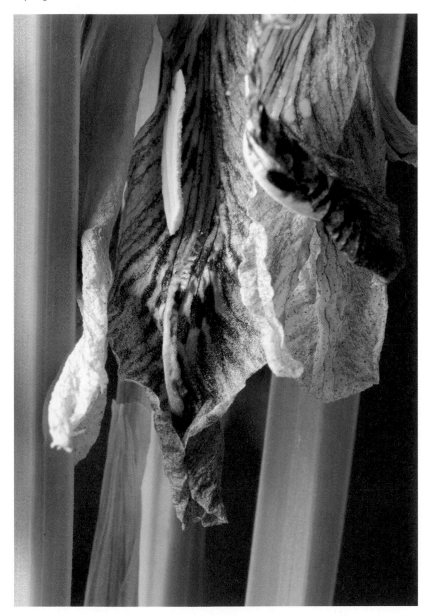

Figure 4-65:
The result of the blending operation done using Photoshop CS4 merging the images of figure 4-61. The result is definitely not perfect, as a number of artifacts indicate, but some retouching using the Photoshop clone tool and by editing the layers masks could fix this.

While Photoshop CS4 might not currently be the best available application for focus stacking, its loading and image alignment functionality is quite good.* These features can be used to prepare images for HDRI merges using other programs, such as *FDRTools*, or even *Photomatix Pro*. You can export aligned and cropped image layers to separate files by selecting the appropriate layers and using File ▶ Scripts ▶ Export layers to Files.

** A variation on this method involves not aligning the images using loading scripts, but instead loading the images first, then aligning them using the "Collage" command in the Edit ▶ Auto-Align Layers dialog.*

4.9 Focus Stacking – A Summary

For focus stacking processes, Helicon Focus was our favorite program. It is fast, very reliable, offers more options than PhotoAcute, and unlike CombineZM, it can process 16-bit images and RAW files. Of these three specialized programs, it also offers the most comprehensive online manual.

The only real disadvantage is its price. For users who do a lot of work shooting for focus stacking – possibly even professionally – the investment will soon pay for itself. Also, working with Helicon Focus is fun.

In our test version (Mac Version 3.79) we missed the ability to save entire settings profiles for later re-use. The Helicon Focus forum is abuzz with talk of the upcoming version five, so we can expect to see this function incorporated into the program soon.

Just as with PhotoAcute and CombineZM, the 3.79 Mac version of Helicon Focus cannot incorporate EXIF or IPTC data from source files into the processed image. The Windows version has this capability.

You can enter IPTC data for processed images by hand, but special programs are required to do the same with EXIF data.* We recommend using the *Exactor* freeware by Phil Harvey [41], which also lets you copy IPTC, EXIF, GPS, and/or XMP data. *ExifTool* is available for both Windows and Mac OS X. Another option is the shareware program *EXIFutils* [47]. This is actually a whole suite of command-line-based tools which run on Windows, Mac OS X, and Linux. The freeware program *Exifer* [45] is also quite effective, but is only available for Windows.

It usually makes no sense to edit EXIF data, as these include values such as the lens, shutter speed, and aperture that were used for the shot in question. Most image editors do not support EXIF data editing, with the exception, in some cases, of being able to change the date on which a shot was taken.

In the current 4.60 Windows version of Helicon Focus, the program extracts EXIF and ITPC data directly from the first image of a stack and applies them to the merged image. This is a great feature, and we expect it to be included in the Mac version of the program soon.

If you only want to process a few straightforward images, Photoshop can be used to produce acceptable results quite quickly using layers masks. However, if you are dealing with large numbers of images (such as large stacks of images shot through a microscope), automated processes are faster and more reliable. We also generally recommend PhotoAcute, although it offers less flexibility than Helicon Focus. CombineZM reaches its limits quite quickly when confronted with large image files, and doesn't support 16-bit processing. The CombineZM internet forum, however, indicates that the program enjoys widespread use, and it does, of course have the distinct advantage of being free.

*** A follow-up version of CombineZM called "CombineZP" is now available. We have not tested this version yet.
It can be downloaded from:
www.hadleyweb.pwp.blueyonder.co.uk/ CZP/News.htm*

All three of these specialized programs are constantly undergoing further development, so it makes sense to check for updates and improved versions on a regular basis.** You will often find that bugs and open issues from earlier versions have been fixed in the latest downloads.

Focus stacking is still a highly specialized niche in the photographic world, but can make obvious improvements to certain types of scenes. In the field of photomicrography, the technique is virtually a necessity.

Figure 4-67 shows an image created by merging the source photos shown (reduced) in figure 4-66. We created the merged image using Helicon Focus set to *Method A*, a *Radius* of 5, and the *Smoothing* value set to 2.

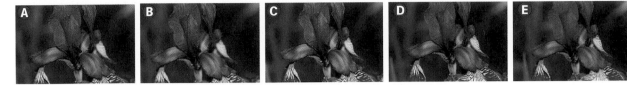

Our first result contained some unsightly background artifacts, which we removed using Photoshop. We achieved this by loading the source image (figure 4-66 Ⓐ) and the composite image on top of each other. We then used the Clone tool 🛠 to copy the out of focus (but smooth) background of the first image into our final image. We also removed some slight color fringing artifacts from around several of the leaves in the foreground using the Clone tool.

Once you have tried focus stacking technology, we are sure you will want to use it time and again.

Figure 4-66: Five photos of an iris taken using a macro lens. This sequence portrays the different sharpness layers moving from front to rear of the scene.

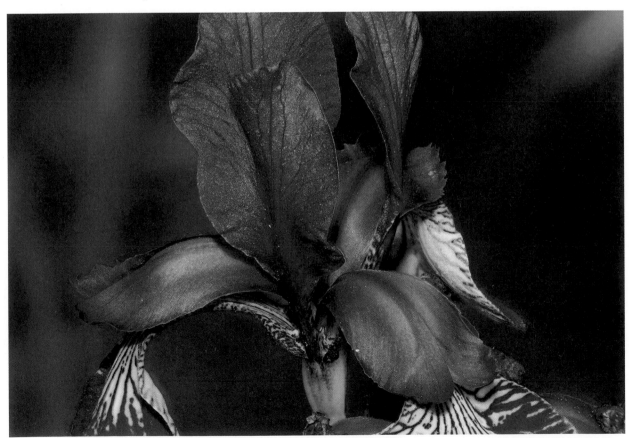

Figure 4-67: This image was created by merging five source files (see figure 4-66) using Helicon Focus. Some artifacts that appeared at some of the leaf edges were eliminated using Photoshop's clone tool.

Stitching - Increasing Image Coverage

5

The most common use for stitching is to construct a panoramic image from a series of interlocking source shots. Simple panoramas can be constructed with just a few shots using the techniques described in this chapter. Complex panoramas require more in-depth knowledge and additional equipment, such as a panorama head for your tripod.

In this book, we will limit ourselves to describing how to construct simple panoramas containing no more than six source photos, and to other situations in which stitching can be a useful tool. Such situations often include the creation of a high-resolution merged image similar to those described in chapter 2, or to create a composite image of a subject that is simply too large or too close to be captured in a single image using the available equipment.

5.1 Shooting Techniques for Stitching Applications

➜ *Although there are a number of different types of images which can be constructed using stitching, some of which are not panoramas in the classic sense, we will nevertheless call all of our resulting images "panoramas" in order to keep things simple.*

Although the manufacturers of stitching software often claim that their programs work well with images shot hand-held, experience has shown that images shot using a tripod yield better results. Even without considering the shifts that hand movements can cause, the algorithms required to produce smooth, accurate seams between the individual component images of a panorama require large amounts of computing power. As we have recommended throughout the book, shooting with a tripod will always help you to improve the quality of your results.

Here, we will only be dealing with simple panoramas consisting of between two and six source images. We also assume that the panoramas we create will only consist of one or two horizontal rows. You do not, of course, have to stick to these restrictions, but it helps to keep things simple while you are still learning a new technique. We will begin by constructing panoramas that consist of a single horizontal or vertical row of images.

The general characteristics of the component images should be as follows:

A. They should be as sharp as possible. This will help the program to establish which parts of the images to overlap. A tripod will help you get better results, as it will eliminate camera shake and allow for longer exposure times, smaller apertures, and thus greater depth of field.

B. All source images should be shot using the same aperture setting. We recommend setting the shutter speed and aperture manually to ensure consistent exposures.

** Autofocus is also easily confused by foreground objects, which are then often (falsely) recognized as being the actual subject.*

C. All source images should be shot using the same distance setting, as far as is possible. We recommend using manual focus, as autofocus can too easily produce images with slightly different magnifications.* Differences in distance settings are less problematic when using smaller apertures.

D. Neighboring images should overlap by about 25–35%. This is the amount required for a stitching program to reliably identify congruent points and the areas which should overlap in the individual images.

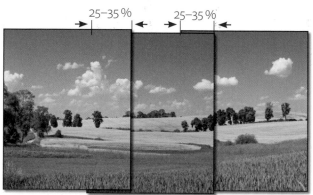

Figure 5-1:
Neighboring images should
overlap by about 20–30%.

E. You should avoid shooting by moving the camera parallel to your scene (sideways), and you should generally shoot your images by panning the camera from left to right, or vice versa. Ideally, you will rotate the camera about its *optical center*, also known as the *no-parallax point*. This point is also sometimes (incorrectly) referred to as the *nodal point*. The *no-parallax point* is the point within the camera/lens construction where hypothetical rays of light cross at a given distance setting.

Unfortunately, this optimum point is not usually positioned directly above the camera's tripod socket or the tripod's quick-release plate.

If you simply move your body while shooting hand-held, the distance between the optical center and the axis around which the camera is being rotated becomes even greater. If you have to shoot hand-held, it is best to rotate the camera around an imaginary axis positioned as close as possible to the front element of the camera's lens. Another effective tool for such situations is simple monopod.

If, however, your subject is far enough away (landscapes at a distance of forty or fifty feet, for instance), then the effect of the camera being rotated around a non-ideal axis will not have a very noticeable effect on your stitched results. However, if you are shooting a more immediate environment, such as the interior of a room, the resulting parallax shifts can have visible negative effects.

F. Try to allow as few changes as possible to take place within the frames. Moving objects such as cars or people passing by, or moving clouds, can cause problems if they are in one of the overlap areas. Also try to make sure the lighting conditions remain as consistent as possible throughout your source sequence.

The sum of all these points presents a substantial photographic challenge, so we will now address each point individually.

We aim to make useful suggestions, rather than write hard and fast rules, and it is often possible to shoot usable panoramas without adhering to all of the guidelines we describe. Smaller panoramas can often be successfully shot hand-held.

A. Using a Tripod

This should really be self-explanatory. Our best advice is to use the sturdiest, most robust tripod you can find. Your tripod and its head need to be strong enough to support your camera/lens combination adequately, and it should ideally have a built-in scale for measuring angles of rotation and tilt accurately. Hanging a backpack from a hook on a tripod's center post can also increase stability. Some panorama heads and specialized brackets also allow the whole assembly to lock in to specific preset angles. This is a useful addition when shooting panoramas, and can be seen in heads manufactured by Novoflex [40], Manfrotto [52], and Nodal Nija [51]. The downside of such

*Figure 5-2: A typical 3-D panorama head
(here, the Novoflex Panorama VR-System Pro).*

*Figure 5-3: A spirit- level attached to the
camera's flash shoe can help to ensure that
the camera remains perfectly level.*

devices is often the price – usually somewhere between $200 and $1,000 – and they can be quite heavy, which can be a disadvantage if you have to carry your equipment over large distances to your shoot, or if your tripod is part of your carry-on baggage on a flight.

There will almost always be some vertical displacement between the individual shots in a panorama, which means they won't always line up perfectly at the top or bottom. It is therefore important to allow sufficient space at the edges of your shots for cropping once the images have been aligned. When shooting for a horizontal panorama, it is often advisable to take your shots in portrait mode (with the camera rotated to a vertical position), and simply to take more shots.

When shooting for horizontal panoramas, another useful tool is a small spirit-level, which can be purchased for around $15 and which can be mounted on the camera's flash shoe. Here, you need to make sure that the flash shoe is parallel to the camera's optical axis.

One way to consistently reduce camera shake is to use a cable-release or an infrared or remote-controlled remote release instead of the shutter button. There are a number of inexpensive alternatives for most camera models available. You can also use the self-timer, but this does take extra time, and makes it more difficult to time your shot to avoid moving objects within the frame.

An even greater help is mirror lock-up – a function which is often available in modern bridge or DSLR cameras. (For further information on how to use mirror lock-up, check your camera's manual.) Mirror lock-up allows you to lock the camera's mirror in its raised position before the shutter is actually released. There are two ways cameras deal with this process:

▸ With some older cameras, such as the Nikon D100, the shutter button is pressed with the mirror lock-up function activated. The camera then raises the mirror and waits a moment for the vibrations this causes to subside before releasing the shutter. This method also works very well if you are using a cable-release, but the pause needs to be at least two seconds long for it to be effective.

▸ Other cameras raise the mirror when the shutter button is pressed once and make the actual exposure only when the shutter button is pressed a second time. Canon uses this technology, and it is also used in newer Nikon cameras, such as the D200. Here, you have to determine the time lag between the two actions yourself. Two or three seconds should be sufficient to allow all vibrations in your camera/tripod assembly to subside. Feel free to experiment, but remember, you won't really be able to see how your results are affected until you see them enlarged on your computer monitor.

Of course, using mirror lock-up only makes sense if you are also using a tripod (or other support) and a remote release. Wind is always a problem, regardless of how you shoot.

B. Obtaining the Correct Exposure

Greater depth of field in your images is an advantage for nearly all the processes described here. We therefore recommend that you always use a smaller aperture in the range between f/8 and f/16 (while bearing in mind the "optimum aperture", which we discussed in section 4.2 on page 56).

If moving objects such as people, vehicles, water, or leaves appear in a scene, it will be necessary to use shorter shutter speeds and smaller aperture values (i.e., a larger aperture) in order to avoid motion blur.

When you are shooting for stitching purposes, it is important that your exposures remain consistent from frame to frame, in order to keep the transitions between the individual shots smooth. You can keep your exposures constant by using your camera's manual (M) exposure control function.

We then start by using the camera's automatic exposure metering to meter all the shots in the sequence, and then switch back to manual to make a constant setting for all shots in the sequence, based on the best average of the automatically metered values. It is better to set your exposure to account for the highlights in your scene rather than for the shadows. As we are working with a relatively short sequence, this kind of discrepancy shouldn't cause too many problems. If your camera has an Auto ISO function, please disable it.

Shooting with your back to the sun or with an overcast sky makes it easier to achieve consistent exposures, and you should always use a lens hood to reduce the effects of stray light and ensure maximum contrast.

Do not use polarizer filters or flash when shooting for panoramas (especially if you are using a wide-angle lens), as these both tend to cause irregularities in brightness and color which will make it difficult to achieve smooth stitching effects.

A slightly overcast or "busy" sky always looks better in broad landscape panoramas than simple, bright sunshine or a low-contrast, clear blue or white sky.

If, however, the range of contrast in a scene is too great to capture in a single shot or sequence of shots, you can always turn to bracketing techniques for assistance. This involves taking several shots of each portion of your scene using a constant aperture value and differing shutter speeds. You can then merge the bracketed shots into HDRI images which can then be stitched together to make your panorama. We will discuss this approach in depth later.

Figure 5-4: Set your camera to "Manual" when shooting stitching sequences.

➜ *If you are working with a cable-release and an SLR camera, remember to cover the eyepiece when you are not looking through it. Otherwise, stray light can enter the camera body and cause your images to look washed-out. Stray light can also disrupt the camera's light metering systems.*

C. Consistent Distance Settings

Because different distance settings lead to variations in framing as well as depth of field (which can change the apparent size of individual elements in a shot), it is important to take all the shots in a stitching sequence using consistent distance settings. It is best to focus manually, but you can use

➡ *A number of calculators specifically designed to determine hyperfocal distance are available online. One example is: www.onlineconversion.com/ field_of_depth.htm*

For the more mathematically inclined, here is the formula used to calculate hyperfocal distance:

$$hfd = \frac{f}{aperture \times d_u \times 328}$$

In this case:

hfd: hyperfocal distance (in feet)

f:　the actual aperture (not the 35 mm equivalent)

d_u: *circle of confusion diameter (mm) = 0.03/crop factor*

Aperture value: i.e. f/2.8 → 2.8

Table 5.1: Examples of Hyperfocal Distances

Focal Length	Aperture	Hyperfocal Distance
10 mm	f/2.8	3.9 feet
10 mm	f/5.6	2.0 feet
10 mm	f/11	1.0 feet
24 mm	f/2.8	22.5 feet
24 mm	f/5.6	11.2 feet
24 mm	f/11	5.7 feet
35 mm	f/2.8	47.8 feet
35 mm	f/5.6	23.9 feet
35 mm	f/11	12.2 feet
50 mm	f/2.8	97.6 feet
50 mm	f/5.6	48.8 feet
50 mm	f/11	24.9 feet
75 mm	f/2.8	219.7 feet
75 mm	f/5.6	109.9 feet
75 mm	f/11	55.9 feet

These values apply for a crop factor of 1.0 and a 0.03 mm circle of confusion diameter. For other crop factors, simply multiply the distance by the crop factor.

autofocus for landscape shots, provided that there are no objects in the foreground which can mislead the autofocus system.

If there are no nearby objects in the foreground, it is best to set your lens to the *hyperfocal distance* that applies to the aperture you are using. This is the closest distance at which your lens can be focused while keeping objects at infinity acceptably sharp. It depends on the focal length and the aperture being used. A 50 mm lens set to f/5.6, for example, will have a hyperfocal distance of about 50 feet (for a full-frame camera). See also the formula in the sidebar and table 5-1.

D. Image Overlap

This is the easy part: make sure the edges of neighboring images in your sequence overlap by 25–35%. More is also acceptable, but once the overlap exceeds 50%, your images will start to overlap with the next image, causing the stitching process to fail.

Pick an object (when panning from left to right) which is about a third of the way from the right-hand edge of your frame. When shooting the next image in the series, pan the camera so that this object is located almost at the extreme left-hand edge of the next shot. You don't have to be over-precise here, at least if you are only shooting single-row panoramas. It is also advisable to do a test run to establish how many shots you will have to make before you actually start shooting. Table 5-2 can help you make a rough guess, but it doesn't take a specific degree of overlap into account.

If your scene includes any finely detailed critical elements, it might also be necessary to take an extra shot with these elements positioned in the center of the frame (where no overlapping will occur). You can then exclude the extra shot from your initial merge and crop your critical object into the merged image to compensate for any inaccurate merging that the stitching program may have produced.

Moving objects only really present a problem if they lie within an overlap area or if they are actually blurred. Moving objects in the center of an image do not present us with any additional difficulties.

If you are stitching a panorama that consists of more than two source images, you will first have to decide which of your shots is to be your central image in the resulting panorama. You should then compose your panorama using this image as a central point. This will ensure that your chosen central image will be least affected by the optical distortions stitching produces.

Because shooting landscape panoramas almost inevitably produces vertical shifts in an image sequence, we recommend that you shoot with your camera in portrait (upright) mode. Otherwise, it will be necessary to align the camera almost impossibly accurately on its horizontal axis. In order to shoot vertically, however, you will need to mount your camera on

an L-plate – simply rotating the tripod head through 90° would position the camera well outside the vertical nodal point.

You can either build your own L-plate out of aluminum (see [50] for instructions) or buy one. Such accessories are available nowadays as high-quality professional equipment. Novoflex [40], for example, offers the model illustrated in figure 5-5 for about $80. Some advanced panorama heads also have built-in L-plates.

We use an L-plate manufactured by the American company Really Right Stuff [41] for our panorama shots (see figure 5-6). This model is a little more elegant than the Novoflex one shown in figure 5-5. It is, however, less flexible because you have to purchase a different one for each type of camera, and it doesn't accommodate battery grips.

L-plates are not only useful for mounting your camera in portrait mode, they also allow you to switch quickly between portrait and landscape modes, and to align the camera's vertical optical axis with the pivotal point of your tripod.

Figure 5-5: A camera mounted vertically on a Novoflex L-plate, which is itself mounted on a focus rail, mounted on a Novoflex panorama plate. The panorama plate ensures precise camera rotation.

Figure 5-6:
This Really Right Stuff L-plate allows you to switch quickly between portrait and landscape shooting modes.

Focal Length	Full Frame (approx. 24 × 36 mm)	APS-C Sensor (Crop Factor 1.5)	APS-C Sensor (Crop Factor 1.6)
Wide-angle			
10 mm	245°	150°	140°
15 mm	160°	106°	100°
20 mm	95°	63°	59°
35 mm	51°	34°	32°
Normal			
50 mm	45°	30°	28°
75 mm	30°	20°	19°
Telephoto			
100 mm	24°	16°	15°
150 mm	16°	11°	10°
200 mm	12°	8°	7°

Table 5.2: Horizontal Angle of View for Various Lenses*

* *The vertical angle of view for a 3:2-format camera (such as a Canon 40D or a Nikon D200) is – on average – 66% of the angle listed in this table. For cameras with a 4:3 aspect ratio this value increases to 75% of the listed angle.*

Figure 5-7: The nodal point lies vertically over the middle of the lens axis.

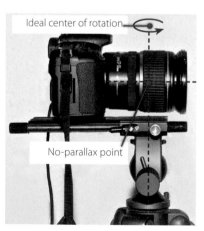

Figure 5-8: In the case of this camera/lens combination (Canon 20D + Canon 17-55 1:2.8 IS USM), we have found the nodal point to be located at the marked spot. With the help of the focus rail, we have located it directly above the tripod's center of rotation.

E. The Optical Center – Locating the No-Parallax Point

If you do not rotate your camera precisely around the optical axis while shooting your panorama, your results will be subject to *parallax shift*. This means that objects located at varying distances from the camera will change in their relative positions to one another from image to image. This effect makes effective merging to a single image difficult or impossible, as illustrated in figure 5-9. If, however, you rotate the camera around the optical center of your camera/lens assembly, this effect will not occur. Although the term *nodal point* does not quite correctly describe the optical center, it has become an accepted standard which we will use in the following sections. A more accurate term that is also used in this context is *no-parallax point*.

Where exactly is the nodal point for a particular camera/lens combination? Vertically, this point lies on the so-called *optical axis* of the camera/lens and is located in the center of the lens (see figure 5-7). It is important to ensure that this point is located directly above your tripod's center of rotation. If you are using a tripod with a quick-release head, it can be useful to use a quick-release plate that is larger than necessary to allow you some leeway in positioning your camera on the tripod itself.

Establishing the horizontal position of the no-parallax point is more difficult. Our first reference point is the position of the aperture within the lens. The aperture mechanism is not necessarily located directly at the nodal point of a lens, but is usually quite close to it.

The position of the no-parallax point in fixed focal length lenses is independent of the current focus setting. In the case of zoom lenses, the no-parallax point can move, depending on the focal length setting. In the following example, we will start at the widest possible focal length setting. Once you have found the nodal point (we will tell you how shortly), it remains largely independent of your distance setting, and only needs to be established once. The fine-tuning for an initial rough guess can be conducted as follows:

1. Find two objects with vertical edges. The first object should be as close to the camera as possible, and the second should be further away. For simplicity's sake, line these edges up to coincide in the center of the frame. Arrange the tripod, tripod head, and camera so that the vertical lens axis is directly above the center of rotation of your tripod, and so that the camera remains perfectly level when rotated. If you are using a focus rail to set the horizontal position, make sure the camera is situated parallel to the rail. Now position your camera with your estimated nodal point horizontally above the center of rotation.

2. Next pan the camera to the left and observe the relative distance between your two vertical edges. If the coverage doesn't change as the camera turns, then you have already found the correct point. However, if the foremost edge apparently moves to the right when you pan to the left, then the nodal point lies in front of the current estimated position.

If the foremost edge moves to the left when you pan to the left, then the nodal point lies further back (see figure 5-9). Adjust your camera position based on these tests and repeat the steps described until you have located the exact nodal point.

→ *If you pan to the right, then both instances are reversed.*

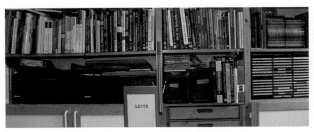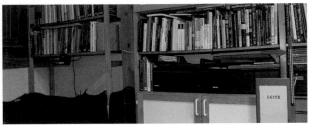

Figure 5-9: When panning to the left (image to the right), the red pen has moved to the right in relation to the beam in the shelf. In this case the optical middle point lies in front of the current turning point, so the camera needs to be pushed back some.

We were often surprised at how far forward the nodal point actually lies – often near the front edge of the lens. In the case of our Canon 18–55 mm zoom lens (a standard bundled lens), the nodal point barely moved between the two extreme zoom settings.* For this zoom lens, we really can make do with a single no-parallax point for objects which are not too close to the camera. Once you have found the no-parallax point, mark it on the side of the lens with a piece of tape or nail polish. In the case of push-pull zooms and zooms with a greater degree of extension, the nodal point can often move significantly from one focal length setting to another.

* *In our example, 18 mm and 55 mm respectively.*

F. Moving Objects

Moving objects, such as people, vehicles, or birds, are only problematic when they are located in the overlapping areas of your source images. Leaves moving in the wind or fast-moving clouds can also cause problems. If such objects appear in an overlap area, then ghosting can occur in the resulting overlap areas. It is nevertheless amazing how well modern stitching software handles moving objects.

One way to reduce the effects of moving objects is to use a stamp tool to remove them before you begin the merge process. If you decide to use this technique, you should take several shots of the relevant part of your scene, so that you have sufficient "clean" material for subsequent stamping into your image. Another option is to use the PhotoAcute *Remove moving objects from the scene* command.** PhotoAcute recommends using at least five images of the image area in question. You can then create a "clean" image of the part of your scene containing moving objects using just the *Remove moving objects* function, and build it into your panorama using your chosen stitching tool.

** *See the description of PhotoAcute in section 3.5 on page 46.*

Sometimes, however, it's simpler to retouch the finished panorama and to use the Photoshop Clone tool to remove any remaining ghosting or shadows.

5.2 Image Preprocessing

* Reasons for this are listed in section 2.3.

We recommend that you shoot your images in RAW format.[*] However, most stitching programs will require you to convert your images to TIFF or JPEG before processing. If your stitcher supports 16-bit files, you should use 16-bit output in your RAW converter, even if your final image output is only going to be 8-bit. This is because your images will be rotated, stretched, compressed, and skewed during stitching, and 16-bit source material provides you with a greater reserve of image detail to work with. However, if you are working with limited RAM capacity, working with 8-bit images during the whole workflow will halve your main memory requirement.

As already mentioned, you should process your images as consistently as possible in the RAW converter. This applies to all image aspects, including white balance, color and exposure correction, and other optimization processes (such as vignetting or chromatic aberration corrections). If you decide to crop your images during preprocessing – for example, to remove a bland sky – then make sure you crop exactly the same areas in all of your images. Most stitching programs require all images to have identical pixel dimensions.

Some stitchers have automatic, profile-based lens distortion, chromatic aberration, and vignetting correction functionality. If your stitcher has these functions, you should avoid making these types of corrections using a RAW converter, as they would then have to be performed manually. Programs based on the *Panorama Tools* application (such as Hugin, PTGui, or PTMac) include the above mentioned capabilities.

It is sometimes an advantage to use your RAW converter to sharpen your images. This can help you (and your software) to identify the common points and overlap areas in your panorama. It is important to make sure that any presharpening is consistent and not over done, as you will nearly always apply some final sharpening once your stitched panorama is complete.

When applying any of the adjustments described here, you should always start by correcting your central image – i.e., the one with the most important details. You can then apply the same corrections to all other images in the sequence.[**]

** See the description of how to do this in section 2.1 on page 16.

In Photoshop, use the *Bridge* image browser to select all the images in a sequence and start Adobe Camera Raw (ACR) using the right-click context menu for the selected images. ACR will then open the selected images and display them in the Filmstrip sidebar. Select the central image and optimize it. Then select the rest of your images (by holding down the ⇧-button) and click on Synchronize. ACR will then ask which settings should be transferred.[***] You can select either all settings, or only those which you have actually changed in the central image. Save your images using the Save Images button – preferably all in the same folder.

*** See figure 2-8 on page 16.

If you are using Lightroom, you should optimize the central image before selecting the rest of the sequence in the Filmstrip or Grid view. You

can then click the Synchronize button. As in Adobe Camera RAW, a dialog box will prompt you regarding which settings you want to transfer.

If you are using a different RAW converter, you will need to consult the user manual in order to find out exactly how to transfer your changes to the other images in your sequence.

Organizing Your Images

Selecting images in Adobe Bridge or Lightroom and automatically loading them into the Photoshop Photomerge (stitching) function is a simple process. When working on larger projects, we recommend that you copy your preprocessed source files to a dedicated folder, which will later also contain the stitched image. If you are making more than one panorama, use a separate folder for each. A large and complex panorama can quickly become an independent project, and some stitchers allow for discrete project data, such as type, start date, or correction information to be saved in a separate project file. This is a useful reference and can save you having to start from scratch if things do not go according to plan. As explained in section 2.1, you should name your files using conventions which allow them to be displayed in the correct sequence. If you followed our recommendation to separate your individual panorama sequences using a blacked-out frame or a picture of your hand, you can now delete these with confidence.

5.3 Types of Panorama (Projection Forms)

The technicalities of the stitching process would be fairly simple if it were possible to move the camera paraxially between shots. However, instead of a sideways (or vertical) shift, our examples involve rotating the camera around a single axis, leading to distortion in some parts of the resulting images. It is therefore necessary to tell the stitching software which type of projection you want to use before processing begins. The best projection type to use depends in part on the number and arrangement of the individual images involved, and in part on the purpose of the final image. There are four typical and popular projection types, and many more available in various stitching programs:

1. **Linear Projection.**
 Here, the images are projected onto a flat surface. This type of projection is also referred to as *rectilinear projection,* and in Photoshop it is called *Perspective Layout.* While the central image remains largely untouched, the images to the left and right of it are compressed and/or stretched, and the further an image is from the center, the greater the artificial angle of view will be, causing even greater distortion. Figure 5-11 should clarify the reasons for this. The angle of view to be covered by the panorama here should not exceed 100–120° – otherwise, the edges of

the image will become extremely distorted. Some distortion is already visible in figure 5-11.

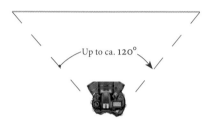

Figure 5-10: Camera panning for a linear projection.

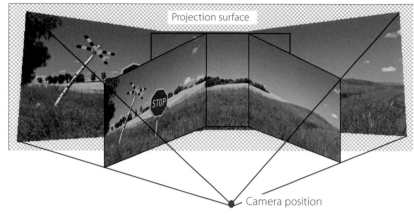

Figure 5-11: Linear projection

2. **Cylindrical Projection**

This type of projection is based on the concept of an obsever placed in the center of a circular room on whose walls the image is projected. Cylindrical projections also cause image distortion when they are stitched, in this case most noticeably in the barrel distortion evident in the individual images (see figure 5-14). This distortion is the result of a flat image being projected onto an imagined, cylindrically-shaped surface.

Figure 5-12: This image resulting from a cylindrical projection shows typical barrel distortion.

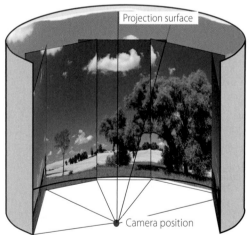

Figure 5-14: Cylindrical projection

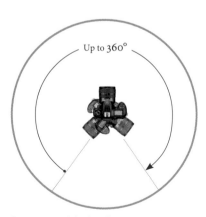

Figure 5-13: Cylindrical projection is suitable for images and projection surfaces with a circumference of up to 360°.

To shoot images for a cylindrical projection, the photographer simply rotates around his/her own axis, resulting in a sequence of images which can cover an angle of view of all the way up to 360°. If you want to present your image "in the round" in a presentation cylinder or – with appropriate preparation – in a digital format which allows the user to virtually turn around within a scene, the stitcher will also need

to overlap the first and last images of the sequence. Not all stitchers are capable of realizing this type of 360° overlap.

3. **Spherical Projection**

This type of projection method assumes that the observer is situated in the center of a sphere and that the image is projected onto the sphere's interior surface. Specialized software is necessary to view this type of projection, and to allow the viewer to virtually rotate about his/her own vertical and horizontal axes and to "look up and down" within the image.

Photoshop only supports this type of projection in its latest CS4 version, so we will not go into any further detail at this point.

4. **No Projection**

This is also a valid approach if the source images have been shot either by moving the camera parallel to the subject plane, or by moving the subject horizontally in relation to the camera lens – as is often the case in microphotographic situations. The Windows version of Helicon Focus offers a function for stitching this type of panorama. Photoshop calls this type of stitching *Reposition Only*. In this case, the stitcher simply searches for appropriate connection points, arranges the images based on these, and performs an overlay process using a blending mask.

We will be sticking to simple linear projection for our examples, covering angles of view of up to 100–120°, which is quite sufficient for our purposes. This type of panorama also requires the use of less specialized equipment, and is most suitable for our ultimate goal of a printed image.

Figure 5-15: Spherical panoramas require the camera to be rotated around two axes.

5.4 Merging Images Using the Photoshop "Photomerge" Command

Our first example uses the five source images displayed in figure 5-16. As you can see, these contain plenty of overlapping areas. These images were shot hand-held in JPEG format using a compact camera.

The simplest way to start Photoshop's Photomerge feature is to start it from Bridge or Lightroom. In Bridge, select the images you want to stitch and start Photoshop using the following menu sequence: Tools ▸ Photoshop ▸ Photomerge.

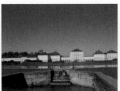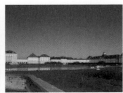

Figure 5-16: Five source images of the Nymphenburg Palace in Munich. They were shot hand-held in JPEG format using a compact camera.

➜ *Currently, Photoshop only allows you to merge images which have the same pixel dimensions. Keep this in mind when preprocessing and/or cropping your source images.*

The same option has been available since version 2 of Adobe Lightroom. In this instance, you also need to select the images in the grid view and then load them into the Photoshop panorama function using a right-click and Edit in ▸ Merge to Panorama in Photoshop. There, you can use the *Browse* dialog to select images.

If you use Bridge or Lightroom to start the Photomerge function, RAW images are automatically converted to TIFF or PSD before they are transferred. Bridge always exports 8-bit TIFF files, and Lightroom exports to the format selected in the program's preferences for transferring files to Photoshop for editing.

You can also start Photomerge directly in Photoshop using File ▸ Automate ▸ Photomerge. There, you can use the *Browse* dialog to select your source images.

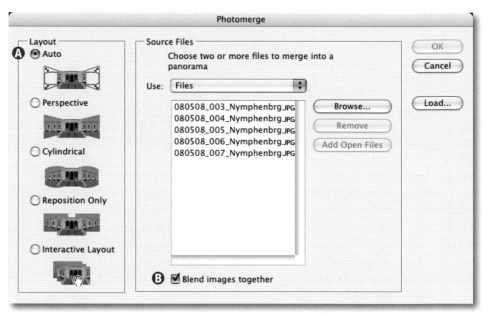

Figure 5-17: Having selected your source files, you can define the type of layout (projection) you want to use, and whether Photoshop should blend the images together (the screenshot here is from Photoshop CS3).

In all three cases, the dialog shown in figure 5-17 will be displayed. Start by selecting the type of layout (projection type) you want to use Ⓐ, and then select whether or not you want Photoshop to blend the images together Ⓑ. We recommend that you select *Auto* (Ⓐ) and activate option Ⓑ for your first few attempts. We will go into more detail on this topic later.

When you click *OK*, Photoshop starts to perform the basic operations necessary to create a panorama: it loads the images in sequence in individual layers, aligns them appropriately, corrects the individual images based on the type of projection you have selected, and creates any necessary layer masks. Don't let the resulting flurry of activity in the program window irritate you. The merge process can take quite a while, depending on the number and size of your source images, as well as the selected pro-

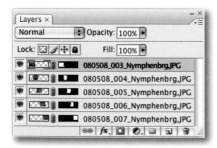

Figure 5-18: Our Layers palette after loading and aligning our source images.

jection type – but this is not uncommon when using multishot techniques, and is something we have gotten used to at this point.

Figure 5-18 shows the layer palette after the operation is complete. Figure 5-19 shows the accompanying Photoshop window.

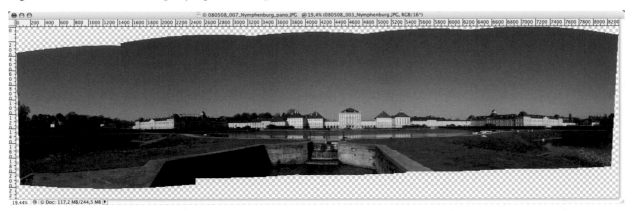

The individual images can still be moved if necessary at this point. You can shift the individual elements by selecting the appropriate layer from the palette and moving using the ✛ tool, or you can use the Edit ▸ Free Transform command to shift, rotate, or even distort each image separately. This will not usually be necessary, as Adobe continues to improve the Photomerge module, and the CS3 version produces excellent results without the need for any user intervention.

Even the automatic brightness adjustment in our example has turned out pretty well, although the source images were shot (contrary to our earlier recommendations) in automatic exposure mode. In this situation, it helped us that the sun was situated behind the photographer, and that the white walls of the building were relatively distant from the camera. Figure 5-20 shows the same resulting image that Photoshop produces if the *Blend images together* option is deactivated.* We recommend leaving this option activated as part of your standard procedure.

Figure 5-19: The results of the first stitching run. Because the shots were taken without using a tripod, the panorama shows a good deal of vertical offset between the individual images.

* We activated this option for our first run using option ⓑ in the dialog box shown in figure 5-17.*

Figure 5-20: With the option "Blend images together" deactivated, obvious differences in lighting are visible at the seams within the panorama.

We decided to discard the second version and proceed using the first. It is clear that even this excellent merged image will require some post-processing.

Obviously, we will need to crop the final image using the cropping tool ⌗. You can also realign the image (if, for example, the horizon isn't quite level). To rotate your image, simply move the cursor outside the image area – this will automatically start the rotate tool (the cursor will look like this: ↻), allowing you to rotate your merged image freely to the required position.

Figure 5-21: Before saving, crop the image to remove any uneven or unexposed borders.

If you have difficulty finding the right angle of rotation, you can use the Ruler ✎ tool to draw a straight line through your proposed horizon. You can then use the *Rotate Canvas* command (Image ▸ Image Rotation ▸ Arbitrary) to align your image. The resulting dialog will display the angle you

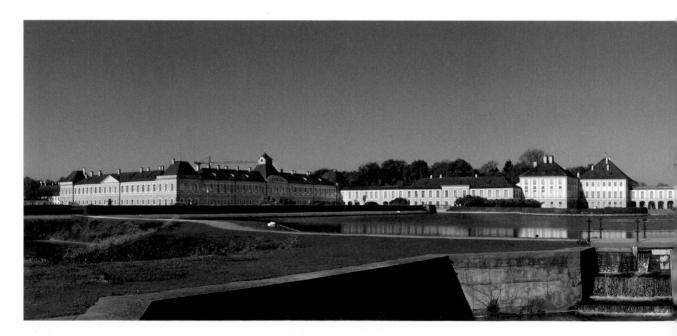

have just measured using the Ruler tool, which you can adjust, or simply confirm by clicking *OK*. Finally, crop your image using the cropping tool ⌗.

Even a large monitor probably won't be able to display your merged image at a large enough scale to inspect it thoroughly, so you should zoom in using the (Ctrl/⌘-+ keystroke) to check image detail before merging your image into a single layer. Start at the top left and work your way to the bottom right, carefully examining the whole image area. Once you have finished, you can zoom out by pressing Ctrl-- (or ⌘--, if you are using a Mac).

For less critical flaws, you will have to decide whether it is quicker and more practical to correct them using individual image layers or in the final composite image. Birds sometimes appear as specks of dust in landscape panoramas, but can be easily removed using the clone stamp tool ⛯.

Perspective corrections are also best carried out after the images have been merged into a single layer, and the same applies to dodging or burning individual image areas. Adjustments to the alignment of your source images definitely need to be carried out before merging, and moving objects can also be more effectively removed from the source images than from the merged panorama.

For our completed image, as displayed in figure 5-24, there was hardly anything which needed to be corrected before merging. Although the source images were shot using an older, 5-megapixel camera, the final, cropped image nevertheless measured 6300 × 1400 pixels, which would print up to 21 × 4.7 inches when printed at 300 dpi (common for most ink jet printers).* The image proportions are not necessarily ideal, but are dictated by the subject.

Figure 5-22: If you select Image ▶ Image Rotation ▶ Arbitrary, *"Angle" will be preset to the value you have just measured using the ✐ tool.*

Figure 5-23: The birds in this detail are bothersome because they are too small to really see. It is better to remove them completely using Clone Stamp tool.

Figure 5-24:
The aligned and cropped panorama with the birds over the central building removed.

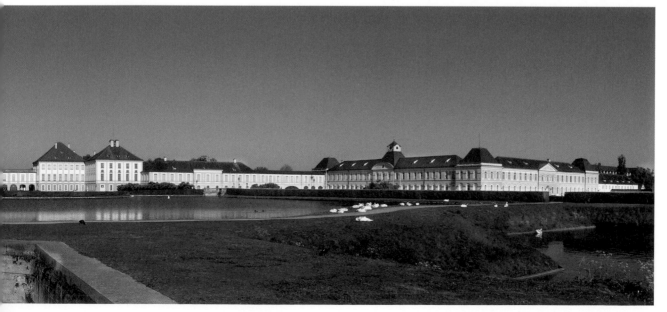

Because this type of image is almost always viewed from a distance, printing a larger image with a lower resolution (200 dpi, for example) is also an option.

In figure 5-24 we have already dodged (brightened) several of the darker areas using a technique we'll demonstrate later on. This is a correction we carried out after the individual layers had been merged into one.

Merging Layers

If you have plenty of hard drive space available, you can save the cropped image as a TIFF or PSD file with all the individual layers intact. As the steps we have taken so far are not too complicated or time-consuming (should you have to repeat them), you can also risk merging your layers into one and retouching the resulting single image. Layer merging is applied using the Layer ▸ Merge Visible command (which can be accessed more quickly using ⇧-Ctrl-E or ⇧-⌘-E). For images consisting of large numbers of layers, this can significantly reduce the size of the resulting image file.

Dodging and Burning

In the image shown in figure 5-24, we removed birds from the sky over the central building and lightened up some of the darker areas after the layers were merged into one. We achieved this by creating a new layer (Layer ▸ New Layer) on top of the basis layer.

Figure 5-25: How to create an adjustment layer for dodging and burning.

In the *New Layer* dialog box, we set *Mode* Ⓐ to *Overlay* and activated option Ⓑ *Fill with Overlay-neutral color for (50% gray)* (see figure 5-25). We named this new layer "Dodge and Burn" and used it to selectively brighten or darken specific areas of our image. Here, we used the Paintbrush tool 🖌 set to a minimal degree of hardness (0–5%). We then used the color white to dodge (brighten) and black to burn where necessary. (The terms *burning* and *dodging* originated in conventional dark rooms, where these eponymous techniques were used to selectively correct exposures by hand.)

Overlay mode works by leaving areas of 50% gray unchanged, while lighter areas are dodged (brightened) in degrees right up to pure white. In those areas where the adjustment layer is darker than 50% gray, a converse, burning (darkening) effect takes place, which is black at its strongest.

In order to retain control over the dodging and burning process, we use a low opacity value (10–20%) for our brush, and simply re-paint the areas which require a more marked effect. The brush size can be changed using the Ⓒ key to enlarge it and the Ⓓ key to shrink it. You can easily step backwards (undo) using the Ctrl/⌘-Z keystroke. In areas where you may have over-corrected, you can compensate by using a brush of the opposite color.

Figure 5-26: The layers of our dodged and burned panorama.

In the image in figure 5-24, we only dodged a little in order to brighten a couple of specific areas. Figure 5-27 shows our image before the adjustment and figure 5-28 afterwards. Figure 5-29 shows the brush strokes used in the adjustment layer. The results in the corrected image are subtle, but that is what we were aiming for.

This type of technique can be used to make similar corrections to many types of images, which is why we've addressed it so thoroughly. However, truly washed-out highlights and underexposed shadows cannot be corrected this way.

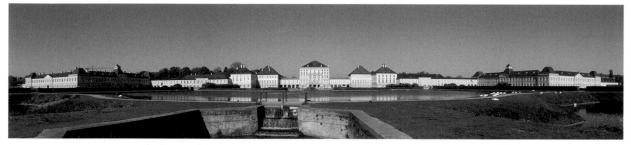

Figure 5-27: Image with birds removed from the sky before dodging.

Figure 5-28: The dodged image – note the (formerly) darker surfaces of the buildings to the left and right of the central building.

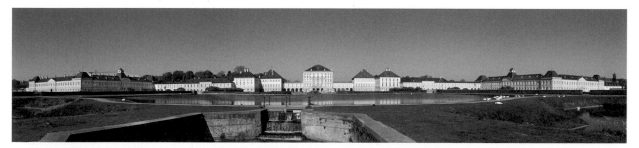

Figure 5-29: The adjustment layer used to dodge and burn the image shown in figure 5-28. The 50% gray areas have a neutral effect.

One thing which takes some getting used with this method is that – while Photoshop makes it possible to see corrections in the image window – the individual brush strokes are only visible in the (very) small thumbnail in the Layers palette. A workaround in this situation involves hiding all the other layers by holding down the Alt-key and clicking the 👁 icon in the Layers palette. Alt-clicking the icon a second time shows all the layers again.

Corrections Using the Clone Stamp Tool

Instead of simply cropping the "empty" areas around your merged image, you can also fill these with artificially generated details using the Photoshop Clone Stamp tool (🖌️). This process requires suitable material for cloning, which is not usually a problem for image areas containing grass, water, or pavement. Cloning simple cloud structures so that the results are not too obvious is also quite simple. The entire process becomes more complex and laborious once perspective plays a role, but Photoshop (CS2 and newer) once again has a solution.

Start by enlarging the canvas using the crop tool 🔲, then use the normal Stamp tool 🖌️ to retouch the areas which do not require perspective correction. The Stamp process is conducted on a new, empty layer, with the Stamp tool's options set to *Current and Below* (see figure 5-30).

Figure 5-30: *The Clone Stamp tool settings.*

Figure 5-31 shows a merged image compiled from nine source images taken using a tripod. Stitching and various adjustments have resulted in a good deal of empty space above and below the main image area. In order to avoid excessive cropping, we will first use the method described above to fill out the sky, and then the foreground – the latter with the help of the program's Vanishing Point function. These are all corrections that are made once the image has been merged into a single layer.

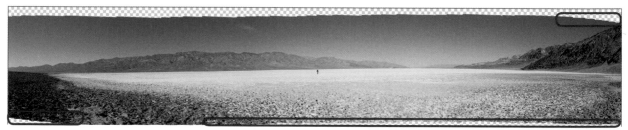

Figure 5-31: *In this panorama, the area marked in red will be filled with detail using the Clone Stamp tool.*

We now start filling in the sky in the upper right corner using the Clone Stamp tool 🖌️.

The next step is to extend the sky upwards. First, we increase the canvas size using the top center handle in the crop 🔲 frame. At this point, using the Stamp tool to fill the new space would be difficult, due to the fact that the sky gets darker towards the top. Instead, we select a strip of sky towards the top of the image which covers the entire width of the panorama using the Rectangle Marquee tool.

Now we activate the Free Transform tool (Edit ▸ Free Transform) and drag the upper marquee handle all the way to the top of the canvas (see figure 5-34).

Figure 5-32: Dragging the center handle upwards with "Transform" activated stretches the selected area.

This stretches our selected area of sky to fill the rest of the canvas. The color gradient remains natural-looking and is simply stretched to fill the available space. To finish up, we cropped the remaining white space above the sky.

We perform our final correction – stamping in the foreground – using the Photoshop Vanishing Point function (Filter ▸ Vanishing Point). The function displays a dialog box like the one shown in figure 5-33, along with an image preview and a toolbar on the left of the image window.

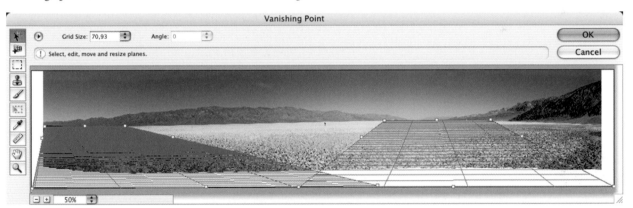

Figure 5-33: The vanishing point dialog window with two perspective planes already drawn.

Here, the first step involves defining the perspective planes using the *Create Plane* ⊞ tool, which is located at the top of the function's toolbar (see figure 5-33). You can then use the mouse to position the four corners of the plane in counterclockwise order, starting at the front left. If necessary, multiple perspective planes can be created one after the other.

Figure 5-33 shows the Vanishing Point dialog box with two perspective planes already drawn. You can adjust the corners of your perspective plane using the active Create Plane tool (⊞), or using the ⊮ tool. Click on the plane you want to adjust and adjust the corner points at will. The concept of perspective planes and vanishing points can be quite complex, and can take a little getting used to.*

We now switch from using the Vanishing Point tool to using the Clone Stamp tool ♨ within the Vanishing Point dialog. Hold down the Alt key, click on the image area you wish to clone (as the source for your stamping), then simply paint using the stamp.

** The Photoshop CS3 online help guide (search for "Vanishing Point") includes a good explanation of the concept, and a video tutorial.*

If you're used to working with the standard Clone Stamp tool, stamping on a perspective plane will feel strange at first. The reaction time will be slower, and the stamping action itself (i.e., the replacement of individual pixels) also behaves differently, due to the new perspective which has to be interpolated into the new pixels before they are mapped.

For the Clone Stamping process, we used a brush with 80% hardness, 90–100% opacity, and a very large diameter. If you are working with more than one perspective plane, you will have to activate each plane individually (by clicking 🐾 and selecting the appropriate plane) in order to make corrections to it.

As an alternative to the Stamp tool, you can also use the Selection tool ⬚ to select rectangular areas for copying.* This creates a floating selection, that can then be moved (copied) to another area within the image, where it is transformed to match the perspective plane that is active in the new position.

This can, as usual, be done using the Ctrl-C and Ctrl-V keystrokes, or, in the case of a Mac, ⌘-C and ⌘-V.

Once we had made a number of stamp-based corrections and their associated changes to the perspective planes, we finally cropped the image and ended up with the result shown in figure 5-34. When using the stamp tool it is better not to clone sections which are too far towards the optical rear of a perspective plane, as the corresponding pixels will have been significantly distorted and enlarged, which can in turn lead to an unnecessary lack of sharpness and coarse textures.

If you are working with 16-bit images, you should only save your results to an 8-bit format at the very end of the process, once all your cloning and perspective corrections are complete. You can, of course, also stick with your 16-bit files if you have enough disk space.

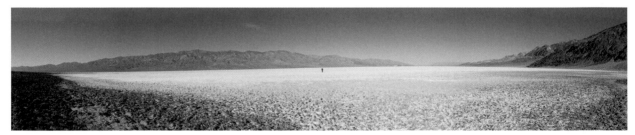

Figure 5-34: Here, the sky has been altered using the Clone Stamp, and the foreground has been enhanced using the Vanishing Point function.

Vertical Panoramas and Perspective Correction

In the example we just completed, we used *Auto* projection mode, which is usually accurate in its analysis of the source images and chooses *Cylindrical* or *Perspective* projection accordingly. The program uses some of the EXIF data stored within the source files to reach its decision, but the information concerning lens type and focal length will be missing from images that were either scanned or taken using older equipment which doesn't transmit lens information to the camera. This can cause Photoshop problems when it is

interpreting source images. Generally, Photoshop uses the central image of a panorama as its reference vanishing point, and distorts and shifts all other images around this central point.

In most cases, Photoshop can even detect which shots were taken using horizontal and which using vertical pans, and aligns them correctly, as can be seen in figures 5-35 and 5-36.

Figure 5-35:

A typical shooting situation. Because of the small room and the 24 mm lens (plus a crop factor of 1.5), two shots were necessary to shoot the whole closet. The obvious noise in the image is the result of the high ISO speed setting (ISO 3200 shot using a Nikon D200).

Figure 5-36 shows the results we achieved using *Photomerge* set to *Auto*. The images were shot hand-held, and so had to be aligned before merging. We did this using the Ruler tool 📏 to draw a line along the edge of the closet. We then confirmed the automatically-calculated angle of rotation in the dialog Image ▸ Rotate Canvas ▸ Arbitrary.

There is, however, still a noticeable degree of perspective distortion in the merged image, indicated by the three guidelines we have drawn through the image. You can create such guidelines simply by dragging the mouse from the rulers at the left or top edges of the image window.

We then merge the individual layers into one, as previously described and move on to the lens correction stage (Filter ▸ Distort ▸ Lens Correction) shown in Figure 5-37. Here, we can adjust horizontal and vertical perspective, as well as correcting pin-cushion and barrel distortion.

Figure 5-36: Result using Layout set to "Automatic".

For our example, we were able to restrict our processing to vertical and horizontal perspective corrections. Each redrawing of the preview image requires a fair amount of processing power, so make sure you move the sliders slowly, and wait for the preview image to complete before judging your results and making further corrections.

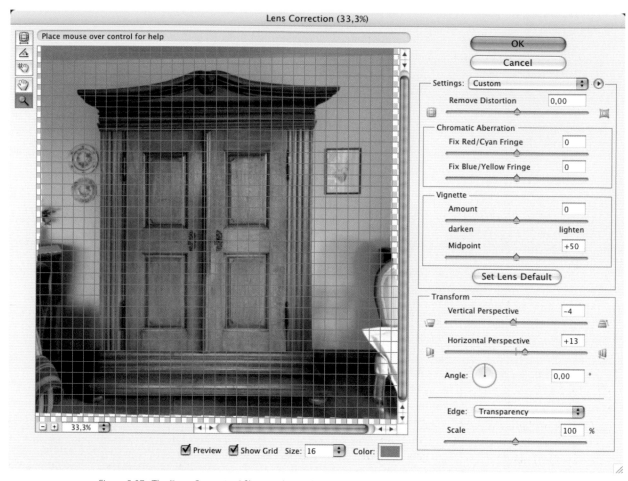

Figure 5-37: The "Lens Correction" filter can be used to manually correct perspective and lens distortions.

If you need to carry out a number of corrections, it is better to treat them as individual steps of a single process, and not to exit the Lens Correction filter dialog between individual corrections. If you exit the dialog after every step by clicking *OK*, the dialog is continually being restarted and interpolates the rounding errors involved in each new correction into the image data, causing creeping image quality loss.

If you have experience with the Photoshop Free Transform function you can often achieve faster results for simple examples, such as our closet. Free Transform cannot, however, be used to correct pincushion or barrel distortion. Figure 5-38 shows the corrected and cropped image of our closet.

Figure 5-38:
The final view of the closet after perspective correction and cropping.

Multi-Row Panoramas

Photoshop can also handle simple multi-row panoramas, as we will now demonstrate. For this example, we will be using source images of the famous *Swieta Lipka* church in Poland (see figure 5-39), again shot hand-held. In order to capture the height of the church, we had to use two rows of three images each.

 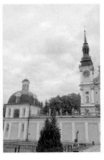 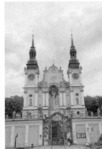 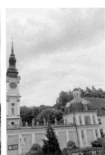

In Photomerge, we chose *Auto* layout and ended up with the result shown in figure 5-41. Even using our fairly fast computer, Photoshop took its time to process the 10-megapixel images. Photomerge obviously used perspective projection, evident in the slanting lines visible at the edges of the image shown in figure 5-41. Because of the photographer's low shooting position, pronounced perspective distortion is also clearly visible. Figure 5-40 shows the Layers palette with the masks created automatically by Photomerge.

For the purposes of analysis, it is interesting to see exactly which parts of each source image are used in the final image. Clicking on the eye icons next to the individual layers hides them temporarily, and often reveals astonishing results. Keep in mind, though, that Photoshop has at this point already aligned the source images and distorted them to match the chosen perspective layout.

In the case of moving objects (pedestrians in this example), Photomerge has done a pretty good job of automatically removing or matching them. An initial viewing reveals no obvious ghosting.

The next step is to merge the individual layers into one using ⇧-Ctrl-E or ⇧-⌘-E. We did not crop the image at this point, as we will be needing the surplus image area later to provide source material for our perspective corrections.

We now return to the Lens Correction filter and start by using the Straighten tool to align our image. We drag the ◢ tool along the front edge of the roof of the entrance building, creating an artificial horizon that the filter then uses to automatically rotate the image.

The second step is to correct perspective. Here we will primarily be using the *Vertical Perspective* slider.

Figure 5-39: Six source images were shot hand-held in two rows, using a Canon 40D and a 21 mm lens (16 mm equivalent with a crop factor of 1.6).

Figure 5-40: The Layers stack and layer masks created by Photomerge.

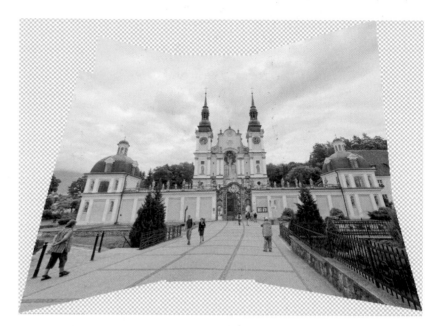

Figure 5-41:
Our initial result using the "Perspective" layout
shows distinct perspective distortion.

The substantial distortion our example shows requires us to use a high correction value of -96. Again, this type of correction is complex and will take time, even if you are using a powerful computer.

The next step is to correct horizontal perspective, this time using a much more modest value of +5. These settings are shown in figure 5-42. The two towers are still slightly too short, and are still slightly canted outwards. These are, however, not corrections we can address using the current dialog, so that is how our image remains for the time being.

Figure 5-43 shows our preliminary results. The image is still not ideal, but this is the best we can achieve using the methods described and the available image material.

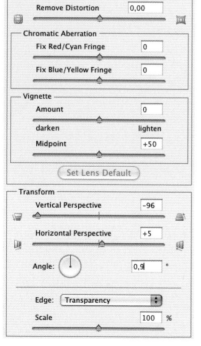

Figure 5-42: The "Lens Correction" filter
settings used to create figure 5-44.

Figure 5-43:
Results of perspective correction with the
help of the "Lens Correction" filter.

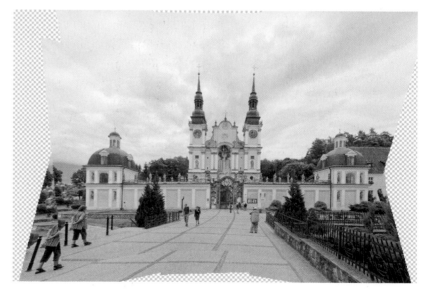

Finally, we reduce our image to a single layer and crop it using the ⌗ tool. Figure figure 5-44 shows the cropped image – we have deliberately left a large amount of sky at the top of the frame. There are now three remaining problems to be corrected: the pedestrian in the bottom far left corner of the image, the white space in the bottom right corner, and the church towers, which appear a little shorter than in reality, and which still appear to lean slightly outwards.

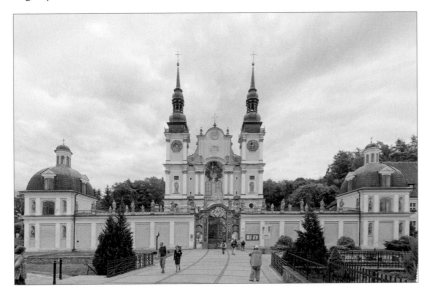

Figure 5-44:
The cropped image. There are still several visible imperfections.

The white space near the bush at the bottom right can be simply corrected using the Clone Stamp tool. The pedestrian at the bottom left can also be removed (we hope she will forgive us!) using the stamp tool, although the process here is a little more complicated. In order to avoid having to use perspective planes, we will stamp almost exclusively horizontally. And, in order not to give ourselves away, we will remove the chain link fence too. As usual, we create a new, empty layer, and here, we activate the *Current & below* option in the *Sample* dialog (see figure 5-30 on page 116).

Correcting our leaning towers is more complicated. Here, we select an area around the star above the main gate using a fairly broad, soft edge, and leaving plenty of space on both sides. We then copy the selection using Ctrl - C and paste it into a new layer using Ctrl - V . Figure 5-45 shows the resulting Layers palette.

We now use Ctrl - T (or ⌘ - T) to start the Free Transform tool in the new layer. First, we stretch our selection carefully upwards (see figure 5-46, Ⓐ) to give the towers the appearance of more height. To retain realism, it is important not to overdo this type of stretch.

Now, we need to straighten the towers. We do this by clicking the top right-hand handle in the selection while holding down the Ctrl or ⌘ key (the cursor will take on the ▼-form), and dragging the handle slightly inwards

Figure 5-45: Our Layers palette after clone stamping and creation of a selection layer based around the church towers.

Figure 5-46: The tower detail during the Free Transform process.

until the right tower appears to be vertical (Ⓑ). Figure 5-46 shows this transformation process.

Again, we can use guidelines dragged out of the rulers to assist us. And remember that here too, Photoshop will need time to process each adjustment and to redraw the image preview. Pressing the enter key or double-clicking on the free transform area saves the current changes to the image file.

The final step involves improving contrast and mid-tones using Curves. We will use the standard S-curve for our example (see figure 5-47).

We then improve microcontrast using the technique described in section 7.1. The DOP Detail Extractor will automatically generate a new layer that combines the layers beneath it and enhances detail contrast. Finally, we use the Photoshop Shadows/Highlights command to slightly dim the highlights and brighten the shadows.

Figure 5-47: The Curves dialog showing the classic S-curve. This curve increases mid-tone contrast and, in most cases, color saturation.

Figure 5-48: Our final image once all of the described corrections have been performed.

In order to improve the contrast of the sky, we create a Hue/Saturation adjustment layer, select the blue color channel, and select the sky's blue hue using the eyedropper tool. We then increase saturation and decrease brightness, using a mask to prevent the building itself from being affected.

Now all we have to do is save our image, make a copy, and merge the individual layers into one. We then scale the image to our desired output size, adjusting the resolution if necessary. We then sharpen the resulting image to yield the result shown in figure 5-48.

Photoshop Photomerge Layout Modes

The previous examples have shown that Photoshop usually selects the appropriate projection type automatically if you use *Auto* layout mode. Sometimes, however, Photoshop evaluates a scene incorrectly, or you may explicitly want to use a different projection type. There are various ways of doing this: you can either set a specific projection type in the Photomerge dialog (see figure 5-49), which may require one or two attempts before you find the right choice; or you can select the *Interactive Layout* option. As of the CS3 version of the program, there is also a third option, called *Reposition Only*. This is a projection type used for panoramas which have been shot using parallel camera movements, rather than rotation – a technique that is usually used for panoramas that only encompass smaller numbers of images.

A correct but easily comprehensible explanation of projection types is not easy to formulate. Harald Woeste addresses the topic extensively in his Rocky Nook book, *Mastering Digital Panoramic Photography*. Here is our (extremely simplified) explanation: If the total angle of view that you wish to cover with your panorama does not exceed 120°, you should use a *Perspective* projection. Some practitioners cite a maximum angle of view of 170°, but this is a number that appears to be based more on theory than practical usage. In a perspective projection, the horizontal and vertical lines in the center of the panorama image remain mostly unaffected, while the lines in the surrounding areas become increasingly distorted to fit the overall view – and the more extreme the angle of view, the more extreme the distortion will be. In the case of total angles of view of more than 120°, you should really use a *Cylindrical* projection.

The types of manual perspective adjustments we have had to make in our examples are generally caused by the shooting angles for the source images, and not by the actual stitching process. Photoshop cannot automatically compensate for a tilted camera. Some other stitching programs support this type of correction, although they require additional input regarding the angles of tilt involved in order to function correctly.

We will now go into some more detail concerning the Photoshop *Interactive* layout type. Our source images for this example are shown in figure 5-50. They were taken using a compact camera with an effective

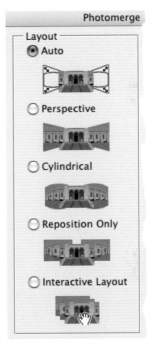

Figure 5-49: Photomerge offers several layouts (i.e., projection types).

(35 mm format) focal length of 37 mm. This represents a horizontal angle of view of about 53° per shot, which definitely adds up to more than the recommended 120° upper limit for perspective projection panoramas.

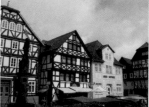

Figure 5-50: Our four source images, taken hand-held at the old market square in Fritzlar, Germany.

Start the Photomerge function and select the *Interactive Layout* option to display the dialog shown in figure 5-51. Although everything looks fine at first glance, a closer look reveals some scruffy-looking overlaps and a fair amount of distortion. Many of these problems can be remedied interactively.

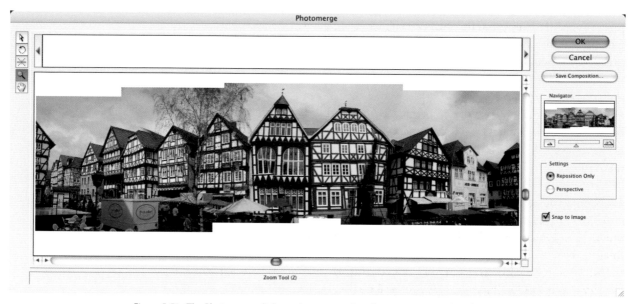

Figure 5-51: The Photomerge dialog as it appears when "Interactive Layout" is selected.

Figure 5-52:
The five tools available in the
Photomerge interactive layout.

Before we continue, here is a quick description of the tools available in the dialog shown above (see also the magnified view in figure 5-52). At the bottom right in the *Settings* box, we see that the *Reposition Only* option is activated, which generally leads to bad results. Choosing the *Perspective* option will improve things immediately, as can be seen in figure 5-53. We now have obvious distortion at the left end of the image, as the angle of view is too large for this type of projection, and the vanishing point has not been well-chosen.

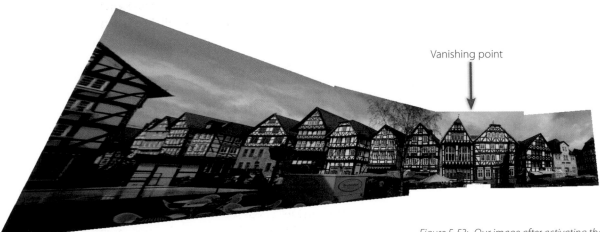

Vanishing point

Figure 5-53: Our image after activating the "Perspective" option. The distortion to the left results from the asymmetrical vanishing point and the very large angle of view.

We can use the ➤ tool to drag individual images from the panorama onto the lightbox area of the dialog box or vice versa. If you use the ➤ tool to click on a particular image area, the corresponding layer will be activated and that portion of the image selected. You can then use the mouse to shift that part of the image within the panorama. You can position your selection even more precisely using the arrow keys on the keyboard.

The Vanishing Point tool ✳ is self-explanatory, and is used to select the source image that Photoshop should use as its vanishing point reference. (It is only available when using *Perspective* layout.) The program will then arrange the other source images correspondingly to the left and right of this image. The Vanishing Point tool can only be used when the projection type is set to *Perspective*.

The ⟳ tool allows you to rotate individual images. The zoom tool 🔍 allows you to zoom in (and out while holding down the Alt key), and the hand tool ✋ allows you to shift the visible detail within the window using the mouse. This can be helpful if you have zoomed in so far that the entire image cannot be displayed at once.

As is the case with other complex operations, you will here also need to work slowly to give Photoshop time to update the preview.

Complex panoramas can take quite a while to perfect. For this reason, Photoshop offers the *Save Composition* button, which saves the current settings and associates them with the appropriate source images in a project file with the ".pmg"* ending. You can then load this file later to resume working exactly where you left off.

The CS4 version of Photoshop has added three additional layouts (projection types): *Spherical* (as described on page 109), *Collage*, and *Reposition*. *Interactive Layout* is no longer available as an option.

* *"pmg" stands for Photomerge.*

5.5 Bringing People Together – Group Panoramas

Photomerge's ability to analyze and group images is so sophisticated, that it can recognize individual faces and merge them intelligently. We shall demonstrate this functionality using source images of a family gathering.

Our group was large and broadly spread out – i.e., perfect panorama material. We could have simply used an ultra-wide-angle lens to take our photo, but this would definitely have led to the kind of distortion that is disadvantageous in portraits. We could also have simply stood further back, but this would have led to excessively large border areas in the final photo, which we would have had to crop, in turn leading to a reduction in image resolution. The results would have sufficed for a 4 × 6 inch or 8 × 10 inch print (the source images were taken with a Nikon D200), but not for a larger, high-quality print.

So, is it possible to create a usable panorama using source images in which people are continuously changing positions?

Thanks to Photoshop (CS3 and higher), it is. We haven't by the way, tested this functionality using older versions of the program.

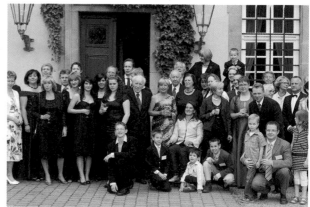

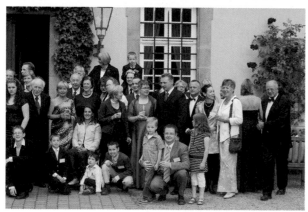

Figure 5-54:
The three source images for our family stitching.

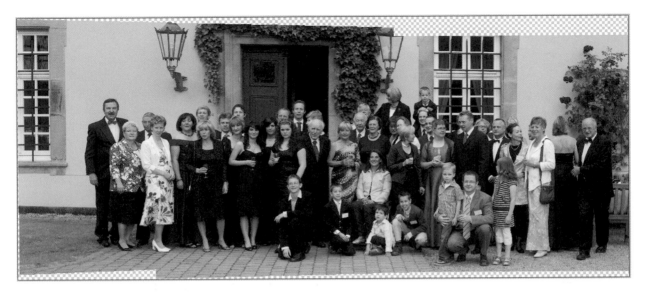

We loaded our source images into Photomerge via Photoshop as described earlier without any further preparation. We then merged our images using the *Auto* option, and the result can be seen in figure 5-55.

In order to avoid having to crop too closely in our final panorama, we used the Clone Stamp tool to add in some extra cobble stones in the foreground. We also straightened the image, applied a little perspective correction, cropped, and then used Shadows/Highlights to add texture to the dark suits and bright jackets. We also sharpened the entire image using the Unsharp Mask (USM) filter. The final result can be seen in figure 5-56. The image measures 6,050 × 2,650 pixels and can be successfully printed at up to 20 × 9 inches (at 300 ppi). Because this type of image is often viewed from a slight distance, it would also be possible to get away with a slightly larger print (28 × 12 inches, for example) printed at 220 dpi.

Figure 5-55: The initial result of using Photomerge to stitch our family together.

USM is the "Unsharp Mask" filter of Photoshop.

Figure 5-56: The final picture has been slightly corrected with a stamp tool, cropped, perspective adjusted, and sharpened.

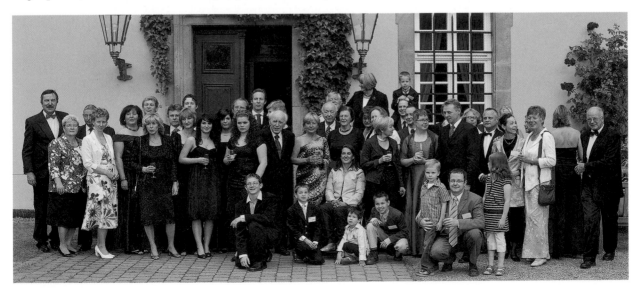

5.6 Other Stitching Programs

➜ *A useful and easily accessible web site dealing with panorama photography in general can be found at www.panoramas.dk/panorama/ software.html.*

To some extent, Photoshop CS4 also offers profile-based correction of vignetting and geometric (lens) distortion.

Photoshop is a great program for basic stitching applications, and its functionality is expanded with every new version release. For more complex processes, however, it lacks a number of subtleties and extensions which are available in other programs. Specialized programs offer more sophisticated functionality including:

▶ Profile-based corrections to lens errors (distortion, aberration, and vignetting)

▶ The option of setting fixed coverage points in individual images. These fixed points will later be used to coordinate overlap in the stitched image, allowing more precise stitching. This can be useful for applications where straight lines are critical, such as for architectural photography.

▶ Extended perspective distortion correction

➜ *Since Photoshop CS4 this feature is also available in Photoshop.*

▶ Creation of 360° panoramas. While Photoshop is capable of creating 360° cylinder panoramas, it is still not capable of ensuring a smooth transition between the first and last image of a 360° stack.

* *Which some of you will recognize as an established cartographic projection.*

▶ Creation of spherical panoramas (Photoshop CS4 also supports this) and other projection types, such as the Mercator* projection.

QTVR stands for "QuickTime Virtual Reality"

▶ Export to various panorama formats, which can then be viewed using specialized panoramic viewing software. One example is the QTVR, format, which allows you to take virtual tours, and to zoom in and out of panorama images. There are many more formats available for online viewing of panoramas.

▶ Better support for multi-row panoramas. 360° panoramas are almost always multi-row panoramas. Since the CS3 version, Photoshop also has adequate multi-row panorama support for panoramas which are not too wide.**

** *Photoshop CS4 even supports spherical panoramas.*

▶ Support for fish-eye lenses and fish-eye lens distortion correction (also supported by Photoshop CS4)

▶ Batch processing of images in a panorama sequence

▶ While Photoshop isn't capable of working with 32-bit HDR images, some other stitching programs are. These include Hugin and *Stitcher Unlimited* by REALVIZ.

▶ Hotspot support. These are "live" points within a panorama which produce an action when clicked. Hotspots function in a similar way to HTML links.

Currently available panorama software ranges from simple, easy-to-use programs (usually included for free with the purchase of a new digital

camera) to very powerful and sometimes very expensive specialist program suites. Please note, however, that *powerful* doesn't always imply *expensive*.

One such powerful freeware tool is *PanoTools*. This program was originally developed by Professor Helmut Dersch, and remains in continual development as an open source project at [30].* Because PanoTools is a command-line-based program, a number of graphical front ends have been developed to simplify its use. Such graphical interfaces either run the program's commands in the background, or start each command manually in sequence. These command-based tasks include establishing overlap points, correcting perspectives, general image optimization, creating overlay masks, and much more besides.

The program's multifarious capabilities are simultaneously a strength and a weakness, as the program assumes that all the individual modules are installed correctly, and that they are up to date. This is necessary if the program is to successfully pass individual module parameters to the computer's operating system, or for potential error messages to be correctly interpreted. Additionally, some of the program's modules can be called by various different sub-routines, which can make using the program confusing.

One of the better freeware variants is *Hugin* [29]. Commercial programs such as *PTMac*, *Calio* (both by Kekus [31]), or *PTGui* [32] are available for prices of around $40 to $120 per module. Some of the programs listed have moved away from the PanoTools base and now use their own modules and algorithms.

PanoTools can be downloaded as source code or as a binary file for Windows, Mac OS X, and several different flavors of Linux.

HDRI Panoramas

In the case of very wide panoramas, including 360° and spherical projections, the dynamic range of the entire image is usually greater than can be captured by the camera using a single exposure setting. The same is also true for panoramas shot indoors or at night. These types of situations are therefore ideally suited for enhancement using HDRI techniques. To create HDRI panoramas, you need to make multiple exposures of each part of your scene using different exposure values. You can then build your panorama using one of two basic methods:

A. Source images with the same exposure values are merged to make multiple panorama images. These "source panoramas" are then merged together into a single HDRI panorama.

 The advantage of this method is that it can be applied using almost all stitching programs, including Photoshop. The disadvantage is that the stitcher may have difficulty automatically finding control points in images which are over- or underexposed. Additionally, the automatic brightness balancing which is often applied to panoramas can cause problems when merging differently-exposed panoramas into a single HDR image.

B. Alternatively, you can merge each of the different exposures of one part of your scene into separate HDRI source images, and then stitch them to create a single HDRI panorama. If you want to use this technique, you need to make sure your stitcher supports the stitching of HDR images.

In both cases, the initial result will be an extremely large image file. You will definitely need a powerful computer, lots of RAM, and patience if you want to experiment with this type of technique.

If the tonal range of your scene is not too broad, and you do not necessarily want to produce a typical HDRI look in your final image, there is another alternative method you can use to create your panorama. Simply process your individual source images using DRI or HDRI tools, tone map your images at 8-bit or 16-bit color depth, and then merge them into a panorama. This method avoids the final tone mapping stage, and allows you to stitch images with a program that doesn't support HDRI. The PhotoAcute HDRI function is a good option for this type of process, and produces 8-bit or 16-bit LDR* images.

LDR = Low Dynamic Range. These images no longer have extended tonal range and can be processed using most standard image editing programs.

Further Information

This has been a relatively simple introduction to the problems – or better, challenges – associated with stitching techniques. There is a wealth of additional information available online, and we have already mentioned [53] and [58] as starting points. Once you have decided which stitching program you want to use, it makes sense to search for information relating only to that program, as many online solutions are highly program-specific.

Before you go out and spend money on specialized panorama equipment, you should gather experience shooting and stitching simple panoramas. This way, you can learn a lot that can help you later in a variety of contexts, not just in relation to panorama shoots. Basic stitching techniques can be useful in many other situations, and should be part of every photographer's repertoire. Photoshop is a thoroughly serviceable entry point to panorama processing, although if you are prepared to spend a day or two on a fairly steep learning curve, the free, powerful, but complex *Hugin* [29] has a lot to offer. For a small investment, you can get to grips with *PTGui* [32], *PTMac* [31], or *Stitcher Unlimited* by REALVIZ [34]. Another alternative is *Autopano Pro* by Kolor [33], which is very simple to use but nevertheless allows a fair degree of customization. Most of these programs are available for Windows and Mac OS X, and some are even available for Linux. Again, the appropriate forums are the best source of up-to-date information relating to all the programs mentioned.**

** For examples see www.autopano.net/forum/ for Auotopan Pro, http://groups.google.com/group/ptgui/ for PTGui, or http://tech.groups.yahoo.com/group/PanoToolsNG/ for Pano Tools.*

The CS4 version of Photoshop has introduced a number of improvements, including spherical panorama layouts, as well as automatic vignetting and geometric distortion correction (see figure 5-57). Only the *Interactive Layout* function described on pages 125 to 127 is no longer available in the latest version.

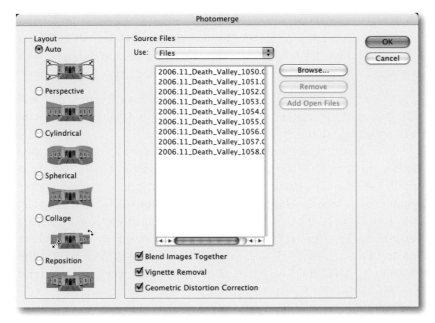

Figure 5-57:
Photomerge in Photoshop CS4 offers a
number of additional layouts (projection
types) and automatic correction of
vignetting and geometric distortion.

Photoshop CS4 also offers a new way to stitch images without using Photomerge:

1. Load your source images using File ▸ Scripts ▸ Load Files into Stack. Do **not** activate the option *Attempt to Automatically Align Source Images.*

2. Select all images in the Layers palette and use Edit ▸ Auto-Align Layers. This will call up the dialog shown in figure 5-58 (which is almost identical to the dialog shown in figure 5-57). Here, you should select either *Auto* or your desired layout.

3. Finally, with all layers selected, use the Edit ▸ Auto-Blend Layers command. This will display the dialog shown in in figure 5-59. Activate the *Panorama* option and check the *Seamless Tones and Colors* check box, and then click *OK*. Photoshop will then blend your images while retaining all the individual layers.

We cannot cover all the new layout types offered by Photoshop CS4 in detail here, but it is well worth trying them out, especially as some of them (*Spherical*, for example) can be combined with the new 3D functions that are included in the "Extended" version of CS4.

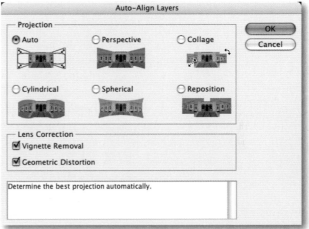

Figure 5-58: The Auto-Align Layers dialog.

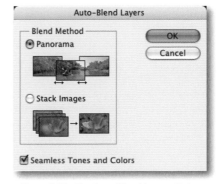

Figure 5-59: The Auto-Blend Layers dialog.

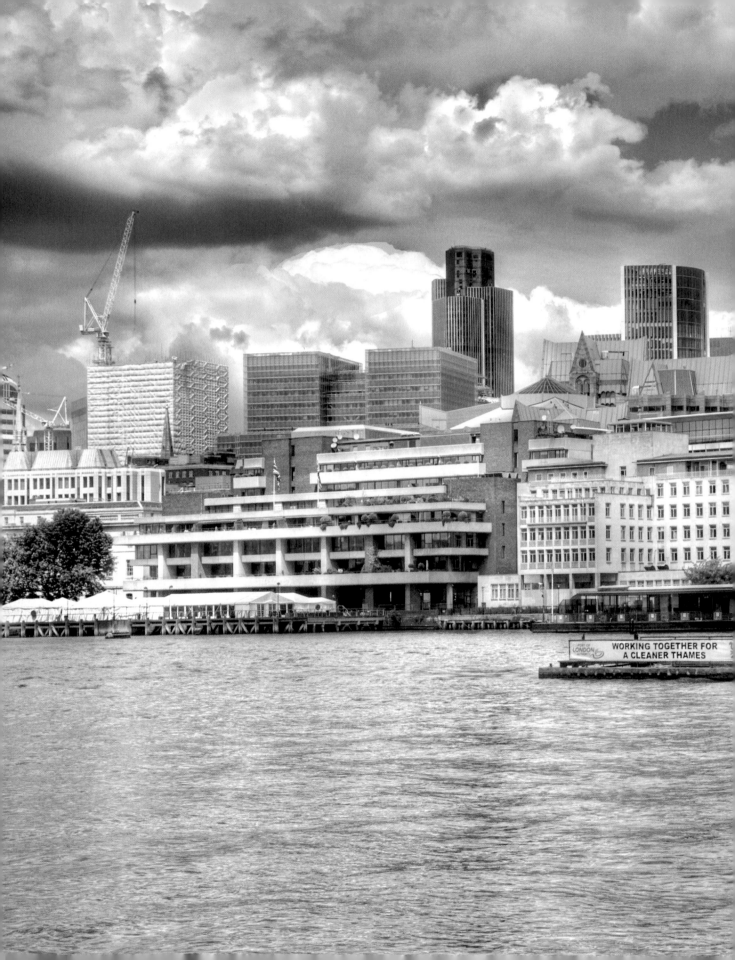

HDRI – Increasing Dynamic Range

6 *In spite of rapid improvements that have been made in camera technology in recent years, we still often come across scenes which encompass a broader tonal range than a normal digital camera is capable of capturing. Shooting multiple images with different exposure settings and then merging those images into one allows the photographer to create images with extended dynamic range. This technique produces what are known as HDRIs, or High Dynamic Range Images. The acronym DRI stands for "Dynamic Range Increase". Here, the term "dynamic range" describes the difference in brightness between the pixels with the brightest and the darkest tonal values within an image.*

You can also reduce image noise by merging several images of the same scene which have been exposed slightly differently and averaging the pixel values of the individual images in the sequences. This enables photographers to shoot in low-light situations using high ISO speeds and short shutter speeds without having to accept the image noise which such circumstances normally produce. We will describe both of these techniques in this chapter.

To increase dynamic range, we will be using Photoshop, PhotoAcute, Photomatix Pro, and FDRTools. For the noise reduction section, we will be using just PhotoAcute. Simple overlay effects are most easily achieved using Photoshop. A typical HDR workflow consists of five phases:

1. *Shooting phase – creation of the source images*
2. *Merging – i.e., the actual production of the HDRI image*
3. *Optional optimization of the HDR image*
4. *Tone mapping – reducing the dynamic range to a spectrum that can be displayed on normal monitors and easily printed*
5. *Post-processing (fine-tuning)*

6.1 High Dynamic Range Images and Tone Mapping

→ *A relatively simple introduction to HDR Imaging can be found at www.hdrsoft.com/resources/dri.html.* *Part of the information presented here originates from that web site. Christian Bloch has written a great book on the subject, and Jack Howard's "Practical HDRI" [5] is also a useful source of information.*

Due to the limitations of technical light-capturing processes, neither film nor digital cameras can always adequately capture the entire tonal range of a high-contrast scene. The dynamic range (i.e., the difference between the brightest and darkest parts) of a scene is often simply too great. Black-and-white or color negative film is capable of differentiating and reproducing contrast of about 4,000:1. This represents an exposure range of between 10 and 12 f-stops (12 in the case of black-and-white negative film). Color slide material can generally differentiate a range of about 7 to 8 f-stops. The differentiation potential of a good DSLR lies somewhere between only 8 to 10.5 f-stops, with the higher values being achieved by the newest camera models with larger image sensors. Some FujiFilm cameras use so-called Super CCD sensors, which attempt to improve dynamic range by utilizing two sensor elements per pixel – one element for bright and mid-range tones, and a larger, separate element for recording darker tones.

The image sensors in digital cameras also tend to lose sensitivity more rapidly at the top and bottom of the exposure range than film material, as depicted in Figure 6-1.

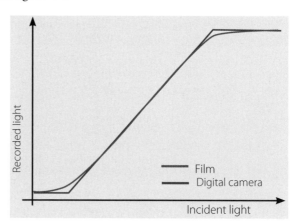

Figure 6-1:
Light sensitivity curves for film and digital camera image sensors.

** This represents a dynamic range of about 16–17 f-stops (2^{16} = 65,536:1).*

In a high-contrast scene – in broad daylight, for example – the range of contrast can be as much as 100,000:1.* The photographer usually only has the choice between exposing for the mid-range, for shadows, or for the highlights present in a scene. Figure 6-2 illustrates just such a situation.

Ideally, we want to reproduce as much of this range as possible in the digital original as well as in any prints we may make. The human eye can adapt to different lighting situations much more quickly and easily than a camera – a single glance can accommodate light within a range of about 100,000:1 (or 10^5:1). Given a little time to adjust, this increases to 10^{12}:1. The human eye is capable of seeing and registering starlight with a strength of 0.000.001 cd/m² just as well as bright sunlight with a strength of 1,000,000 cd/m². This is equivalent to a range of 32 f-stops.

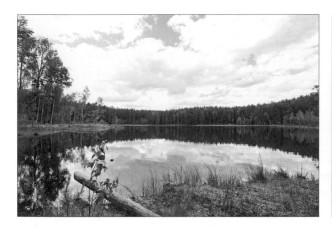 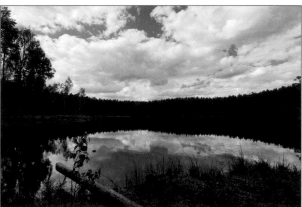

Image sensor technology is constantly improving and modern cameras can capture significant dynamic range – even if the progress from camera generation to generation is sometimes agonizingly slow. There is, however, already another option, which involves taking multiple exposures of a scene using differing exposure settings, and then merging the resulting images into a single, high dynamic range image. This is the basic HDR image concept. "Normal" images (with less or standard dynamic range) are described as *LDR* (*Low Dynamic Range*). HDRI is a technique which has long been used in the digital video sphere, but which has only been introduced into digital still photography fairly recently. HDR functionality first appeared in the CS2 version of Photoshop, and was improved greatly in the CS3 version by the introduction of more 32-bit data support.

Figure 6-2: A typical, somewhat contrast rich scene. The image to the left was exposed so the shadows display texture. The image to the right was exposed so the highlights display texture (i.e., in the sky).

Table 6-1: Examples of the Dynamic Range of Different Media and Shooting Situations

Medium	Dynamic Range
Color Slide Film	6–8 f-stops or about 100:1
Color Negative Film	8–10 f-stops or about 250:1 to 1,000:1
Black-and-White Film	10–12 f-stops or a contrast of 1,000:1 to about 4,000:1
Digital Compact Cameras	6–8 f-stops or a contrast of 100:1 to about 200:1
DSLR Cameras	8.5–10.5 f-stops or a contrast of 500:1 to about 2,000:1
Situation	
Outdoors, cloudy sky	8–12 f-stops or a contrast of 256:1 to about 2,000:1
Outdoors, bright sun	12–16 f-stops or a contrast of 4,000:1 to about 50,000:1
Indoor shots by day, facing outdoors	14–20 f-stops or a contrast of 8,000:1 to about 100,000:1
Output Medium	
Computer Screen	7–10 f-stops or a contrast of 128:1 to about 1,000:1
Print (newspaper offset printing or matte paper printed with an ink jet printer)	6–7 f-stops or a contrast of 64:1 (i.e., newsprint) to about 120:1
Print (coated paper, glossy paper) offset printing	7–8 f-stops or a contrast of 100:1 (i.e., offset) up to about 200:1

In order to be able to truly differentiate the tonal values in a digital image with substantial dynamic range, it is necessary to maximize the precision of the tonal values of each individual pixel, which in turn, requires a great deal of memory space. Limited dynamic range can be captured and displayed using 8-bits per pixel and color channel. RAW images generally have 12 or 14 effective bits per pixel when they are downloaded from a camera (even if they are saved as 16-bit images) and show noticeably greater dynamic range.

➜ *Normal images – those with standard or low dynamic range – are called "Low Dynamic Range Images" (LDRI or LDR images). The term MDR (standing for "Medium Dynamic Range") is also sometimes used.*

If you want to further increase dynamic range and the ability to differentiate between tonal values, you will need to resort to even higher values of 32 bits per pixel and color channel. Theoretically, this will enable you to encompass a range equivalent to 32 f-stops. 16- or 32-bit images, however, are not automatically HDR images, although the potential dynamic range they possess is one of the prerequisites for producing effective HDR results. This type of image processing requires the use of special 32-bit file formats such as OpenEXR or 32-bit TIFF.[*] Photoshop can also save HDR images in PSD or PSB formats, as well as PBM (*Portable Bit Map*) or Radiance file formats. Nowadays, there is a whole range of different HDR formats available, each with its own advantages and disadvantages.

* *OpenEXR, for example, can save image data as 16-bit or 32-bit floating point pixels, or as 32-bit integer pixels.*

While HDR image creation is a subject in its own right, the reproduction of HDR images is another matter entirely. Most typical output media – monitors, offset printing, or inkjet printing – are not capable of reproducing the dynamic range of HDR images satisfactorily. Modern printing techniques are generally limited to 8-data bits per RGB or CMYK color channel, and often raise the question of whether even the resulting 256 color values can be genuinely and faithfully reproduced using the currently available technology. Generally speaking, printed output will display closer to 120–180 different tonal values.

➜ *16-bit drivers and printing plug-ins have only been available since about 2007, and are still not available for all printers and operating systems. They improve color rendering, but cannot increase dynamic range.*

The solution to this problem lies in effective compression and display of tonal values, known as *tone mapping*. The goal of tone mapping is to reduce the large amounts of image tonal value data available in a high dynamic range image into a range that can be reproduced conventionally while retaining the attractive look of the original HDR image. This is generally only possible within a limited range using linear regression techniques. During tone mapping processes, it very important to differentiate between pixels with high, mid, or shadow values and to see these in relation to their neighboring pixels as well as within the context of the entire image.

Unfortunately there isn't a single tone mapping method which works equally well for all images, and this makes automatic tone mapping techniques difficult to realize. As a result, most of the tone mapping methods presented here will involve hands-on user involvement, and you will need to experiment to develop your own methodology and feel for how best to process your own images.

6.2 Shooting Techniques for HDR Images

HDR images are constructed from a number of individual exposures shot with differing exposure values. This is generally quite easy for non-moving subjects, but is more difficult to achieve for scenes that contain moving objects. Here are the main points to keep in mind when shooting HDR sequences:

▸ A stable tripod is essential, even though most HDR modules enable users to also merge images that are not perfectly matched using a stitching-type process. This type of process nevertheless reduces precision and increases the risk of losing edge detail due to cropping.

▸ In order to maintain uniform depth of field, you should only vary the shutter speed, and not the aperture. Use the Av (or A) exposure mode setting (see figure 6-3).

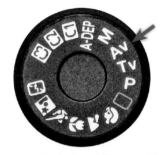

Figure 6-3: Use the Av or A (Aperture Priority) or manual exposure mode when shooting for HDR images.

▸ In order to avoid differences in depth of field, switch the camera to manual focus. This will ensure that the camera's autofocus system does not refocus between shots.

▸ To avoid ghosting effects in your HDR images, avoid shooting moving objects, such as the pedestrians shown in figure 6-4.

▸ If you are prepared to limit yourself to three exposures, then the auto-bracketing function available on most DSLRs (set to aperture priority –Av) is a good choice. If, however, you wish to obtain maximum dynamic range in high-contrast scenes, you will probably have to add additional manual shots to your sequence. Many cameras only allow for three bracketed shots.

Figure 6-4: If moving objects are present in a scene, ghosting may result.

If you use a bracketing increment of 2 EVs (in this case shutter speed values varied by a factor of 4) per shot, then three exposures allow for a maximum dynamic range of 4 f-stops plus the basic 8–10 f-stops your camera can capture in a single shot. The bracketing settings can be found in most DSLRs in the AEB (*Auto Exposure Bracketing*) menu (see figure 6-5). The exact sub-menu structure will vary, depending on your camera model. The maximum number of bracketed shots and the maximum bracketing interval will depend on the capabilities of your camera. Some cameras can shoot bracketing sequences of more than three exposures. These include the Nikon D200 and D300, as well as the Canon EOS DS1 Mark III. If you need more bracketed shots than your camera allows, you will have to program multiple bracketing sequences with differing shutter speed settings. Keep in mind, however, that not every high-contrast scene needs to be captured with the same extremes of tonal value range.

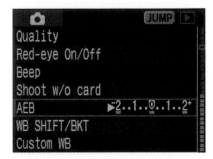

Figure 6-5: The bracketing settings in a Canon 20D – to be found in the AEB menu.

▸ The necessary practical steps are as follows: Use your camera's spot metering mode to meter the darkest shadows in your scene and record the

values. Then repeat the process for mid-tones and highlights. You can then use the two extreme values to calculate the number of f-stops you need to cover, and thus the number of shots you need to include in your sequence.

If you want to capture the entire tonal range of a scene, you need to make sure the brightest image doesn't have any washed-out highlights and that the darkest image doesn't have any underexposed shadows. Washed-out highlights are easily recognized using a DSLR's image preview function, and the histograms displayed by most modern cameras will help you to locate underexposed image areas.[*] The histogram of the brightest image should not show values at the extreme left of the graph (in the shadows), and the graph for the darkest image should not have significant values at the right hand end of the scale (highlights). The most reliable way to check exposure is using an RGB histogram (see figure 6-6), which shows the tonal values for the individual color channels in your image. A luminance histogram evaluates the individual color channels at different strengths (green is displayed the strongest), which can make it difficult to recognize the true impact of the red or blue channels. While washed-out highlights are generally not acceptable in an image, underexposed shadows can sometimes be considered part of an effective composition, especially in night shots or other low-key situations which include very dark image elements.

If you activate this option (for example, using a Canon 40D), the camera will mark overexposed areas using a blinking pattern in the image preview on the camera's monitor.

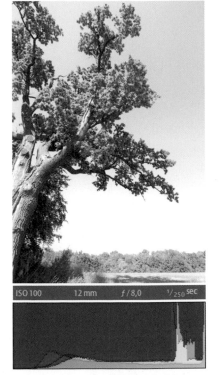

Figure 6-6: To capture the entire dynamic range in a scene, the darkest image shouldn't contain any tonal values equivalent to the highlights (right) and the brightest image shouldn't contain shadows (left). The center image can contain some overlap (These are Lightroom histograms).

▸ If you are shooting in JPEG or TIFF formats, you should always use the same white balance settings. RAW images should all be converted using the same color temperature setting for white balance. If your camera calculates and embeds differing white balance values in your image files, you will have to transfer the settings from your reference image to all the other images in your sequence during the conversion process.*

* *This is described in detail on page 16.*

▸ Disable your camera's "Auto ISO" setting (if available), and select a suitable preset ISO value.

6.3 Simple Photoshop Blending Techniques

Combining Two Differently Exposed Shots

Occasionally, you may have two or more shots that are nearly identical, but where each image contains areas which are better or more pleasingly exposed than the equivalent areas in the other image. Instead of using a classic HDRI program to process these images, it's often easier and faster to merge them in Photoshop using the Layers command and layer masks to blend the appropriate areas. There are a number of different ways of going about this, and we will describe two of the possible techniques.

We have two source images (figures 6-7 and 6-8). The shell in the first image (6-7) is pleasingly lit with diffuse light from above. However, that same light casts a hard shadow on the sea urchin below the shell. In the second image (figure 6-8), the sea urchin is better lit, but the shell is not as bright. These two images can be blended together using a simple and effective technique.

Figure 6-7: In this shot, the shell is pleasingly lit, but casts a hard shadow.

Figure 6-8: In this shot the sea urchin is well illuminated, but the shell is poorly defined.

To get started, open both images in Photoshop and drag the image in figure 6-7 over the one in figure 6-8 while holding down the ⇧ key.** Select the upper layer using the Layers palette and reduce its opacity until you are able to see whether the two images are correctly aligned. If not, use the move tool ✥ to shift the upper image so that it coincides exactly with the lower one. It

** *If you are using Photoshop CS3 or CS4, you can also load and align your images using* File ▸ Scripts ▸ Load Files into Stack, *as described on page 62.*

Figure 6-9: The Layers palette after our first blending attempt.

Figure 6-10: The Layers palette after creating the Layer Mask for the blending process.

may also be necessary to rotate the image slightly. Once this is done, we set the opacity of the upper image back to 100%.

If you are using Photoshop CS4, you can replace this entire process by loading your images using File ▸ Scripts ▸ Load Files into Stack. Simply select both layers and use Edit ▸ Auto-Align Layers with the *Collage* layout setting to align your images.

Next, we create a white (empty) layer mask for the active upper layer (click on ▢ at the bottom of the Layers palette). Remember to explicitly select the layer mask using a single click on the mask icon in the Layers palette entry. Our Layers palette now looks like the one shown in figure 6-9.

We then use a large, soft brush (hardness 5–10%) to paint black into those areas of the mask where the lower layer should show through. We recommend using a brush opacity of 15–25% and repainting the same area multiple times if necessary. This will give you more control over the exact structure of your mask. In the places where the mask is black, Photoshop will display the layer below. In those areas where it is white, only the upper layer will be visible. The gray areas are partially transparent, based on the corresponding darkness of the area in question.

After a couple of brush strokes with the black brush, the corresponding parts of the lower layer will become visible in the black-painted areas. During this whole process, it is very important to make sure that the shadows and highlights not being manipulated remain natural-looking. This is why we also darkened the upper edge of the shell slightly with a gray brush stroke (which is, in fact, a low opacity black brush stroke).

The result can be seen in figure 6-11. Figure 6-12 show the corresponding layer mask, and figure 6-10 shows the layer stack with the mask icon on the upper layer.

We could also have created a similar transparency effect by working directly in the upper image using the Eraser tool ✏. Working with a layer mask, however, allows you to undo any mistakes you might make by repainting the mask, or erasing the sections of the mask that don't suit your purposes.

Figure 6-11: The blended image made from two layers, and using a blending mask in the upper layer.

Figure 6-12: The Layer Mask used for the blending process. The mask is linked to the upper image layer, making the black areas transparent.

Replacing a Traditional Gradation Filter

Landscape photographers often cannot get by without using a neutral gray gradation filter. In the days of black-and-white photography, such a filter (or a red filter) was practically a must. A gradation filter can often be used to darken a bright sky at the shooting stage, while retaining a smooth transition between the sky and the horizon. However, filters and filter mounts can be tricky to align and are bulky to carry around. These types of filters can still be useful to a digital photographer, but if you don't have one with you, you can simulate the same effect digitally. Simply take multiple shots of your scene using shutter speed bracketing. You can then blend two images together – one with the sky exposed correctly, and the other with the landscape itself exposed correctly. This process is called *Exposure Blending.*[*]

Figures 6-13 and 6-14 show our two source images (after conversion to black-and-white). The image on the left was exposed to show the detail in the landscape portion of the image, resulting in a flat-looking sky. The image on the right was exposed using a shutter speed that was 1½ stops faster, allowing the textures in the sky to come to the fore, and causing the

** We will describe a variation of this process using Photomatix Pro on page 170.*

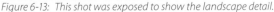

Figure 6-13: This shot was exposed to show the landscape detail. *Figure 6-14: This shot was exposed to show detail in the sky.*

Figure 6-15: The "landscape" image is on the lower layer, and the "sky" image is on the upper layer.

Figure 6-16: Select the top left gradient pattern.

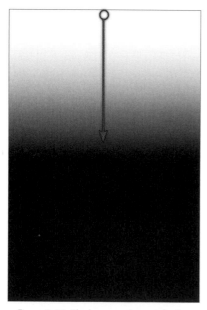

Figure 6-17: The layer mask created using the gradient tool. The red arrow indicates the direction in which we dragged the gradient.

landscape itself to be under-exposed. We will now merge these two images together to achieve a better overall result.

We open and align our two images in Photoshop using the technique previously described (e.g., using the Load Files into Stack script). We now activate the upper layer (with the darker sky) and apply a black layer mask by clicking the ⬛ symbol in the Layers palette while holding down the Alt key (Mac: ⌥ key). Figure 6-15 shows the resulting Layers palette. Photoshop now displays our lower "landscape" image.

In this case, we will be using the gradient tool ⬛ instead of a brush tool to manipulate our image. The effect we want to achieve will mask the landscape in the upper layer and provide a gradual transition between the horizon and the sky.

We select a linear gradient from black to transparent in the activated ⬛ tool (see Figure 6-16). If we then set the background color in the Photoshop toolbar to white, the gradient takes on a white to transparent progression.

We then point the mouse to the upper edge of the image (the "center point") and drag it down to shortly above the horizon near the level of the lake (our "end point"). This causes our dramatic sky to become visible again, while creating a seamless transition between the horizon and the sky. The trees on the horizon have become a little darker, but still appear natural.

Figure 6-17 shows the layer mask we created to fine-tune the transition between the horizon and the sky. This mask can be further manipulated and perfected using any number of Photoshop tools, but the standard gradient mask is sufficient for our purposes.

We enhanced our resulting image slightly using the DOP Detail Extractor (described in section 7.1). Here, we also used a layer mask to avoid increasing the local contrast in the sky. This mask was basically the opposite of our blending mask, and was also created using the gradient tool. Another option would have been to duplicate the existing layer mask and invert it using Image ▸ Adjust ▸ Invert (or Ctrl/⌘-I).

Finally, we sharpened our image slightly using the USM filter, also with the additional use of a mask to avoid unwanted sharpening of the sky – in this case, the same mask we used to protect the sky from local contrast enhancement.

To create a copy of a layer mask, go to the Layers palette, and then drag the mask you want to copy from one layer entry to another while holding down the Alt key (on a Mac, use the ⌥ key).

The Layers palette shown in figure 6-18 illustrates the various layers we used while processing this image, including all the post-processing corrections. Figure 6-19 shows the final image.

Figure 6-18: *The Layers palette of the final, processed image. The top two layers are used to improve local contrast and sharpness.*

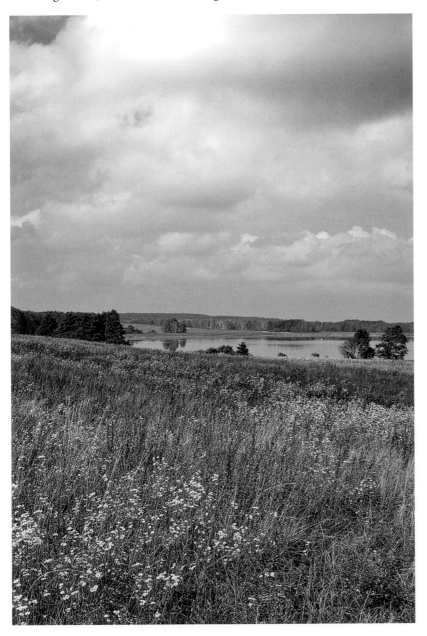

Figure 6-19:
The final image consisting of the two blended layers and some slight microcontrast enhancement.

6.4 Creating HDR Images Using PhotoAcute

The basic functions of PhotoAcute have already been addressed in section 3.3. One of the numerous functions the program offers is the creation of increased dynamic range images. In contrast to Photoshop's *Merge to HDR* function (which we will describe in section 6.5), the PhotoAcute functions described below only work for 8- or 16-bit images.*

The possibilities for user control are relatively limited, as we've already learned in section 3.3. Nevertheless, the results produced in many simpler scenarios are quite acceptable, and are also quick and easy to realize.

Our choice of source formats (as previously described) includes JPEG, TIFF (8- or 16-bit), DNG files, or other RAW formats supported by the Adobe DNG converter.

As a rule, we recommend that you either do not preprocess your images at all, or that you limit yourself to any necessary white balance correction or cropping before saving your source images as 16-bit TIFF files. As always, make sure any preprocessing steps are applied in equal amounts to all of your source images.

For our example, we will load our non-preprocessed TIFF files into the PhotoAcute processing list using the program's File ▸ Open function. We then inspect our images and select the ones we want to use. At this point, if we are going to use the *Correct image geometry* or *Fix color fringing* functions, we need to check that the program has correctly identified our

Sidebar notes (left margin):

* *Actually, the current versions of PhotoAcute could also produce HDR images. The program does not, however, offer tone mapping functionality. You can, therefore, only save your image to an HDRI format and perform tone mapping using another program.*

➔ *The usual three HDRI phases (shooting, merging, tone mapping) are reduced to simply shooting and merging when using PhotoAcute. This simplifies the process but lessens user control over the tone mapping process.*

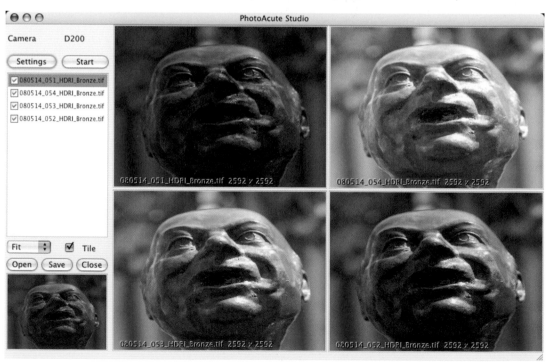

Figure 6-20: The PhotoAcute window after loading our source files. Don't be misled by the sometimes extremely distorted images in this window. These are only previews images which have been adjusted to fit into the available window space.

camera and lens. If the camera or lens was incorrectly recognized, we reset the parameters manually using Settings ▸ Camera. If PhotoAcute does not yet support the lens you are using, you can either select a similar one from the menu, or simply switch off the corrections which are not supported (see figure 6-21).

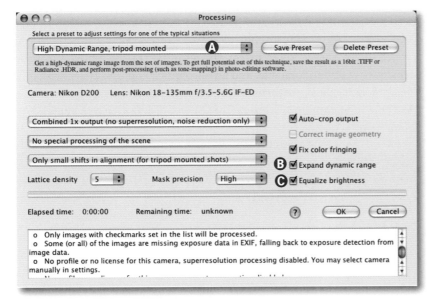

Figure 6-21:

The PhotoAcute settings for DRI processing.

In order to create an image with extended dynamic range, we start by activating *Expand dynamic range* Ⓑ and *Equalize brightness* Ⓒ (see figure 6-21), provided these haven't already been automatically activated by a preset from menu Ⓐ.

Because PhotoAcute DRI images generally require post-processing, we recommend using 16-bit source images and exporting to a 16-bit output format. This will only work if your source images are RAW or 16-bit TIFF files. JPEG source images can provide a maximum of 8-bit color depth.

For our example we will use the head of a bronze figure mounted on a decorative fountain. We started by cropping the head to a square format in our RAW converter (Photoshop Lightroom), and then exported the resulting five 16-bit TIFF images into PhotoAcute.

Our DRI processing settings can be seen in figure 6-21. Our Nikkor 28–70 mm f2.8 lens is not yet supported by PhotoAcute, so we set the program to a different (but similar) lens and switched off the *Correct image geometry function*.

Specific tone mapping settings are not part of the available options. We also activated the *Expand dynamic range* option Ⓑ, and we deactivated the *Equalize brightness* option Ⓒ for the first run.

The result can be seen in figure 6-22 and, although not ideal, it is an improvement on the original, and was created without any extra tone mapping. The "grunge" look common to many HDR images is not visible in our example, which we consider to be a positive aspect of the result. The image

is generally slightly dark, but this can be easily remedied using the Photoshop Shadows/Highlights tool.

As an experiment, we processed the same images a second time with similar settings, but this time with the Equalize brightness Ⓑ option activated. The result can be seen in figure 6-23. This image is visibly brighter, but this can also be corrected using Shadows/Highlights, this time to darken the highlights instead of lightening the shadows, as we did in our previous example.

When working in PhotoAcute, keep in mind the role of the reference image you selected at the start of the process. This is the image which is highlighted blue in the selection list when you click the *Start* button. If you use a bright reference image, the resulting image will also be brighter. For darker results, select a darker reference image.

Figure 6-22: The result of our first PhotoAcute DRI run without the "Equalize brightness" option activated.

Figure 6-23: The result of our second run – this time with "Equalize brightness" activated.

As you can see, PhotoAcute's DRI functionality is sparsely equipped, but delivers usable results quickly and easily for straightforward projects. If, however, you plan to post-process your HDR images using Photoshop, you will need to use a different program or save your processed image to the Radiance HDRI format (this option is only supported since version 2.8). You can then tone map your HDR image using either Photoshop, Photomatix Pro, or FDRTools.

6.5 Creating HDR Images Using Photoshop's HDR Functionality

As previously mentioned, Photoshop has included HDR functionality since the CS2 version. This functionality was extended in the CS3 version to include more tone mapping methods, which we will describe later. CS3 and future versions are also becoming increasingly 32-bit capable, and support for 32-bit processing is already available in the Levels, Hue/Saturation, Channel Mixer, Photo Filter, and Exposure tools. (A number of Adobe's HDRI options are only available in the "Extended" versions of Photoshop CS3 or CS4.)

We have already described the basics of HDRI shooting techniques. Figure 6-24 shows our new source images and their corresponding histograms. The brightest image shows no shadow clipping, and the darkest one shows no discernible highlight clipping. The shutter speeds were each about two stops apart.

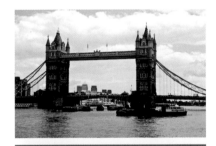

To create an HDR image in Photoshop, navigate to File ▸ Automation ▸ Merge to HDR. Because it is almost impossible to avoid slight shifts in your source images – even when using a tripod – it is necessary to activate option Ⓐ *Attempt to Automatically Align Source Images* in the dialog box illustrated in figure 6-25. Deactivating this option can lead to ghosting effects. Now use the dialog shown in figure 6-25 to select the images you want to merge.

You can perform these steps in *Bridge* by selecting Tools ▸ Photoshop ▸ Merge to HDR, or in Lightroom (version 2 and higher) using Merge Photos to HDR in Photoshop in the Edit menu. However, both these methods do not include the option of aligning the source images. As of Photoshop CS3, however, the alignment option is automatically activated, even for instances where the images have been opened using Lightroom or Bridge).

The "normal" Photoshop dialog (accessed via File ▸ Automation ▸ Merge to HDR) is shown in figure 6-25.

Figure 6-24: Our three source images and their corresponding Lightroom histograms.

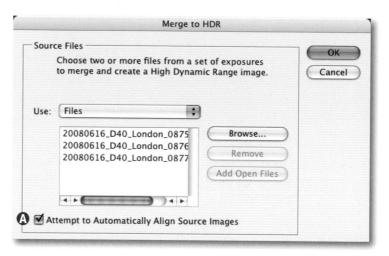

Figure 6-25:
The dialog box used to select the source
images for an HDR image. We recommend
activating option Ⓐ.

Photoshop starts by loading the files, then aligns and merges them into a (temporary) HDR image. Additionally, it will generate a preview (see figure 6-26). This can use a lot of processing power, and may take some time (even using a faster computer). In the dialog displayed in figure 6-26, you can use the preview list Ⓐ to deactivate (exclude) selected images from the merge process.

The EVs which can be seen below each image thumbnail are either automatically extracted from each file's EXIF data or estimated automatically by the program. The histogram Ⓒ shows the dynamic range of the merged image. Use the slider beneath this histogram to find an appropriate white point – in our experience, this will be further to the right than to the left end of the slider scale.

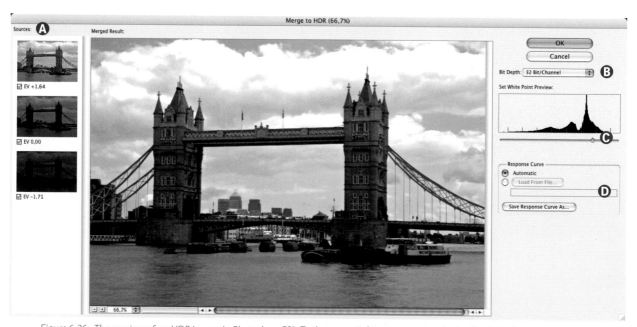

Figure 6-26: The preview of an HDR image in Photoshop CS3. To the upper right you can select the bit depth for the resulting image.

You can select the desired bit depth (8-, 16-, or 32-bit) for the resulting image using the dropdown menu Ⓑ. We suggest using 32-bit images for your first attempt. Click on *OK* and Photoshop will start the merging process and then display the resulting HDR image. Photoshop will give the file a ".pfm" extension, which stands for "Portable Floating Map".*

Do not be irritated by the look of the preview image (the previews shown in figure 6-26 or 6-27 have a relatively normal appearance because the scene has a relatively moderate dynamic range). In the case of images with a much larger dynamic range, Photoshop has to create a temporarily tone mapped preview image which simply cannot be displayed on a conventional computer monitor.

** Depending on the input format used, Photoshop may also resort to an output format other than ".pfm".*

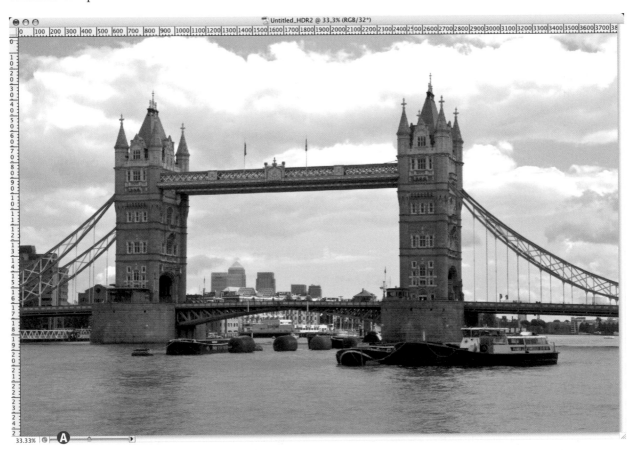

You can now adjust the brightness of the image using the slider Ⓐ (at the bottom left in the preview image shown in figure 6-27). Adjusting this value does not, however, change your actual image. It is designed simply to enhance the preview image in order to help you to make good subsequent processing decisions.

You can also make changes to the tone-mapping preview using the settings located at View ▸ 32-Bit Preview Options. This opens the dialog shown in figure 6-28. In Photoshop CS3, one of two possible mapping

Figure 6-27: A provisionally tone-mapped preview of our Photoshop HDR image.

Figure 6-28: Choosing the tone mapping display method for 32-bit images.

** These settings were first introduced in Photoshop CS3*

➜ *Tone Reproduction Curves are explained in detail in Christian Bloch's HDR book [4] or at www.fdrtools.com/documentation/ creating_profiles_d.php*

➜ *Unfortunately, Photoshop CS2, CS3, and CS4 do **not** display histograms for 32-bit images via* Window ▸ Histogram. *In order to view a 32-bit histogram, you need to create a Levels adjustment layer.*

methods can be selected using the dropdown menu Ⓐ. The *Highlight Compression* method has no further settings, and is often a good choice for getting a first impression of images which do not otherwise make a favorable impression. The *Exposure and Gamma* option offers more control over the preview image via two sliders (see figure 6-28). Try not to spend too much time adjusting things at this stage – the actual tone mapping takes place later when your 32-bit HDR image is converted to 16- or 8-bit color depth.

The dialog shown in figure 6-26 (setting Ⓓ) can also be used to determine whether Photoshop calculates a tonal response curve based on the loaded images, or whether it uses a preset response curve.* Tonal response curves (also called *Tonal Reproduction Curves,* or TRCs) describe the way the camera's sensor reacts to differing brightness values within the visible spectrum, and allow the source images to be linearized. If your source images are already stored in a linear form (as are RAW image files), response curve analysis is no longer necessary.

We recommend using the automatic setting, as shown in figure 6-26. If your images contain relatively neutral colors, automatic mode will function adequately. However, if an image is dominated by a single, strong color (when shooting a sunset, for example), automatic mode can deliver unsatisfactory results. To avoid this, we recommend saving and using the automatically generated response curve from a bracketing sequence with a broad dynamic range. You can then load this curve into your more problematic images later. You can also achieve a similar result if you shoot a separate image sequence of a neutral gray card, shot using different exposure values, and with the lens deliberately left out of focus. You can then merge this sequence into an HDR image using Photoshop, and save the curve generated automatically by the process for later use.

Unfortunately, stored response curves cannot (yet) be transferred between different HDR programs.

Returning to our HDR creation dialog box in figure 6-26: if you have chosen the *32 Bit/Channel* option, you will be able to use a number of further enhancements in Photoshop CS3 or CS4 (although, as mentioned, most 32-bit filters and tools are only available in the "Extended" versions of the program). Keep in mind that the image being displayed is the result of a provisional tone mapping process, making it difficult to make accurate visual judgments. You will here have to rely much more on the quoted tonal values and histogram displays for reliable image information.

One advantage of a 32-bit export format is that you won't have to rely solely on the Photoshop tone mapping tools. There are a number of other specialized Photoshop plug-ins which are compatible with 32-bit HDR images, such as *Enhancer* by Akvis [18], *Tone-Mapper* by HDRsoft [13] or *FDRCompresser* by Andreas Schömann [24]. (At the time of press, a

Photoshop CS3- or CS4-compatible version of FDRCompressor was not yet available.)

But for now, we will stick to Photoshop, as we will, at some point, have to reduce our 32-bit image to a 16- or 8-bit format for printing, reproduction at a photo lab, or display on the web.

Once the images have been merged, the program displays a preview HDR image similar to the one we have already seen. The limitations of computer monitor technology make it impossible to display the entire dynamic range of the actual HDR image. Our reproducible image will only become visible once we have tone-mapped it to an 8- or 16-bit format. We now need to save our original HDR image so that we can safely try out various different tone mappings. The saved HDRI file can then be converted and tone mapped using other tools*, such as Photomatix Pro or FDRTools.

** Other stand-alone programs.*

HDRI File Formats

When saving our HDR image using File ▸ Save As, we have a number of different formats at our disposal (see figure 6-29), ranging from standard Photoshop PSD to a specialized 32-bit TIFF format. Each of these formats has specific advantages and disadvantages. A detailed explanation would be beyond the scope of this book, but Christian Bloch's HDRI book [4] provides further, comprehensive information on the subject.

Figure 6-29: Photoshop (here CS3) offers a number of different HDR output formats.

Our choice is guided by two separate considerations: the size of the resulting image files and compatibility with the other programs we wish to use. Table 6-2 contains information related to these issues. There are also a number of HDRI formats that are not supported by Photoshop – for example, the very compact JPEG-based format. Table 6-2 does not include information on formats that are not supported by Photoshop.

Table 6-2: File Size and Compatibility of Various HDRI File Formats[1]

Format/Program	Compression	Photoshop	Photomatix	FDRTools	HDRI Viewer
Photoshop (.psd)	None	✔	–	–	Only Bridge
PSD-Large (.psb)	None	✔	–	–	Only Bridge
OpenEXR (.exr)	High (various)	✔	✔	✔	Many
Portable Bitmap (.pbm)	None	✔	–	–	Few
Radiance (.hdr)	Good	✔	✔	✔	Many
Portable Floating Map (.pfm)	None	✔	–	–	Few
32-Bit-TIFF (.tif)	Various compression types	✔	✔[2]	✔[2]	Several (depending on the format variant)

1 *This information is based on Photoshop CS3/CS4 Extended, Photomatix Pro Version 3.03, and FDRTools Advanced Version 2.2.*

2 *Not all variants of the TIFF formats supported by Photoshop are also supported by the other programs mentioned. We recommend using the "32 Bit (Float)" method with LZW Compression.*

103.0 MB	Photoshop (.psd)
103.0 MB	Photoshop (.psb)
24.2 MB	OpenEXR (.exr)
26.5 MB	Radiance (.hdr)
103.0 MB	Portable Bitmap (.pbm)
103.0 MB	32-Bit-TIFF, none (.tif)
82.4 MB	32-Bit-TIFF, LZW (.tif)
56.7 MB	32-Bit-TIFF, ZIP (.tif)

Figure 6-30: The selected format determines how large our HDRI file will be. The compression factor may, however, vary from image to image.

Figure 6-31: Photoshop offers a number of options when saving 32-bit HDR images to TIFF.

There are also a number of compression and compatibility options available when saving HDR images as TIFF files in Photoshop.

If you save your images in OpenEXR, Radiance, or Floating Point TIFF (also known as *32 Bit TIFF*) formats, the resulting files will be compatible with other HDR programs, whereas HDR-PSD, HDR-PSB, and HDR-PMB are supported almost exclusively by Photoshop. Radiance and OpenEXR are probably the most useful formats when it comes to striking a good compromise between compression and compatibility.

Should you choose to save your HDR image as an HDR TIFF file, you will be presented with a long, possibly confusing list of options (see figure 6-31). We use the 32-bit (Float) option with LZW compression, as experience has shown that this combination yields relatively compact files with good compatibility characteristics.

In order to differentiate more easily between HDR TIFF and normal TIFF files, we attach the additional "HDR" suffix to our file name – for example: *TowerBridge_HDR.tif.*

As well as the programs that generate HDR images, there are also a number of dedicated HDRI viewers available, covering a wide range of different HDR formats. The Adobe *Bridge* image browser, for example supports the same formats as Photoshop. Other free viewers include *Preview* (, the Mac OS X image viewer), *HDR View* (, [26]), *OpenEXR Viewer* (, [25]), *XnView* (, , [27]), and *IrfanView* (, [28]). Not all of these viewers, however, provide the same levels of speed and viewing quality.

Processing and Optimizing HDR Images

HDR images can be optimized using Photoshop, but not all of the typical Photoshop functions are available for this type of image. In Photoshop CS3, many adjustment layers and filters are not 32-bit compatible. The full repertoire of 32-bit functionality is only available in the "Extended" versions of Photoshop CS3 and CS4.*

Image cropping and rotation is still possible, as is use of the Stamp tool (for removing sensor dust flecks, for example). Although the (CS3/CS4 Extended) Lens Correction filter isn't available, several of the transforma-

** No new 32-bit features have been added in CS4.*

tion functions used for correcting perspective distortion are. In our example, we started by straightening the image (using the ✏ tool, and then Image ▸ Image Rotation ▸ Arbitrary). We then corrected the perspective distortion in the bridge's towers using the free transform tool (Edit ▸ Free Transform). The Hue/Saturation command is also available, and can help you correct specific image areas selectively. For example, by reducing the luminance of an otherwise flat-looking blue sky.

The middle section of figure 6-32 shows the range of adjustment layers that support 32-bit files. One of the most important functions is Exposure (see Photoshop Help for more information). However, if you make use of adjustment layers and want to retain the layer structure of your HDR image, you will have to save to PSD, PSB, or 32-bit TIFF, which will, in turn, destroy any compatibility with other HDRI programs. We therefore recommend that you merge your image into a single layer before exporting it for processing in other (non-Adobe) programs.

Sharpening is also an option, either using the USM filter (Filter ▸ Sharpen ▸ Unsharp Mask) or Filter ▸ Sharpen ▸ Smart Sharpen. As a rule, though, we only sharpen our images as a very last step – usually after the image has been scaled for output. We therefore very rarely sharpen HDR images. Uniform, minimal sharpening can be applied to all images in a sequence at an earlier stage using a RAW converter.

However, the problem of visual inspection of the largely inadequate preview image remains. This is especially relevant in the case of corrections to color and hue. As previously mentioned, the 32-Bit exposure slider in the bottom left corner of the preview window can help you gain a better overall impression of your image.

It is nevertheless worth the effort to correct your images in 32-bit mode, as you will then have the largest possible reserves of quality and color depth. As a result, many of the potential negative side effects of your corrections will not be visible in the final image. Image alignment, for example, is best performed directly on HDR images (provided it hasn't already been applied using Lightroom or Adobe Camera Raw). Adjustments made using ACR or Lightroom can be transferred to the other images in a sequence using the *Synchronize* command.[*]

The same is true for cropping. Cropping can reduce the amount of data in a file, which can, in turn speed up processing in general.

As already mentioned, the 32-bit exposure slider in the preview window (see figure 6-33) can greatly improve the rendering of your preview image, helping you to get a better overall impression of your HDR image. This tool is very important to the decision-making process when correcting HDR images. But remember, the slider setting only affects the preview image, not the image file itself.

Figure 6-32: Not all Photoshop corrections are available when working with 32-bit images.

** See the description in section 2.1 on page 16.*

Figure 6-33: The "32-bit Exposure" slider in the Photoshop preview window provides a simple way to adjust the lighting in a preview image without actually changing the image file. This helps when planning decisions about exposure corrections.

Tone Mapping HDR Images

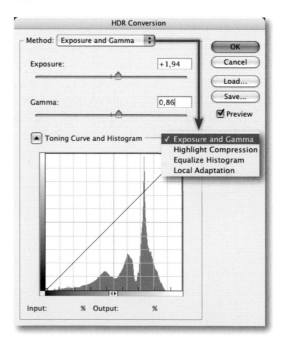

Figure 6-34: Converting from HDR to LDR reduces the dynamic range of an image to 8 or 16 bits per color channel. The details of the algorithms used to do this remain the secret of the software companies who make them.

The next important step is tone mapping. This process (illustrated in figure 6-34) reduces the increased dynamic range of your HDR image to that of a 16- or 8-bit LDR (*Low Dynamic Range*) image. The resulting LDR image can be reproduced more naturally and is supported by a much larger range of processing functions and filters. Printing is also currently only possible for 8-bit images, or (with some limitations) 16-bit images.

The dialog shown in figure 6-35 will appear when using Photoshop to convert an image from 32-bits to 16- or 8-bits. It can be accessed from the dialog box shown in figure 6-35 or through Image ▸ Mode ▸ 16 Bits/Channel. Here, you can select your tone mapping method, and the results of your selection are displayed directly in the preview window. There are four tone mapping methods available in Photoshop CS3 and CS4. These are called *Exposure and Gamma*, *Highlight Compression*, *Equalize Histogram*, and *Local Adaptation*.

Figure 6-35:
Photoshop CS3 provides four methods for tone mapping 32-bit images for 16- or 8-bit output. The expandable histogram view shows the range and distribution of tonal values within the selected image.

The best way to choose a method is to experiment and see which suits your personal taste and your type of images best. Not every method works equally well for every type of image.

We have already seen the *Exposure and Gamma* and *Highlight Compression* options in the 32-bit HDR tone mapping preview window. Figure 6-35 shows the *Exposure and Gamma* tone mapping dialog. The default settings will correspond to the settings you made in the white point preview. Our initial goal will be to find an *Exposure* value which clips highlights as little as possible. The degree of clipping you are prepared to accept will depend largely on the subject you are portraying.

The sliders react quite sensitively to movement, so we prefer to click on the numerical value box and use the arrow keys (\uparrow, \downarrow) to make changes. This allows for much greater precision. Holding down the \Uparrow key while changing the value will increase the size of the increment.

A flat-looking image is more easily corrected than an image with too much contrast – even if the high-contrast image is more immediately visually appealing. Figure 6-36 shows the results of using the described settings, which have reduced the tonal range in some of the cloud formations.

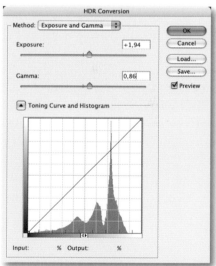

In any process involving sliders, remember to make changes slowly to allow Photoshop time to update the preview.

The *Highlight Compression* and *Equalize Histogram* methods do not have any dedicated sliders and therefore appear to be simple and less configurable. This isn't necessarily true, and *Highlight Compression* works well if you simply want to enhance highlight detail. However, images with broader dynamic range can turn out quite dark, as shown in figure 6-38.

The *Equalize Histogram* method shares some aspects of its methodology with the Photoshop Auto Tone command, which attempts to optimize contrast by stretching the portions of the histogram that contain more

Figure 6-36: The result of "Exposure and Gamma" tone mapping using the values shown above.

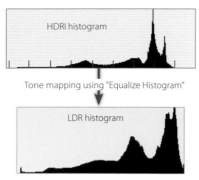

Figure 6-37: Histogram of the LDR-imge after applying "Equailze Histogram".

pixels. This can only be achieved at the expense of the portions of the histogram which contain less pixels, which are then correspondingly compressed. The result is an equalization of the tonal values and a compression to 16- or 8-bit dynamic range.

Images which have only moderate dynamic range can usually be effectively optimized using Photoshop. Figure 6-39 shows the results we attained using this process. It is obvious that here, the extreme shadow and highlight tones have been too highly compressed, creating a flat, somewhat lifeless image.

The three tone mapping processes we have described apply a global tone mapping which processes all pixels with the same tonal value uniformly, resulting in a new LDR image in which all these pixels also have the same (possibly changed) value.

Figure 6-38: The result of our tone mapping using the "Highlight Compression" method.

Figure 6-39: The result of our tone mapping using the "Equalize Histogram" method.

You can usually achieve better results if the algorithm you use takes neighboring pixels into account. This type of method is described as *localized tone mapping*.

Photoshop offers the *Local Adaptation* tone mapping method for exactly this purpose (see figure 6-40). This is the most versatile method. In addition to the *Radius* and *Threshold* sliders, you can also use a gradation curve to fine-tune your adjustments. (The gradation curve that can be displayed in the other tone mapping dialogs can be viewed but not edited.) We use this method to tone map most of our images. We begin by moving the black point to the far left, and the white point to the far right of the available tonal range using option Ⓐ *Toning Curve and Histogram* (see figure 6-40).

If you click on the brightest and darkest points of your image using your mouse, Photoshop will indicate the position of the equivalent luminance value on the gradation curve with a small circle icon. However, the histogram can be misleading, especially in the highlight areas, which are sometimes hard to identify, and thus easy to clip. Using the eyedropper

tool together with the info window (Window ▶ Info) and the circle marking in the *Local Adaptation* window (see figure 6-42) can often provide more accurate analysis of your image than a purely visual approach. Once the black and white points have been set, we can start experimenting with the *Radius* and *Threshold* sliders.

During this process, Photoshop generates a brightness map, which is never actually seen by the user, and which works similarly to a soft-focus filter. The *Radius* controls the size of the area around each pixel which is taken into account while tone mapping – setting the value to "1" will only include the four immediately neighboring pixels.

The *Threshold* value controls the degree of blur, or, more accurately, how great the difference in tonal values between neighboring pixels should be in order that they become grouped and equalized. In other words, the threshold value sets the maximum difference in brightness between neighboring zones within the image. The threshold value here has nothing to do with the sharpness of the image.

Figure 6-40: We begin the "Local Adaptation" process by setting the black and white points.

Figure 6-41: The "Local Adaptation" tone mapping method uses a virtual luminance mask.

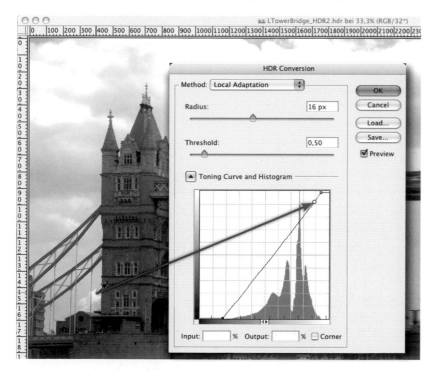

Figure 6-42:
Using the eyedropper tool to click in the image sets a marker at the corresponding luminance value in the HDR conversion histogram. This only works with the "Local Adaptation" method.

Figure 6-43: A halo effect can appear at high-contrast edges if the threshold and radius values are set too high.

A higher threshold value – strengthened by a large radius – can soon lead to halo effects appearing at high-contrast edges, as illustrated in figure 6-43.

Unlike the standard gradation curve, the *Local Adaptation* tone mapping method does not process all pixels of a certain luminance uniformly. Instead, it couples the effect of the gradation curve with that of the luminance mask, making a certain amount of experimentation necessary to find the right levels for your particular image. As with all other complex processes, it pays to vary the slider values slowly, so Photoshop has time to update the preview between changes.

Finally, we fine-tune the gradation curve, as illustrated in figure 6-44. This is a process that requires a good deal of trial and error while you search for the place on the curve where the tonal value of a specific image area lies.

Normally, Photoshop smooths the curve. You can, however, create corners in the curve by creating a new point and activating the *Corner* option (see Ⓐ in figure 6-44). This is not an effect you would want to apply to most normal gradation curves. As in the standard Photoshop Curves dialog, a curve point can be removed by selecting it and pressing delete.

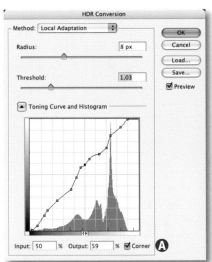

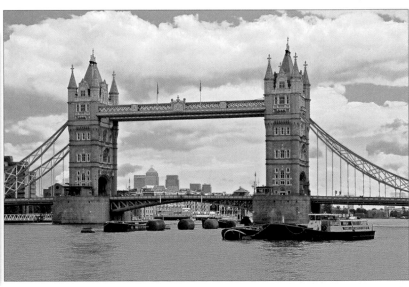

Figure 6-44: Our image after "Local Adaptation" tone mapping using the settings shown on the left. Unfortunately the sky is still a little bland, so we will optimize it later using Photoshop.

Figure 6-44 shows only one of many possible versions of our original HDR image. We used Photoshop to improve color rendering (using the Hue/Saturation command) and heightened contrast slightly before enhancing the details on the bridge structures using DOP Detail Extractor*. We protected the sky from unwanted filter effects using a layer mask during this process, and the result can be seen in figure 6-45.

** As explained in section 7.1 on page 204.*

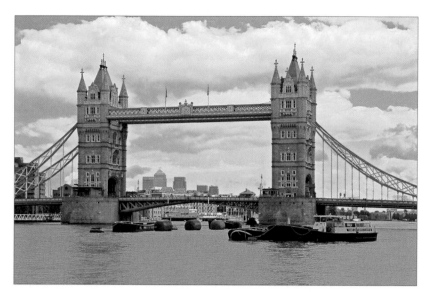

Figure 6-45:
Our sharpened image after post-processing with Photoshop.

Instead of converting an HDR image to LDR using Photoshop's tone mapping function, you may want to use a third party filter. HDRsoft's [13] *Tone Mapping* filter is a good choice. This plug-in delivered better results than Photoshop for the example shown here. The *Tone Mapping* plug-in's handling is very similar to that of the *Details Enhancer* in Photomatix Pro, so we decided not to describe it in detail here.

That concludes our discussion of Photoshop-based HDR techniques. Because of its superior loading and aligning functionality, we often use Photoshop to generate HDR images that we later process using either Photomatix Pro or FDRTools.

Optimizing HDRI Processes

Even today's faster computer systems require a considerable amount of time when processing HDR images, although Photoshop is definitely one of the faster programs available. For most of the processes described here, it is necessary to experiment with different combinations of settings. One way to save time is by trying out your ideas on scaled-down images before applying them to your full-sized image files.

→ Bear in mind that the effects the "Local Adaptation" settings have (especially the "Radius" setting), depend very much on the resolution of the original image.

It is possible to save and reload Photoshop settings for HDR and most other corrective processes. This can save a lot of time if you are processing multiple images. Photomatix Pro and FDRTools

Figure 6-46:
Photoshop (and other HDRI tools) allow you to save settings for later use.

have a similar function, which can be used in a special batch-processing mode.

6.6 HDR Imaging Using Photomatix Pro

HDRsoft's Photomatix Pro [13] is one of the best currently available HDRI tools. The program is available for Windows and Mac OS X (both Intel-based and PowerPC-based systems). It is powerful and fast (although not quite as fast as Photoshop) when processing complex HDRI algorithms. As with all HDRI tools, a fast processor and plenty of RAM are an advantage when working with Photomatix Pro.

HDRsoft also offers "Photomatix Basic" (for Windows) as a free download. The program can create and tone map HDR images but is less versatile than its Pro counterpart. We will therefore stick to describing Photomatix Pro in this book.

A Photoshop CS4-compatibel version will be available soon – quite possibly by the time this book is printed.

Photomatix Pro is a stand-alone program, and is complemented by its sister product, the *Tone Mapping* Photoshop plug-in. This can be used to tone map 16- and 32-bit HDR images using Photoshop CS2 or CS3.* Compatible source programs include PhotoAcute, FDRTools, and Photoshop. Even if the Pro version of the program is too expensive for you, you should at least give the Photoshop plug-in and the Basic version a try.

➜ *There is also a free Lightroom plug-in for Photomatix Pro, that allows you to directly export images form Lightroom 2 to Photomatix Pro.*

The stand-alone version of Photomatix Pro 3.1 supports a range of LDR input formats including JPEG, 8-, and 16-bit TIFF files, and a number of RAW formats (including DNG). If you want to adjust white balance, remove aberrations, crop, or otherwise preprocess your RAW files, please bear in mind that Photomatix cannot interpret corrections made using Adobe Camera Raw or Adobe Lightroom, as these changes are either embedded in the DNG file itself or reside in an XMP sidecar file. As is the case with PhotoAcute (and other RAW processing software), the program can only interpret the original RAW image data. We therefore recommend that you export your images to 16-bit TIFF before processing them with Photomatix Pro.

Personally, we are not particularly fond of the results that Photomatix Pro's *dcraw* RAW converter delivers. We almost always use 16-bit TIFF source files, but, as always, this type of decision is matter of taste and requires experimentation.

Figure 6-47: You can select your own personal preferences when using Photomatix Pro for the first time.

It is only occasionally advantageous to work with 8-bit JPEG files. If this is your input format, PhotoAcute is probably your best choice of software tool.

Photomatix Pro is augmented by a very good online help function, as well as an online tutorial and a comprehensive online user manual, which is useful both as an introduction and a working guide to the program.

As usual, you should navigate to the program's *Preferences dialog* when using it for the first time (see figure 6-47), where the available tabs and settings are generally self-explanatory. On the *RAWs* tab, we recommend setting *Demosaicing Quality* to High

(if you prefer to use RAW source files rather than TIFFs). Here, you can also set your preferred output color space (we use either *Adobe RGB* or *ProPhoto RGB*).

When starting Photomatix Pro, the first thing you will see is a toolbar containing workflow shortcuts (figure 6-48). Here, Photomatix Pro offers four basic options:

▸ Generate an HDR image from multiple source files
▸ Tone mapping for existing HDR images
▸ The *Exposure Blending* function (see page 170)
▸ The batch conversion of LDR images to HDR images and (optional) tone mapping of HDR images to LDR images

There is a *Tutorial* button included in the tool bar. Instead of using the tool-bar dialog, you can also open images in Photomatix Pro by simply dragging them to the program's icon, or by using the new Lightroom export plug-in to load images directly from Lightroom 2. If this option is selected in the program's preferences, Photomatix Pro opens a new dialog window, and asks which process should be applied to the freshly loaded images.

Figure 6-48: The Photomatix workflow shortcut panel offers four basic functions.

Generating HDR Images Using Photomatix Pro

For our example we will use three images of the Swiss Re building taken across the Thames River in London. Figure 6-49 shows the source images and their corresponding histograms.

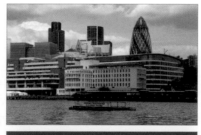

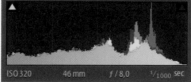

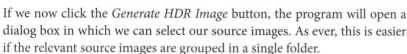

If we now click the *Generate HDR Image* button, the program will open a dialog box in which we can select our source images. As ever, this is easier if the relevant source images are grouped in a single folder.

In the next dialog box (see figure 6-50 and 6-51), we select our image processing options, including alignment type, ghosting removal options, and the type of gradation curve we wish to apply.

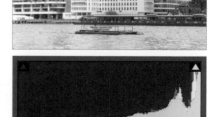

Figure 6-49: The three (16-bit TIFF) source files for our HDR image. The building that looks like a Fabergé egg is, in fact, the famous Swiss Re "Gherkin" building.

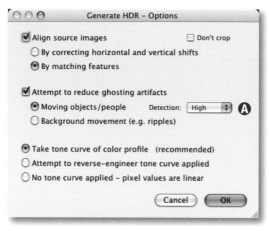

Figure 6-50: Setting the HDRI generation options in Photomatix Pro.

Figure 6-51: The additional options available for processing RAW files.

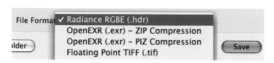

Figure 6-52: Photomatix Pro 3.0's HDR output formats.

We use the Align source images *By matching features* option for most of our images.

The settings for avoiding ghosting artifacts should be largely self-explanatory. Grass and leaves blowing in the wind and fast-moving clouds should be thought of as background movement. If your shot includes moving cars or people, you can use menu Ⓐ (see figure 6-50) to set a higher level of detection. Higher levels will lead to longer processing times and don't always improve the results.

With regard to the tone response curve (TRC) – already mentioned on page 152, and here called the *tone curve* – we recommend using the default setting, which generates a curve based on the color profile stored in your image.

If you are using RAW source files, you will be able to set the additional options shown in figure 6-51. These relate mostly to white balance and color space. As most cameras select and embed the correct white balance (color temperature) setting directly into the RAW image files – at least when shooting outdoors in daylight, as was the case in our example – you should set white balance *As Shot*.

Otherwise, you can select an appropriate color temperature from the list in the *White Balance* dropdown list. It is also possible to set white balance later during tone mapping – an option that gives us better visual control. We usually select the *ProPhoto RGB* option for *Color primaries* because it offers the largest color space. We will transform our image into a smaller color space later (after the tone mapping), once we have scaled our image for output. ProPhoto RGB is not a suitable color space for use with 8-bit images. 8-bit images (JPEGs, for example) are better processed using the Adobe RGB or sRGB color spaces.

Clicking the *OK* button in the dialog box shown in figure 6-50 (or 6-51) will then generate an HDR image and display it in a preview window (see figure 6-53). As with most HDR programs, the preview image is only provisionally tone mapped. The *HDR Viewer* window provides a better quality display, although it only displays a small detail of the entire image. The image displayed is based on the last mapping process that was applied by the program.

We now save our new HDR image using File ▸ Save HDR As. In addition to the Radiance and OpenEXR formats, Photomatix Pro offers the 32-bit floating point TIFF output format (see figure 6-52). This is equivalent to the Photoshop "32 Bit (Float)" format, but we generally use the Radiance format in order to preserve the greatest possible compatibility.

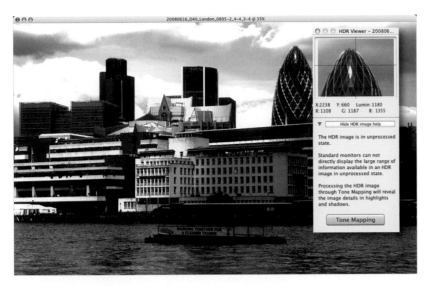

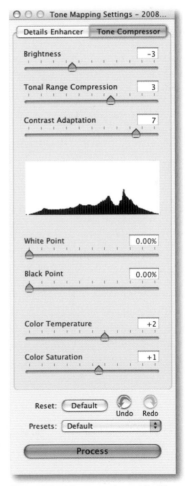

Figure 6-53:
The first preview version of our HDR image.
A better view can be seen in the detail
displayed in the HDR Viewer window.

We use Photomatix Pro for the actual tone mapping, because of its known strengths in this area. Click *Tone Mapping* – either in the workflow shortcut panel or the *HDR Viewer* window – to generate a preview version of the image. Another loupe window will now appear (see figure 6-57 on page 167). We then set the size of the preview image using the buttons at Ⓐ, and we can switch between the tone mapping preview and the original HDR image using the button Ⓑ.

If you're running Photomatix Pro on a slower computer, you can gain some speed by setting option Ⓒ to *Refresh loupe only*. This way, you won't have to wait for the entire preview window to be updated after every change.

Again, the preview only shows a provisional tone mapping, but this time the details are determined by the settings made in the mapping panel. Photomatix Pro offers two different tone mapping processes: *Details Enhancer* and *Tone Compressor*. Both have many more control options than Photoshop, making the Photomatix tone mapping process more versatile, but also more complex.

Tone Mapping Using "Tone Compressor"

The *Tone Compressor* global tone mapping method is similar to Photoshop's *Highlight Compression* process, but offers more settings, as can be seen in figure 6-54. Here, we start by setting the black and white points. Although we can also use the current panel to adjust *Color Temperature* and *Color Saturation*, the actual compression and tonal value adjustment are controlled using the *Tonal Range Compression* and *Contrast Adaptation* sliders.

Figure 6-54: *The control panel for "Tone*
Compressor" tone mapping.

These settings alone will produce a better result more quickly than we could have achieved using Photoshop (even using *Local Adaptation)*. Figure 6-67 shows our initial result, which could nevertheless do with some further optimization.

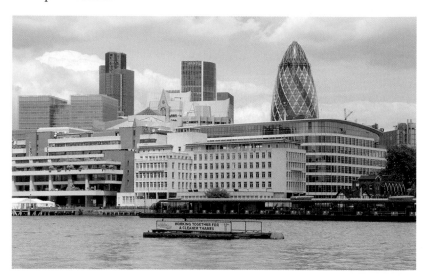

Figure 6-55:
Our image after tone mapping in
Photomatix Pro using "Tone Compressor".

Figure 6-56: Photomatix Pro's LDR output
formats.

But we are still viewing a preview. The actual resulting image can be different in a number of details. It is therefore necessary to convert our image to LDR in order to be able to view the actual results using either Photomatix Pro itself or Photoshop. Start the conversion from HDR to LDR by clicking the *Process* button in the tone mapping panel (see figure 6-54).

You can then save your image using File ▸ Save as (see figure 6-56). We always use *TIFF 16-bit* as our LDR export format.

Tone Mapping Using "Details Enhancer"

The real strength of Photomatix Pro lies in the *Details Enhancer* tone mapping option. Using this tone mapping method often gives us a typical HDRI "grunge" look for many images, an example of which can be seen in the preview window shown in figure 6-57.* The illustration next to it shows the *Details Enhancer* tone mapping control panel.

The *Details Enhancer* method applies a localized tone mapping similar to Photoshop's *Local adaptation*, also recognizable from the similarities between the controls offered by both processes.

We start by setting *Strength* to a moderate, mid-range value. The default value (70) is often a good starting point, but your results will be more natural-looking if you use values of 50 or less. We then need to make our basic settings for the black and white points, which we can fine-tune later if necessary – the higher the values we set, the more highlight and shadow detail will be clipped.

** If you want to avoid the "grunge" look, use moderate "Strength" values. Values below 50 will usually result in "normal" looking images.*

A good working gamma value is 1.0. Higher values will lead to higher-contrast images, while lower values will produce duller results – which is not always a bad thing. Here too, you will need to be patient while waiting for your preview image to refresh. It is all too easy to over-correct your image if you try to work too fast.

→ *It's much easier to increase contrast later using Photoshop. Artificially decreasing contrast is virtually impossible.*

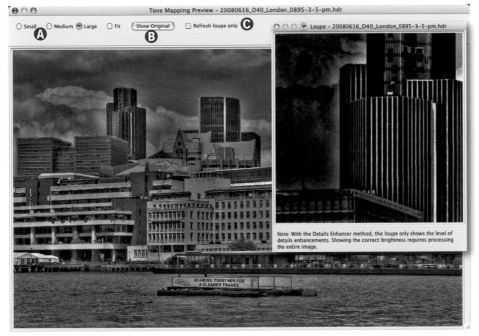
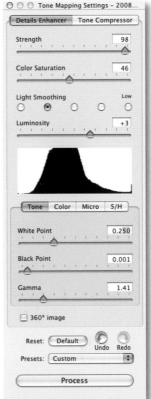

Figure 6-57: The preview of our first "Details Enhancer" tone mapping with the activated HDR Preview window. The look of the preview image results from a high "Strength" value.

Before we start adjusting the color saturation, we navigate to the *Color* tab to make any necessary adjustments to color temperature (see figure 6-58). We then adjust the color saturation for highlights and shadows. Minor increases can make your image much more vibrant, but overdoing things will quickly give your image an artificial and obtrusive look.

We then switch to the *Micro* tab (see figure 6-59) to adjust the micro-contrast (or *local contrast*) level. For more information regarding micro-contrast, see chapter 7. Increasing microcontrast at this stage can make your image appear more lively, and will cut out one of the post-processing steps you would otherwise have to go through later.

One disadvantage of setting microcontrast within Photomatix is that the changes you make are then applied to the entire image, whereas you can use Photoshop masks to enhance microcontrast selectively at the post-processing stage. If you are using high *Strength* values, you may

Figure 6-58: Detail of the Photomatix Pro tone mapping control panel, with the "Color" tab activated.

Figure 6-59:
The "Micro" tab in the Photomatix Pro tone mapping control panel.

Figure 6-60: Settings for shadows and highlights.

Figure 6-61:
In the left-hand image, the tonal values in the clouds are clipped. This was remedied in the image on the right using the "Highlights Smoothing" slider.

** The Gamma slider is located in the Tone tab (see figure 6-57 on page 167).*

also need to increase the level of *Micro-smoothing* to keep the microcontrast effect under control.

The last fine-tuning tab is the *S/H* (*Shadows* and *Highlights*) tab (see figure 6-60). You can set *Shadows Clipping* higher if you are prepared to trade some shadow detail for increased contrast and more shadow saturation. The best settings for your image will depend on the subject itself and your personal taste. Increasing the *Highlights Smoothing* and *Shadows Smoothing* values can help to avoid shadow and highlight clipping by adjusting the range of highlights or shadows that contrast enhancements are applied to. Moving the loupe over the corresponding sections of the image can help to determine the best values to use, as shown in figure 6-61.

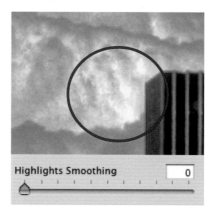 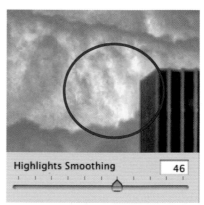

We can now go back to the main settings and once again adjust the *Strength* setting. The best value to use here is also largely a matter of taste. Many published HDR images are vilified for their exaggerated and sometimes unnatural look – which applies to some of the images in this book too. However, if you set a moderate *Strength* value (of 50 or less), you should be able to avoid the more pronounced effects that HDR processes can produce.

Another disadvantage of higher *Strength* values is the increased image noise they produce. We therefore recommend that you keep your *Strength* values low and that you instead shoot at low ISO speeds whenever possible.

We now move on to the *Color Saturation*, *Light Smoothing*, and *Luminosity* settings (see figure 6-62). As a final step, we may readjust the *Gamma* value.*

Setting the *Light Smoothing* control to a higher value can lead to more natural-looking results for high-contrast subjects and images with a generally higher dynamic range.

We have so far described the tone mapping steps you can take in a simple, sequential fashion. However, the reality of the situation is more complicated, as many of the settings described have knock-on effects on each other – which means that when you change one setting, the others react differently.

You should generally expect to have to make several attempts at a tone mapping before you find the optimum set-up. This will, however, help you to gain experience, and to develop your own style.

Once you have found a combination of settings that works well and might be suitable for other images as well, you can save it using the *Presets* dropdown menu Ⓐ (see figure 6-62). This will enable you to reuse the same values when processing similar images. This can save you a good deal of time, even if the resulting image still requires a little fine-tuning.

As before, the actual tone mapping is activated by clicking *Process* in the tone mapping control panel. The results will then be displayed in the preview window.

The second tone-mapped interpretation of our HDR image is shown in figure 6-62. For this version, we used an extremely high *Strength* value of 98 when applying the *Details Enhancer* tone mapping method. The result is a slightly surreal-looking image. This image has already been slightly sharpened in Photoshop.

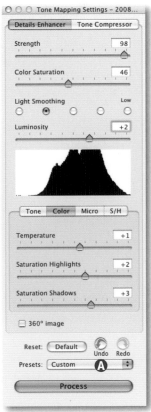

Figure 6-62: The second version of our image was created using the "Details Enhancer" tone mapping method and the settings shown on the left. The resulting image was then sharpened using Photoshop.

The emphasis here is definitely on the word "interpretation", because the program's numerous settings give you a very high level of flexibility in your work. The real indicator of a good result ought to be what the photographer saw or wanted to see while shooting. It is often necessary to shoot and process various versions of the same subject, depending on how the final image is to be used. The dramatic and almost oppressive sky in this image, for instance, is not suitable for every application.

Figure 6-63: Tone mapping settings used for the image in figure 6-62.

The Photomatix Pro "Exposure Blending" Function

Figure 6-64: The Photomatix workflow shortcuts panel offers functions other than just HDR creation.

A simple, but nonetheless useful HDR variant offered by Photomatix Pro is the *Exposure Blending* function. This function also merges source images with differing exposure settings, but outputs 8-bit or 16-bit LDR images. These images do not have to be reduced via tone mapping to a printable format. For this reason, this option is useful not only when shooting individual images for increased dynamic range, but also when shooting HDR series that you wish to stitch together in a panorama using normal stitching software.

This method also works well if you discover that no single image in a short bracketing sequence is exactly the image you envisioned. Instead of using the more complicated Photoshop blending/layer mask process described in section 6.3, simply use the Photomatix Pro's *Exposure Blending* function.

You should use the same basic criteria you use for shooting other HDR source images when shooting images for use with this function. We usually use a small bracketing increment or, if we are only aiming to reduce image noise, no bracketing at all. If this is the case, we use the *Average* tone mapping method.

Figure 6-66 shows our two source images, shot in Death Valley. The first image has captured the sunrise nicely, while the second shows better detail in the salt flat.

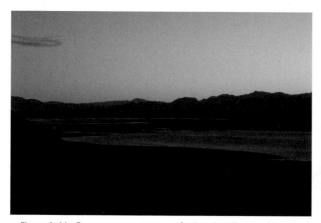
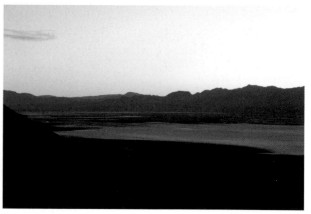

Figure 6-66: Our two source images of a Death Valley slat flat that we will use for "Exposure Blending". The shots were taken two f-stops apart.

Figure 6-65: When you drag files onto the Photomatix icon the program will ask what process it should undertake.

The process is started either by dragging your source images to the Photomatix Pro icon and selecting *Blend Exposures* (see figure 6-65), or by selecting the *Exposure Blending* workflow shortcut.

As with the HDR image creation process, the program will ask how the source images should be aligned. Even if you are working with a tripod, you should let the program align your images. In most cases (since Version 3), we use the *By matching features* option for image alignment.

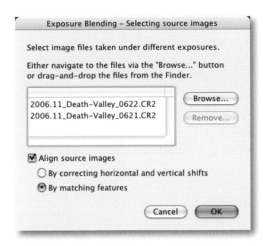

Figure 6-67:

Selecting the exposure blending source files and the alignment options.

Photomatix Pro will load the files and temporarily blend them for preview in the dialog box shown in Figure 6-68. You can then select your blending method from the options offered in section Ⓐ of the window.

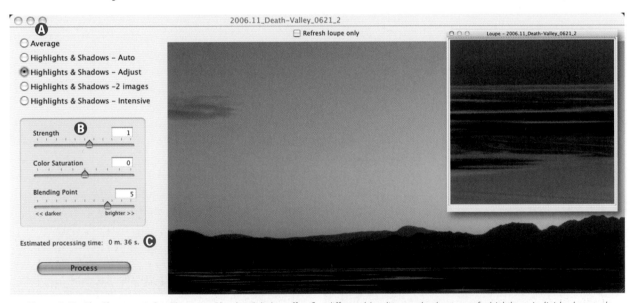

Figure 6-68: *The Photomatix Pro "Exposure Blending" dialog offers five different blending methods, some of which have individual control parameters, as shown here.*

The primary purpose of the *Average* method is to reduce noise. It is most useful for image sequences with largely similar exposure settings, or with small bracketing increments, or where the photographer had to use high ISO speed settings. Here, we are only interested in the resulting low-noise LDR image – a process we have seen before in PhotoAcute. It is equivalent to the PhotoAcute function: *Combined 1x output (no superresolution, noise reduction only)*. We don't generally use the *Highlights & Shadows – Auto* method, because it doesn't allow any manual user control.

Figure 6-69: The parameter settings for the "Highlights & Shadows – Intensive" exposure blending method.

Our two favorite methods are *Highlights & Shadows – Adjust* and *Highlights & Shadows – Intensive*. We nevertheless recommend that you experiment with all the other methods too.

Processing time can vary substantially – from a couple of seconds to nearly an hour, even using the same source files. The actual time required depends on the number of images being processed, their size, the selected blending method and, of course, how powerful your computer is. Photomatix Pro estimates the remaining processing time and displays it in the program window (ⓒ).

While the Photomatix Pro HDR function generates its HDR images from the various tonal value areas in the source images, the Exposure Blending function scans the source files to determine the source of every single pixel in the resulting image.

Our personal favorite method is *Highlights & Shadows – Adjust*, but we used *Highlights & Shadows – Intensive* for our example in figure 6-69. The *Strength* slider controls the microcontrast intensity. The *Color Saturation* control is self-explanatory. *Radius* defines the size of the area around each pixel from which the tonal values for the interpolation of the resulting image are taken. A larger radius will lead to longer processing times, but will reduce halo effects in high-contrast transitions and edges.

After experimenting, we selected the values shown in figure 6-69 and clicked the *Process* button. After nearly six minutes, the preview LDR image was displayed, which we then saved as a 16-bit TIFF file using File ▸ Save As. (The ⏷-Strg-S or ⏷-⏷-⌘-S keystroke is even faster.)

Keep in mind that if you use 8-bit source images (JPEGs, for example), your results will also be 8-bit.

Figure 6-70 shows our resulting image, which we cropped a little at the top. This version is a definite improvement on our source images. The salt flat and the sunrise mountain peaks are both more clearly defined.

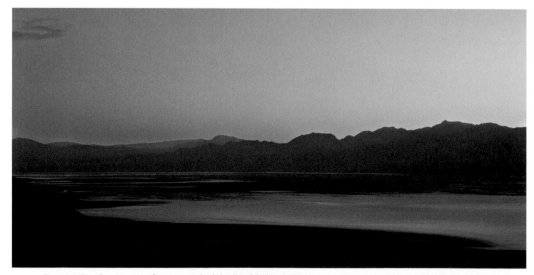

Figure 6-70: Our image after we applied the "Highlights & Shadows – Intensive" exposure blending method.

Batch Processing with Photomatix Pro

When you return from an extensive shoot with a lot of new HDR material, you may find the prospect of processing each of your sequences individually time-consuming and daunting. You will nevertheless want to get an overall impression of the sequences which warrant more work – which is where batch processing can be really useful. Using a batch process, you can run all of your image sequences through the processor using standard settings and then inspect the results for potential. You can then easily select your best images for manual processing

Photomatix has a useful, built-in batch processing function. The function does, however, rely on your source images being sorted according to specific criteria for it to work effectively. There are two ways of ensuring that this is the case:

➡ *The Photomatix online handbook contains a good description of batch processing, which is why we've limited ourselves to a schematic description here.*

A. All your sequences contain exactly the same number of images. In this case you can save all of your images in a single folder and set the Photomatix Pro to batch process a particular number of images per sequence.

B. You save each sequence in its own subfolder, all of which are then placed in a main folder.

If you shoot sequences of very differing natures, it can be an advantage to create several folder structures in order to keep your HDR and Exposure Blending sequences separate.

You also need to decide whether your results should be saved in the same folder as the source images, or to their own, separate folder.

If you shot RAW images but want your source files to be in a preprocessed TIFF format, you will first need to process your images using a RAW converter. The exact process differs from converter to converter, so you will need to refer to your software manual for details.

Once you've organized your source material, you can start batch processing either by clicking the *Batch Processing* workflow shortcut button or by navigating to the Automate ▸ Batch Processing menu item. The dialog box shown in figure 6-71 will now be displayed. The available batch processing settings are as follows:

Ⓐ Process type – HDR image generation or exposure blending. Here, you can select multiple processes, which then generate multiple results accordingly.

The HDR option allows you to specify both tone mapping methods (*Details Enhancer* and another using *Tone Compressor)*, which also produces multiple results if selected.

Ⓑ Which images should be processed and how the images in a series are organized.

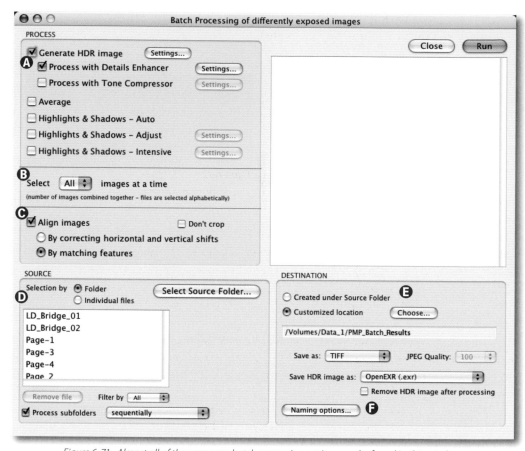

Figure 6-71: Almost all of the necessary batch processing settings can be found in this window.

Ⓒ The settings to be used for aligning your source images. As before, *By matching features* is the best choice in most cases.

Ⓓ The location of your source images, and the options for subfolder processing.

Ⓔ The location and output format for your results. You can also specify whether or not the intermediate HDR files should be deleted once processing is complete. As most of the important corrections take place at the tone mapping stage, it is advisable to keep the HDR images until you are satisfied with the final results.

Finally, you can use the dialog Ⓕ to set a naming convention for your output image files. Photomatix Pro automatically attaches the letters "HDR" to HDR file names and appends "Compressor" or "Enhancer" to LDR file names, depending on which tone mapping method was applied. The exposure blending process also names outputs files "Average", "Auto", "Adjust_Fusion", or "Intensive", according to the method applied. In our example, the settings shown in figure 6-72 produced a satisfac-

tory naming scheme, which allows us to easily refer back to our source images, regardless of where they are located.

Figure 6-72:
This dialog is used to set a naming convention for your output files.

You can define your HDR or tone mapping process more precisely using the *Settings* buttons Ⓐ (see also figure 6-71). These are the same settings that we already know from conventional HDR or tone mapping processes using Photomatix Pro, and you can use previously saved *Preset* configurations here too.

Click *Start* to begin batch processing. Batch processes are run separately from the rest of the program, which means you can also perform other, non-batch Photomatix operations while your batch process is in progress.

The progress of the individual steps involved in the batch process are detailed during processing in the window shown in figure 6-73.

Finally – or as soon as the first results are ready – you can view your finished LDR images and optimize tone mapping in the appropriate HDR images if necessary. This is easier to do if you save your HDR and LDR images in their own folder, separate from your source images.

Large batch processes can take time, but usually run without problems. We often use the Photomatix Pro batch process to make a "first draft" of our HDR images before further processing them using other HDRI tools.

Figure 6-73: The Photomatix Pro batch processing window details the individual steps as they are carried out, and keeps you informed of progress.

Single File Conversion

A simplified batch processing function for single files can be found in the Automate menu under Single File Conversion. This process tone maps single HDR images located in a specific source folder and saves them as LDR images in a target folder. Here too, the user can specify the type of tone mapping to apply and the output format.

6.7 HDRI Using FDRTools

➔ *FDRTools can be found at www.fdrtools.com. Help, discussion, and suggestions for further development of the program can be found in the FDRTools forum at: www.fdrtools.com/smf/index.php*

➔ *The 2.2 version of FDRTools Advanced also includes a focus stacking function (using the xDOF method). We will not be discussing this function at this point.*

You may ask yourself why we are presenting yet another HDRI tool, having already discussed Photoshop, PhotoAcute, and the very powerful Photomatix. The answer is, quite simply, because FDRTools offers functions which are not available in the other programs mentioned. Specifically, FDRTools offers increased control over the HDRI merging process, powerful tone mapping, and specialized viewing tools. FDRTools also includes a somewhat cumbersome, but nevertheless useful project management tool. Acquiring this software and learning how to use it effectively will definitely improve your general image processing skills.

FDRTools' functionality is comparable to that of Photomatix, and *FDRTools Advanced* has the distinct advantage of costing about half as much as Photomatix Pro. The free FDRTools Basic version also has more functionality than the free version of Photomatix. The program's generally poor performance is constantly improving from release to release. FDRTools is available for both Windows and Mac OS X, and comes with detailed tool tips which make it fairly simple to use. Tool Tips are small text windows which temporarily display information about a particular tool if you move the mouse over the buttons or menus associated with it. According to the program's creator, Andreas Schömann, a comprehensive user manual is currently being written.

We will use the abbreviations FDRT for *FDRTools* and FDRTA for *FDRTools Advanced* in the discussion that follows. FDRTA supports a number of source formats, including JPEG and TIFF, as well as the standard RAW and PNG formats. The program uses the Open Source *dcraw* RAW converter, and therefore recognizes all formats currently supported by *dcraw*. FDRTA can also be used to tone map HDR images created using other tools to LDR. As mentioned earlier in table 6-2 on page 153, other supported HDRI formats include 32-bit TIFF, OpenEXR, and Radiance.

The program's user interface will probably appear somewhat unusal at first, as it consists of a number of different windows, not all of which are relevant to each phase of the process.

The program has two basic states – project management and image processing. When you start FDRTools, the first thing you see is the project management window (see figure 6-74). The project window will displays your current projects and can be used to start a new, empty project.

In order to work effectively with FDRTools, it's necessary to grasp the concept of projects. A *project* in FDRTools is a set of data which encompasses references to the images involved and the operations and settings which are to be applied to them. The stored settings include alignment information, tone mapping type, and HDR merge type. Because FDRTA offers a number of different HDR merge process types as well as a number of different tone mapping methods, it

Figure 6-74: The FDRTools Start/Project window.

remembers the last settings made for each type, whether they be the default settings or user-defined.

All of this information is saved in a project file and can be modified at any time, as long as you don't explicitly delete the project. This type of project-based workflow plays no part in the Photoshop philosophy, and only exists in rudimentary form in Photomatix. This approach bears testimony to the fact that HDR images are often processed more than once, and that experimentation and subsequent reinterpretation are integral parts of the HDRI realm.

Project-based processing also allows you to revisit older image projects using newer versions of the program as they become available. Projects are saved in a designated directory, which you can select in the dialog that opens when you click the *Project* icon in the main window (see figure 6-75). In this same dialog box, you can also set a directory containing templates. Templates are, in principle, normal projects whose settings can be transferred to other projects.

As with any other program, you want to customize FDR-Tools to suit your personal preferences once you have become familiar with it. The *Preferences* settings can be found under FDRTools ▸ Preferences. The online handbook will tell you more about the possibilities of each individual setting.

We now create a project by clicking the 🛠 icon in the main window. The *Open Images* dialog box appears, which we use to select our source files. A filter shows us which files types can be selected, and these include LDR formats and HDR images created using FDRT or other tools. For images created using FDRT, you can also open your previously created images by opening the corresponding project. In our example, we will concentrate on creating an HDR image from a series of standard LDR image files.

The selected images appear as thumbnails in the project window. Give your project a suitable name by overwriting the *Untitled* label (see figure 6-76). At this stage, you can still add or remove images at any time. Click on the plus icon to navigate back to the *Open Images* dialog, or select an image and click the minus icon to remove it.

To delete an entire project, click anywhere in the project window (which is then highlighted) and click the *Delete* button in the tool bar above.

If you select an image and open its corresponding Exif window (Window ▸ Exif Info), you will be confronted with an unusually extensive Exif info listing. This can be useful when analyzing an image, and can be hidden if you don't currently need it.

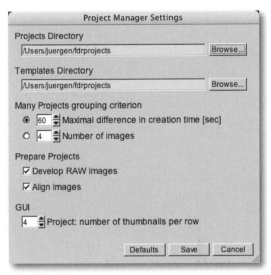

Figure 6-75: The FDRTA project management settings. These include the location of the project directory.

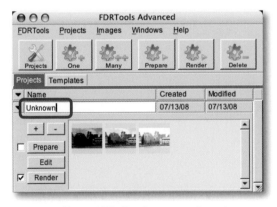

Figure 6-76: Naming your project.

Figure 6-77:

The FDRTA Exif window. This illustration shows only a small portion of the data which is actually displayed in this window.

We recommend activating the progress window (in the Windows menu). This gives information (see figure 6-78) about the progress of currently active processes, and sometimes provides an explanation as to why FDRTools isn't reacting as quickly as it might.

Figure 6-78:

The progress window can also be a useful source of information.

The next step is to prepare your images – click the *Prepare* button in the project frame. If the project is already selected (i.e., highlighted), you can you can use the toolbar *Prepare* button, which also allows you to simultaneously prepare multiple projects using a batch processing function. Batch processing can take a while (see page 192 for more information), but once you've started the process, you can continue using your other tools while FDRTools is working.

The *Prepare* command prepares the images in a project for faster processing. Preparation itself can take some time, but makes the subsequent processes much quicker.

Once prepared, the individual images in a project are ready to be rendered. This means the actual HDRI generation process, or, in the case of existing HDR images, tone mapping.

Clicking *Edit* switches into a new view (see figures 6-79 and 6-80). The program window now shows a set of icons in the toolbar which reflect the workflow sequence of HDRI creation: *Open, Alignment, HDRI Creation, Tone Mapping,* and finally, *Save.* The yellow "lights" in the buttons signalize which phase of the process is currently active.

Figure 6-79:

The FDRTA toolbar icons, shown in "Edit" mode. The buttons follow (from left to right) a typical HDRI workflow.

We have already described how to open images, and FDRTA usually aligns your images automatically during the preparation stage. The adjustments the program has made to alignment are listed next to each image in the program window. If this is not the case, click on *Align* in the *Tripod* tab. The *Tripod* alignment method is new since the release of the 2.0 version of the program, and other methods (such as *Handheld*) are expected to be introduced in the near future.

You can correct image alignment manually (using the slider or by entering a value) if necessary, and you can check alignment in the Preview window, which displays images at a ratio of 1:1. The program aligns images relative to the first image in a project.

You can also temporarily deactivate images displayed in the list by clicking the *Include* button on or off. The green "light" in the button indicates that the image in question will be included in the pending process.

One weakness in the current 2.2 (beta) version of FDRTA is its inability to align images using an object-based method. Photomatix Pro now includes this capability, which is a significant advantage.

Figure 6-80: The basic window in its alignment mode.

The HDRI Creation Phase

In contrast to the other tools we have discussed, FDRTA allows us to control the HDRI generation process manually using a whole range of parameters. Clicking the *HDRI Creation* button displays the four merging methods available in the current (2.2) version of the program:

- ▸ Average
- ▸ Separation
- ▸ Creative
- ▸ xDOF

The tool tips explain each process comprehensively. Each process uses its own algorithm, and uses sliders and curves to control the weighting of the individual source tones in the resulting HDR image. The histograms also help the user to visualize the merging process.

Figure 6-81: The "HDRI Creation" phase with the "Average" method activated.

At this point, we already have a very broad range of parameters and settings at our disposal, and it is simply not practical to discuss them all individually. The best way to find out which parameters affect your images is to try them out.

But don't panic! The program's default settings usually produce perfectly acceptable results, and you will only usually need to intervene for difficult source material, or if you are not satisfied with the results the program produces.

Average

The *Average* method creates an HDR image based on the averaged tonal values of the pixels in the source images. The related curves (see 6-82) determine the exact weighting for each image. Various preset curves can be selected using menu Ⓐ, and you can make additional adjustments to these curves using your mouse, the same way as you can adjust a Photoshop Curve.

Figure 6-82: HDRI creation settings for the "Average" method.

The *Average* method requires additional image exposure information to function correctly, and it extracts this information from the file's Exif data (if the source files are in RAW format). If no Exif data is available, the program attempts its own image analysis. You can switch between the two data extraction modes using the *Auto/Exif* button. The *Color+* option produces strong color rendering in non-RAW images. This method can also be effectively used to generate reduced-noise LDR images from a series of source images taken with similar exposures.

Some of the merging methods provide a *WB Ref.* button in the image list, which allows you to select the image which should be used as a reference point for automatic white balancing. FDRTA will then attempt to adjust white balance for the remaining images accordingly.

Separation

When using the *Separation* merging method, each individual HDR pixel is taken from only one of the source images. Each image covers a particular area of tonal values (or *intensity*) which is determined by the program. Where two areas of differing intensity overlap, the program blends these pixels to provide a smooth transition. The slider beneath each histogram allows you to adjust the intensity, and with it the tonal values for each individual source image.

Separation also allows you a degree of control over moving objects via the *Anchor* option. Once you have selected an anchor image, FDRTA will search through all of your source images to identify any moving objects, replacing these portions of the image with corresponding pixels from the anchor image.

You can only select one anchor image, and this image should be one with regular, average exposure. The *Anchor* option was not yet fully implemented in our beta version of the program, which is why some of the buttons in the illustration are grayed out.

If you click *Separation Mask* (Ⓑ) and then one of the histograms, the non-red portion of the image then displayed in the navigator image or the tone-mapped preview window shows exactly which parts of that source image have been used in the resulting HDR image.

Figure 6-83: The settings for the "Separation" method.

Creative

As the name suggests, this is the most flexible merging method offered by FDRT. According to the program's author, it can be used to merge images with very different, almost arbitrary exposures (for instance, an object lit using multiple light sources) to create interesting and unexpected effects.

The three options *Intensity, Saturation,* and *Contrast* (Ⓐ) allow you to set the selection criteria for the pixels which are to be taken from each source image. The menus Ⓑ and Ⓒ allow you to select differing curve weighting presets and to switch between *Linear* and *Logarithmic* layer scaling.

It is also possible to edit the individual curves manually using the mouse, allowing you to determine precisely the weighting the merging process gives to each individual image area.

This method is very powerful, but also makes it relatively easy to get bogged down when experimenting with different combinations of settings. We therefore only recommend using this method if you are not satisfied with the results you achieve using other methods.

While the preview window helps to preserve an overview of the changes you are making, the program is still entirely lacking a *Save* feature for saving combinations of settings for later use, either for the same image or for other projects.

Figure 6-84: The "Creative" merging method offers the most individual settings.

xDOF

The unusual name of this merging method stands for *Extended Depth of Field*, and was introduced in the 2.2 version of the program. It is still under development (or was, in the beta version we were using at the time of writing). The process aims to create an HDR image while simultaneously applying a focus-stacking technique. Focus stacking merges source images with varying depths of field into a single image with extended depth of field. The technique is described extensively in chapter 4.

Because FDRTA's alignment and scaling processes are not yet as advanced as those of Helicon Focus or MergeZM, we will not go into any further detail here.

Should you over-adjust a parameter – which can happen at any stage of the process – a click on the *Defaults* button resets the program to its standard settings. The button is available at the *Alignment, HDRI Creation,* and *Tone Mapping* stages.

FDRTA updates the preview image and the HDRI histogram for every change you make to a process or parameter, helping you to judge the effects of your changes accurately. FDRTA also displays the total dynamic range and maximum and minimum luminance

Figure 6-85: The "xDOF" merging method is new and has, as yet, no user-controllable parameters.

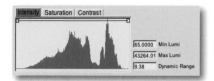

Figure 6-86: FDRTA updates the histogram and luminance values after every change of settings.

values for each image, making it especially easy to determine which method delivers the best dynamic range for your particular subject (see figure 6-86).

Now we have described the program in theory, we will apply it to two very different image sequences. The first was shot hand-held in London, and you will recognize it from earlier examples. The original images were straightened and cropped using a RAW converter before being saved as the 16-bit TIFF source files shown in Figure 6-87.

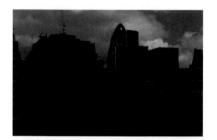
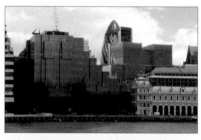
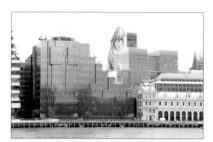

Figure 6-87: The source images were shot bracketed and hand-held. They were straightened using a RAW converter and saved as 16-bit TIFF files.

* We haven't included the xDOF method here because it was still under development at the time of writing.

Figure 6-88 shows the results of applying the three different HDRI Creation methods available in FDRTA* displayed in the *Tone Mapped Image* tab of the navigator window. These HDR variations were all generated using the default program parameters and without any additional optimization. We used the image generated by the *Separation* method as the base image for our tone mapping experiments, although the provisional nature of the preview image makes it difficult to judge exactly which image displays the best characteristics.

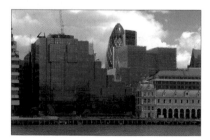
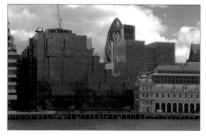
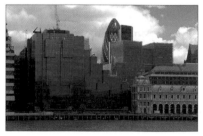

Figure 6-88: HDRI results (tone mapped preview images in the program's navigator window) as generated from the sequence shown above. Left: "Average", Center: "Separation", Right: "Creative".

Our second sequence (see figure 6-89) was shot at sunrise in Page, Utah. We worked with relatively long exposure times, as the exposure data shows. We used a tripod, a cable-release, and mirror lock-up. Due to the long exposure

times, the smoke coming out of the power plant's smokestacks has become a moving object. The middle exposure shows how low the actual dynamic range in the scene was, and we could have worked with smaller bracketing steps to help minimize noise.

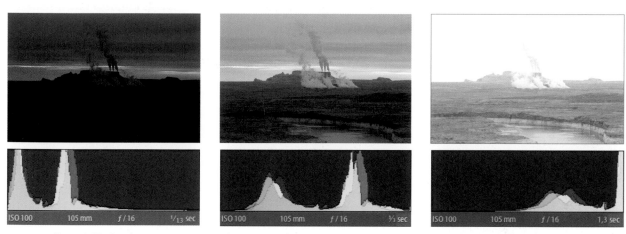

Figure 6-89: Our three source images with exposure information and histograms. The bracketing increment was set to 2.0 EV.

Figure 6-91 shows the results of the first three HDRI creation runs, again using the default parameters and the *Tone Mapped Image* tab in the navigator window. The *Separation* result was our favorite, and we used this as the base image for our tone mapping.

There are some coverage problems where the smoke rises past the bright cloud (figure 6-90), and some clone stamp work is necessary before printing. The next version of FDRTA, with its *Anchor* function will help to alleviate such problems. The function was not yet implemented in our beta version, so there were no real recognizable differences between the results produced by all three merging methods.

Figure 6-90: Some artifacts are visible where the smoke and the sun cross paths.

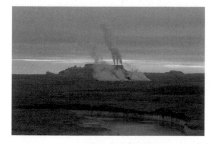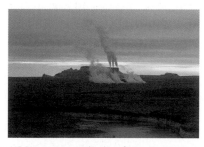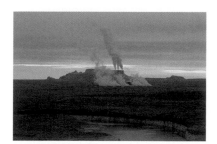

Figure 6-91: The results of three HDRI merging methods. Left: "Average", Center: "Separation", Right: "Creative".

Saving Your HDR Files

It is never a disadvantage to save each HDR image along the way. Click the *HDR Image Inspector* tab in the navigator window to make sure the HDR image is active, then click the *Save* button in the main window to open the *Save* dialog.

Figure 6-92: The HDR output formats offered by FDRTA Version 2.2.

** Obviously, some format parameters (e.g., the white point) are interpreted differently by various programs.*

FDRTA offers multiple HDR formats, most of which also offer several compression options. You will need to experiment a little to find out which combinations are supported by the other HDR tools you use. We recommend using Radiance or OpenEXR formats. If you can only see LDR formats in the Save dialog box, this a sign that the LDR image rather than the HDR image is active in the preview window.

You can also set the program to automatically open your HDR image in another program. This can be useful if you plan to crop, align, or otherwise correct your image (using Photoshop, for example) before you start the tone mapping process. You will, however, have to explicitly open your image in an FDRTools project in order to proceed with tone mapping. We have noticed that Photoshop displays HDR files (or, at least, OpenEXR files) much brighter than FDRTools does. We had to move the Photoshop 32-bit white point slider almost all the way to the left in order to be able to see any detail in an HDR file which appeared quite dark in FDRTools.*

The FDRTools "Tone Mapping" Phase

Evaluating the HDR preview image accurately can be difficult, as the image displayed is only provisionally tone-mapped. Once you have (optionally) saved your HDR image, you can start the most interesting phase of the process by clicking the *Tone Mapping* button. The *HDR Image Inspector* and *Tone Mapped Image* navigator windows were certainly useful for aligning our source images and generating the HDR images. For this part of the process, they are absolutely indispensable.

FDRTA offers three tone mapping methods: *Simplex*, *Receptor*, and *Compressor*. While the *Simplex* and *Receptor* methods apply a global tone mapping to your image, the *Compressor* method performs an additional local tonal value adjustment which takes the pixels surrounding each individual pixel into account. This makes *Compressor* the most processor-intensive and time-consuming of the three methods.

In order to view your results more precisely, you can use the Window menu to activate the *Preview* option, which displays an image detail at 100% magnification in a separate window. You can move the location of the detail within the preview window either by using the scroll bars in the window itself, or by moving the detail frame in the navigator window using your mouse. The preview window can be enlarged, but making it too big can cause the program's performance to suffer.

"Simplex" Tone Mapping

Figure 6-93: Simplex tone mapping is a global method, offering only one slider and a gradation curve for manipulation.

This method is designed to give the user quick and effective results. It offers two adjustable parameters: the *Saturation* slider and the gradation curve, which we use to set the white and black points. As with the Photoshop *Local Adaptation* method and the Photomatix processing dialog, there is no warning in the preview image to alert us to potential clipping situations. This

makes it all too easy to clip highlight detail without the difference being visible in the histogram display – a problem which also applies to the *Receptor* and *Compressor* tone mapping methods.* The *Simplex* method uses a basis gradation curve and the editable curve superimposed upon it to reduce the dynamic range of your HDR image to that of an LDR image.

Figures 6-94 and 6-95 show two images created using the *Simplex* tone mapping method and their related settings. We were not satisfied with either result, but nor were we with the results Photoshop produced. These kinds of results are always strongly influenced by the subject matter and the distribution of tonal values that was originally captured.

** It would be useful if the program had a feature (like the one in the Photoshop Curves dialog), which displays potential clipping if you hold down the* Alt *or* ⌥ *key while making adjustments.*

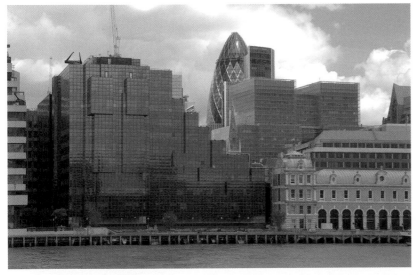

Figure 6-94: Simplex tone mapping clipped some of the detail in the clouds and darkened the shadows too much.

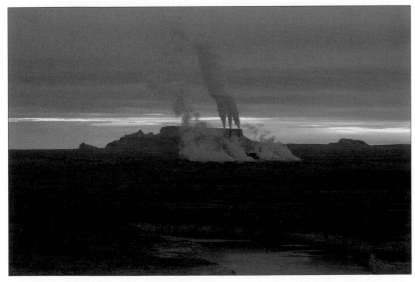

Figure 6-95: A Simplex-generated LDR image of the Page Power Station created using the settings shown on the right.

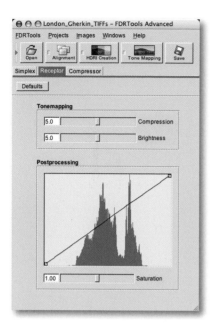

Figure 6-96: The "Receptor" process primarily compresses highlights.

"Receptor" Tone Mapping

According to the program's author, this method is one of the most advanced global tone mapping techniques available. Like the *Simplex* method, *Receptor* is based on the use of a gradation curves base, but is much more adaptable, and functions in a similar way to the Photoshop *Highlight Compression* tone mapping method. Receptor compresses the highlights more strongly than the shadows, which preserves highlight detail – a desired effect in most cases. Unlike the Photoshop solution, Receptor offers *Compression*, *Brightness*, and *Saturation* adjustment sliders, as well as the gradation curve, which you can use to adjust the black and white points. The *Compression* slider controls the degree to which highlight areas are compressed and is applied almost exclusively to the upper third of the tonal range. *Brightness*, too, applies mainly to the higher tonal values and has almost no effect on image shadows. *Saturation* functions the same way as it does for the *Simplex* method.

Figures 6-97 and 6-98 show the results of tone mapping our two images using the *Receptor* method. The London image didn't turn out very well, and we were not able to portray the clouds satisfactorily – and they were the reason we shot our HDRI bracketing sequence in the first place. Increasing compression didn't help, and the mid-tones are simply bland. We had to use very steep curves in the upper and lower ranges to achieve a reasonable degree of detail in the highlights and shadows.

Our image of the Page power station, however, turned out better, due to the generally narrower tonal range involved. *Receptor* hasn't produced perfect results, but they are certainly acceptable.

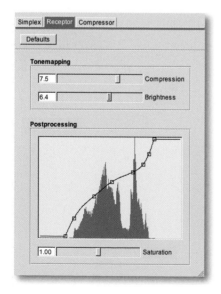

Figure 6-97: Our Thames view in London, tone-mapped using the "Receptor" method.

 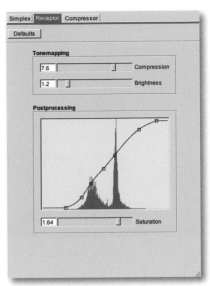

Figure 6-98: An LDR version of our power station image, created using the "Receptor" tone mapping method.

We really wanted more texture in the clouds, but we were not able to achieve this using *Receptor*, in spite of several attempts at fine-tuning the curve. We were also not able to brighten the darker foreground sections of the image. One solution to this problem would be to go back to the HDRI generation stage and use *Creative* mode to reduce the weighting for the darker areas in the final, composite image. *Creative* mode offers a great deal of flexibility, but using it effectively can be time-consuming.

"Compressor" Tone Mapping

This method is the FDRTA equivalent to Photoshop's *Local Adaptation* and Photomatix Pro's *Details Enhancer*, and produces the best results of all. The process uses a gradation curve combined with a step that analyzes each pixel and the tonal values surrounding it individually. This process uses large amounts of processing power and is therefore also slower than FDRT's other methods.

Here too, the *Compression* settings determines the degree to which source image ares are compressed in the final image, but this time only in relation to the immediate surroundings of each pixel. *Contrast* governs microcontrast, with moderate values producing softer transitions between image areas. Higher contrast values result in a typical, high-contrast HDR look. The *Smoothing* slider functions as a kind of microcontrast multiplier – the higher the value, the softer and more natural the transitions and edges in your image will be. An image with a high dynamic range will always need more smoothing than one with a moderate dynamic range.

The *360° Panorama* option is only useful for ensuring a smooth merge where the ends of a 360° panorama sequence meet.

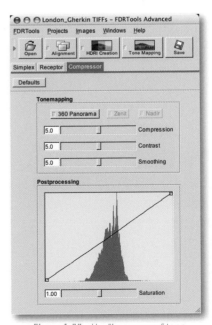

Figure 6-99: The "Compressor" tone mapping process.

Figure 6-100: To avoid clipping, make sure you preserve low peaks to the left and the right of the histogram.

Figure 6-101 shows our London image, tone-mapped using the *Compressor* method. This method's multiple settings make it possible to produce more individual image interpretations than the other methods allow. This version of our image looks much better, and we have finally managed to preserve our cloud detail, but at the price of a strong, high-contrast HDRI look. A glance at the histogram confirms that all of the shadow detail and – more importantly – highlight detail has remained intact (see figure 6-100).

For lifeless-looking images, we have found it effective to leave a little leeway at the left and right ends of the histogram, and then to save the image to 16-bit TIFF before optimizing the colors (and setting black and white points) using a Photoshop Levels adjustment layer. Alternative scaling methods would make optimizing the curve easier, but this feature is unfortunately not (yet) available in FDRTools.

One way to avoid a heavy HDRI look would be to create two image versions: one with pronounced cloud detail, and the other with generally less contrast, especially in and around the buildings. We could then use Photoshop layers and layer masks to blend these two images together using the techniques we have already discussed. As with most images that result from merging processes, the image shown in figure 6-101 could benefit from a little post-processing.

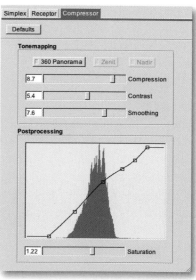

Figure 6-101: The result of using "Compressor" tone mapping and the settings shown to the right. This time, cloud detail was not clipped, but the mid-tones have turned out somewhat flat, and can benefit from some post-processing.

We post-processed our image using Photoshop, and the Layers palette in figure 6-99 shows the steps we took. We duplicated the background layer and used Filter ▸ Distort ▸ Lens Correction to soften pin-cushion distortion and to correct slight horizontal and vertical perspective anomalies. We then used the *Levels* command on a second layer to increase global contrast and brighten the image slightly, which also increased color saturation a little.

Our master image is now finished, and can be saved and used as a basis for further fine-tuning experiments.

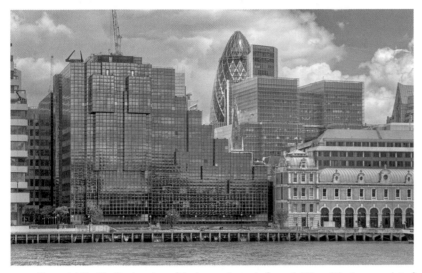

Figure 6-102: The final version of the image shown in figure 6-101 and the Layers palette for the post-processing steps we applied to it.

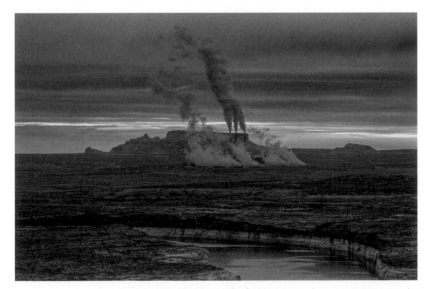

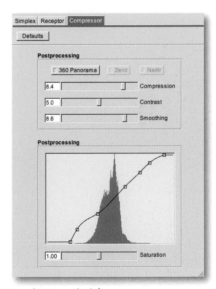

Figure 6-103: The LDR result of a "Compressor" tone mapping using the settings shown on the left.

Figure 6-103 shows our power station image after tone mapping using the *Compressor* method. The image was taken at sunrise but doesn't really contain the colors we remember. We therefore tried to adjust white balance using the eyedropper tool from the FDRTools toolbox (figure 6-104). To do this, we select the eyedropper tool and click in an area of the image that should appear neutral gray once the correction is done – this is technique you may already be familiar with from your work with the Photoshop *Levels* command. You can always adjust your settings using the *Red Balance* and *Blue Balance* sliders if your first attempt doesn't deliver the desired result.

Figure 6-104:
You can adjust the white balance of an HDR image using the eyedropper tool and the corresponding sliders.

Figure 6-105:
Our image after white balance correction
using the eyedropper tool.

(The White Balance dropdown menu allows you to return to the original image settings by selecting *As Shot*.) In our example, we used the whitish-gray smoke as our neutral reference point and increased saturation to achieve the result seen in figure 6-105. The image is now much more reminiscent of a sunrise, and even shows a slightly brighter foreground. The image has a slightly surreal look, but this is an accurate representation of the early-morning scene we photographed, with a light mist still covering the valley floor.

Saving LDR Images

Figure 6-106: FDRTools can save to a
number of different LDR formats.

The final step of the FDRTools workflow is to save the resulting tone-mapped image in to an LDR format. As before, click the *Save* button, and make sure you are saving the LDR and not the HDR image. If you want to continue editing your image using Photoshop (or any other similar program), we recommend that you save your image to the usual 16-bit TIFF format. The color space you choose for your LDR files also plays a role, but this setting can only be changed using the *Output Device* option in the *Devices* tab of the program's *Preferences* dialog. We would prefer to see this setting as part of the *Save* dialog.

We opened our image directly in Photoshop from the FDRTools *Save* dialog. We adjusted the levels and then increased the contrast in the sky using the Curves adjustment layer. We also used the Clone Stamp tool (🖳) to remove some spots that resulted from flecks of dust on the camera's sensor, and we also removed the artifacts we mentioned previously that occurred where the rising smoke passes through the sunlight. Finally, we sharpened our image a little (using Filter ▸ Sharpen ▸ Smart Sharpen), using a layer mask to protect the sky. The final result can be seen in figure 6-107.

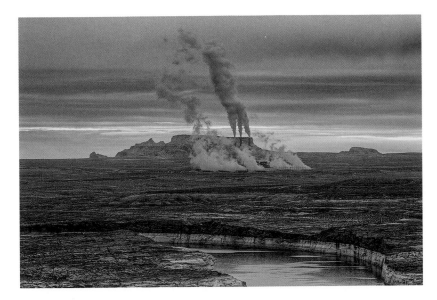

Figure 6-107:
The image after Photoshop post-processing.

Some Observations

None of these three tone mapping processes can correlate the luminance of a particular pixel in the HDR image to a point on the gradation curve – a feature already included in Photoshop. Including this functionality would make editing a gradation curve in FDRTools simpler and much more intuitive.

After we initially spent a lot of time and effort attempting to perfect the gradation curve, we have now adopted a different workflow. Now, we simply fix an approximate gradation curve, leaving some processing leeway at the right and left ends of the histogram. We then save the LDR file to 16-bit TIFF and open the resulting file directly in Photoshop, where we use a Levels adjustment layer and a Curves adjustment layer to optimize our tonal values. As of Photoshop CS3, both of these adjustments are now handled by the Curves dialog – the histogram is now displayed in the curves window.

Back to the Project Window

You can switch easily between the program's individual functions by clicking on the appropriate buttons in the toolbar. You can save the current state of your work at any time using the menu sequence Project ▶ Save active. We highly recommend saving your work at regular intervals, just in case the program crashes. This has happened to us on a number of occasions.[*] If you want to return to the main program window, you can use the menu sequence Project ▶ Close active at any time.

** We were using a beta version of the program.*

Figure 6-110: FDRT's major project management settings.

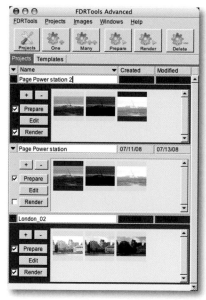

Figure 6-108: The project window with two projects selected.

Batch Processing

FDRTools Advanced offers a function that is very similar to traditional batch processing. This multi-project functionality works as follows:

1. Start by defining the source images for your projects and selecting a template. To create a new template, activate the *Templates* tab, create a new project and make the settings you want to use. These settings will now also be available as a template.

 If you use the *Many* button (rather than the *One* button), you can select the criteria the program uses to group your source images into projects – the maximum allowable time lapse between shots, or the number of images per project, for instance. You can select these criteria in the dialog displayed (see figure 6-110) when you click the *Projects* button .

2. Now select the project you wish to process, and check the appropriate processing options (*Prepare* or *Render*).

3. Click the *Prepare* button at the top of the project window, and confirm the security query that follows. All of your projects will now be prepared for fast processing.

4. The final step (it is also possible to simply skip step 3) is to click the *Render* button in the toolbar. This will start the conversion of all of your projects into HDR images, which will then be converted into LDR images and saved in the project folder. You can select which HDR and LDR formats you want to use using the *Output Device* tab in the FDRTools ▸ Preferences menu.

As a final procedure, you should check the quality of your LDR images. If any corrections are necessary, open the project in question, activate *Edit* mode, and correct your HDR image either by changing the parameters for the HDRI creation process or for the *Tone Mapping* process.

FDRTools – Our Conclusions

We had some difficulty getting used to the program's concepts and work-flow, and some of its processes are definitely slower than their counterparts in some of the other tools we have discussed. As with most complex tools, the longer you work with FDRTools, the more you will become familiar with the many possibilities it offers, and the faster you will be able to achieve satisfactory results. FDRTools is under constant development, and represents great value when you consider the price, the performance and features it offers.

We have only discussed a relatively narrow spectrum of the possibilities and variations the program offers. You can often combine the various functions to achieve better results – you could, for instance, merge a series

of high-noise night shots to a low-noise LDR image using the *Average* HDR process, and then merge the resulting LDR image with a lower-noise shot of the same scene taken using a shorter shutter speed. The end result would then be an HDR image with significantly reduced noise. Noise is one of the problems inherent in HDR images, and local mapping techniques often visibly increase the intensity of the problem.

One work-around for the program's somewhat weak alignment functionality is to load your source images into Photoshop as a stack, align and crop them, and then export them as separate LDR images. As of the CS3 version, Photoshop can export aligned images from individual layers into separate files using the menu sequence: File ▸Scripts ▸Export Layers to Files.

You can then load these into FDRTools in the normal fashion and convert them to HDR using an appropriate method before carrying out any tone mapping. PhotoAcute also offers alignment and re-export functionality.

➔ *Here, I have a request for the program's author: It would be great to be able to really close a project (so that it disappears from the project list) and then use a "Load" function to reload it into the list later.*

6.8 Which Program Is the "Right" One?

As you might expect, the answer to this question is: "That depends." Each of the programs and each method we have looked at has its own particular advantages and disadvantages.

The Photoshop blending technique appears at first to be quite sparse, but can be used in a number of ways. It also uses only limited resources, and doesn't require any additional programs or plug-ins. The process does not require any specialized tone mapping, and it is often impossible to detect that the results have been processed using DRI techniques. The downside of this simple Photoshop approach (which is quite separate from the Photoshop HDRI function) is that, without complex post-processing, the results can only ever encompass a relatively narrow dynamic range.

In most cases, the same applies to PhotoAcute. One advantage of using PhotoAcute is that you can combine multiple corrections and apply them all in one processing run. You can, for example, simultaneously correct lens distortions (if a PhotoAcute profile for your camera/lens combination is available), reduce noise, and increase image resolution (provided multiple source images are available). Tone mapping parameters in PhotoAcute are not user-variable, and the program's output is limited to 8-bit or 16-bit images, rather than the 32-bit output that Photoshop, FDRTools, or Photomatix Pro can produce.

Photomatix is a faster program with multiple capabilities and customizable tone mapping. The 3.02 version (which we used) was the best program for handling moving objects, but nevertheless encountered problems with objects that moved significantly during the shooting sequence. The download version isn't exactly cheap (at around $90*), but we think it

* *The sticker price of the Photoshop tone mapping plug-in is about $65 (including taxes).*

represents good value for the money. The program enjoys rapid development, and is updated several times a year.

FDRTools is traditionally very slow, and while it's true that none of these programs can generate HDR images very quickly, FDRTools always had the additional problem of also reacting slowly during the loading and preparation phases. As of version 2.2 (we tested the beta version), this situation has improved a great deal.

Photomatix's great strength lies in the very powerful *Details Enhancer* tone mapper and its batch processing functionality. FDRTools Advanced, on the other hand, offers great flexibility with regard to user control for the HDRI generation process. The *Compressor* tone mapping method also produces great results, although it tends also to produce unwanted noise. The FDRTools project management system is very useful, and the program's greatest weakness lies in its limited ability to align images.

The grunge look which dominates many HDRI images raises questions of personal taste. We find that extreme-looking images quickly become boring. We prefer images which have a more natural appearance, even if this means accepting an image with less local contrast. At the end of the day, the processing steps that are applied to an image remain the photographer's own decision.

You will also often find that one combination of HDR settings will work well for one particular image area (to accentuate a dramatic sky, for example), while a different combination works better for another part of the image. In such situations, we recommend that you create multiple copies of your image and use the Photoshop layer and layer mask techniques we have described to merge individually optimized sections of the image for a complete result.

Gaining Experience through Experimentation

All of the programs and processes we have described require a great deal of experimentation on the part of the user. You will need to develop a feel for the tone mapping process that works best for certain types of images, and – especially for images with a high dynamic range – you will need to develop your own style, which can also be heavily influenced by the subject matter and the type of output you want to produce.

We have mentioned many times that it is important to save intermediate results. HDRI generation is an inherently unstable process, and all four programs mentioned are subject to hangs or crashes. FDRTools crashed a little more often than the other programs, but we attribute this to our test version being a beta version.

Moving objects are the bane of HDRI images, and although each of the programs we have mentioned offers its own solution to the problem, none of them are really ideal. The best way to avoid this particular problem is to take care while shooting – avoid excessive wind, too much traffic, or too many pedestrians, and try to keep your sequences short.

Figure 6-109 shows an image that we created using three source photos shot using a tripod and a remote release. The exposure times ranged from 0.1 to 0.6 seconds,* and the ISO speed was set to 400. We used FDRTools Advanced and the *Creative* method to create the merged HDR image. Finally, we used *Compressor for* tone mapping to get the LDR version. We also slightly cropped the final image and applied DOP Detail Extractor to enhance the local contrast.

** Equal to an increment of 1.5 EV.*

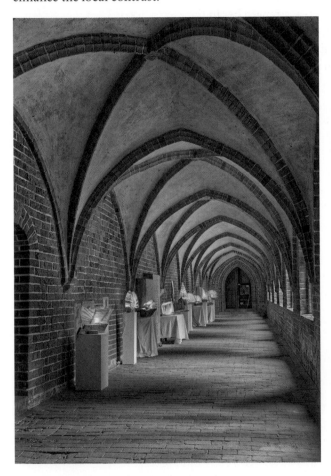

Figure 6-109:
Our three source images and the resulting image, created using FDRTools 2.2, "Creative" for HDR generation and "Compressor" for tone mapping.

Post-Processing

Most LDR images that are created from HDR images will require some post-processing. As we have mentioned a number of times, there are certain optimization steps that cannot be applied directly to HDR images. These steps will include fine-tuning, cropping, and sharpening. If you use RAW files as HDRI source images, you may also need to correct aberrations in your LDR images. You will often find that small errors are difficult to detect in the HDR preview and therefore have to be corrected in the resulting LDR image. We have mentioned many post-processing ideas in the course of this chapter – you will find further, in-depth discussion on the subject in chapter 7.

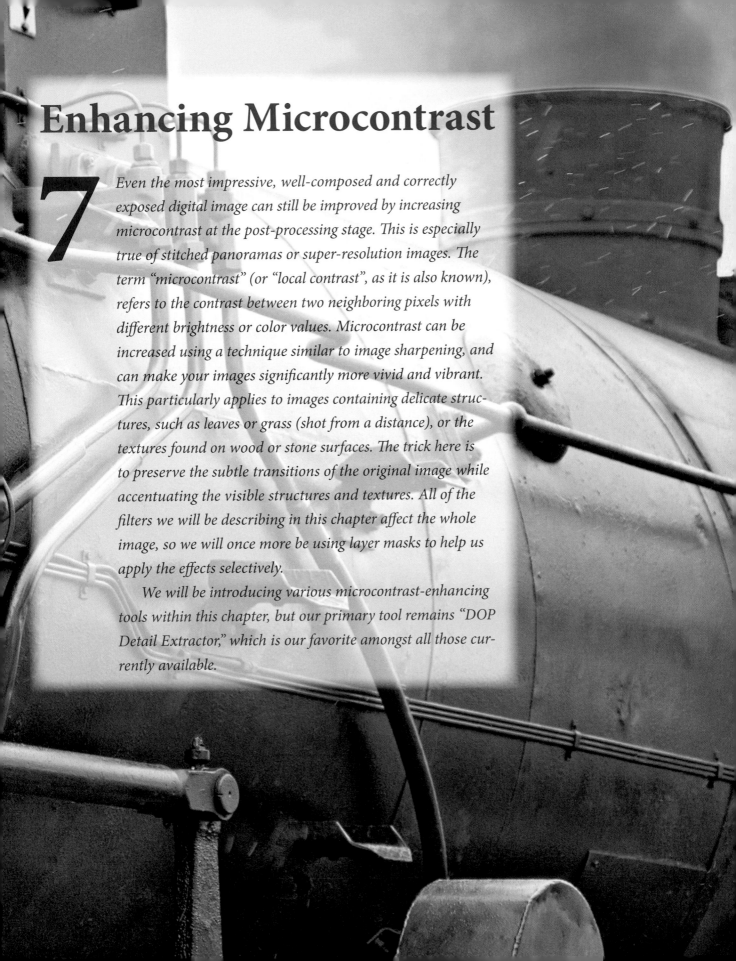

Enhancing Microcontrast

7

Even the most impressive, well-composed and correctly exposed digital image can still be improved by increasing microcontrast at the post-processing stage. This is especially true of stitched panoramas or super-resolution images. The term "microcontrast" (or "local contrast", as it is also known), refers to the contrast between two neighboring pixels with different brightness or color values. Microcontrast can be increased using a technique similar to image sharpening, and can make your images significantly more vivid and vibrant. This particularly applies to images containing delicate structures, such as leaves or grass (shot from a distance), or the textures found on wood or stone surfaces. The trick here is to preserve the subtle transitions of the original image while accentuating the visible structures and textures. All of the filters we will be describing in this chapter affect the whole image, so we will once more be using layer masks to help us apply the effects selectively.

We will be introducing various microcontrast-enhancing tools within this chapter, but our primary tool remains "DOP Detail Extractor," which is our favorite amongst all those currently available.

7.1 Tools for Enhancing Microcontrast

➜ *Because increasing microcontrast has a similar effect to sharpening, you should only sharpen your images slightly (if at all) before making any enhancements. This will also help to avoid unwanted halo effects.*

Tools used to enhance microcontrast are currently "in", and are included in almost all newer versions of good image processors. These include Adobe Photoshop Lightroom and Adobe Camera RAW (use the *Clarity* slider in the *Presence* area of the basic panel), Apple Aperture, LightZone, Capture NX, as well as a number of other programs.

Enhancing Microcontrast Using a USM Filter or a RAW Converter

Figure 7-1: You can use Photoshop's USM filter for local contrast enhancement.

A proven but less well-known way to enhance microcontrast is using the Photoshop Unsharp Mask (USM) filter, which can be found under Filter ▸ Sharpen ▸ Unsharp Mask. If you apply the filter using a low amount setting (20–40%) and a large radius (40–80 pixels) you will achieve an acceptable effect. If you use this method, it is important to adjust the radius setting according to the resolution of the image you are manipulating.

The degree to which you increase microcontrast will depend on the nature of your image, and it will often be necessary to mask the parts of your image that you don't want to change. Increasing microcontrast in a portrait could, for instance, increase the presence of the subject's hair, but also make skin blemishes more obvious. The solution to such dilemmas lies in the use of layer masks.

Our experience has shown that just about all digital images can be improved by a slight increase in microcontrast.

Some newer RAW converters also include direct microcontrast adjustment for RAW image files.

Figure 7-2: Detail of a church door. The version on the left has not been sharpened. On the right is the result of applying the Photoshop USM filter with a strength setting of 37 and the radius set to 52.

Apple Aperture, Adobe Photoshop Lightroom, and Adobe Camera Raw (ACR) all have appropriate tools built in. We often use the Lightroom or Adobe Camera Raw *Clarity* slider set to a value between 20 and 50 if we are not planning to use any other microcontrast enhancement tools. The *Clarity* slider can be found in the *Presence* section of the *Develop* toolbar (see figure 7-3). Try not to overdo the mixture of RAW sharpening and *Clarity*, especially if you plan to increase contrast later at the post-processing stage.

Figure 7-3: The Adobe Lightroom Clarity slider also increases microcontrast.

Figure 7-4: The same detail of a church door. The version on the left is displayed in Lightroom using no additional enhancements. The version on the right has the "Clarity" slider set to 100%.

Specialized tone mapping tools are, however, more effective with regard to fine-tuning and selective application. It is, for example, all too easy to increase general image noise while enhancing shadow detail. A high-quality tool will also allow you to increase detail by using a dedicated slider to darken your highlights selectively.

Increasing Microcontrast Using Akvis Enhancer

Enhancer is a relatively new Photoshop plug-in created by the Akvis company [18], and is available for both Windows and Mac OS X. It is a very effective tool, but uses a lot of processing power and main memory, so you will need to be patient when using it.*

Once installed, the plug-in is available under Filters ▸ Akvis. As is the case with most filters, Enhancer can only be applied to a regular pixel layer. If you have carried out corrections to an image using adjustment layers, you will need to construct an intermediate pixel layer that merges all the individual layers below into a single layer (still retaining the layers below). If the uppermost layer is already a regular layer, you can simply duplicate it by dragging the layer entry to the 🔲 icon in your Layers palette.

An enhancement run for a 10-megapixel (16-bit) image can take as long as 20 or 30 seconds, even when using a fast computer.

Working with Merged Layers

→ *This process of creating combined layers can also be used for many other filters. We also use it before applying the USM or other sharpening filters.*

Since Photoshop CS2, it has been possible to merge the active layer and all other visible layers below it into a new, regular layer by selecting the uppermost layer and pressing ⬆-Ctrl-Alt-E (Mac: ⬆-⌘-⌥-E). Filters can then be applied to the resulting layer – in this case, we will use *Enhancer*.

This technique is also helpful when using other filters (such as the Photoshop USM filter), and we will go into more detail on the subject later. In older Photoshop versions (i.e., pre-CS2), two keystrokes are necessary to perform the same function: first use ⬆-Ctrl-N (Mac: ⬆-⌘-N) to create a new layer and then hold down the Alt- or ⌥ key while clicking Layers ▸ Merge Visible to merge the layers into a new one.

Enhancer Dialog

Once started, the Enhancer window can take a minute or two to appear. Once it does, we suggest you drag it to its maximum size on your monitor, in order to help you best judge the results of the filter's effects before you apply them to the actual image file.

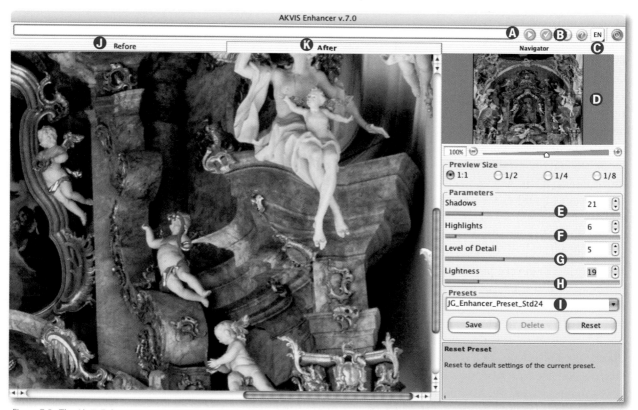

Figure 7-5: The Akvis Enhancer program window. Menu © changes the interface language (for Mac). Windows users have to use the Setup dialog.

The program's sliders function as follows:

Shadows determines to what degree local contrast should be increased in the darker areas of the image. Values that are too high (generally above 35) can cause additional image noise.

Highlights determines to what degree local contrast should be increased in the brighter areas of the image. This value should also be set carefully to between about 3 and 15 to avoid generating additional noise.

Level of Detail is the master strength parameter. Although you can set it between 0 and 15, most images will look best at settings between 5 and 10.

Lightness allows you to increase shadow brightness while leaving mid-tones and highlights generally unchanged. This parameter is similar to the Photoshop Shadows/Highlights command. You need to be cautious here too, as even the default setting (50) brightens shadows considerably. We have reduced our standard value to 19, which brightens images slightly but not overpoweringly.

These parameters can be adjusted either by moving the appropriate slider, by entering values directly in the value box, or by clicking the increase/decrease arrows next to the individual values.

In order to conserve processing power, Enhancer does not make real-time changes to the preview image. You have to click Ⓐ to generate a new preview of any changes you have made. Because even preview generation demands a lot of processor power, the plug-in shows a progress bar in the window's title bar during processing. Once processing is complete, the preview window is updated, and you can toggle (with a slight delay) between your original and the processed version of your image using Before and After (see figure 7-5 Ⓙ and Ⓚ).

To best judge the effects of your enhancement you should (as when sharpening) select the 1:1 preview image size and use the detail navigator to focus on the relevant part of your image.

You can save your current settings using Save. Once saved, configurations can be loaded from the Presets dropdown menu Ⓘ. Reset does exactly what it says, and resets Enhancer to its default values.

Instead of the usual *OK* button, you apply your effect by clicking Ⓥ (figure 7-6 Ⓑ). Ⓧ cancels the process and returns you to the active layer without making any changes.

Enhancer's functionality overlaps to a degree with that of *Detail Extractor*, which we will describe next. Both plug-ins have their uses, and we recommend both (if, of course, you are willing to pay for two licenses). Occasionally, we combine the two plug-ins, using moderate *Enhancer* values for a first run, and using *Detail Extractor* for a fine-tuning second run

Figure 7-6: Enhancer adjustment parameters.

over our image. Detail Extractor has dedicated options for avoiding sharpening artifacts and tone clipping – effects that higher Enhancer values cannot avoid producing.

Because both filters lack a real-time preview feature, it may take a number of attempts to find the optimum settings for your image. This is another reason why you should apply Enhancer corrections to a duplicate experimental layer before committing them to your actual image file.

If you are using a separate layer, and if the Enhancer effect is too strong at first, you can decrease the strength of the Enhancer effect simply by reducing the opacity of your adjustment layer. (See also the description of this technique on page 208.)

Once you have established the right values for your image, you should save them as a preset with an appropriate name.

Here is an example of the effects you can achieve using Enhancer. The left-hand image of a rose bloom is fairly well exposed, but the detail in the individual petals is almost entirely lost (see figure 7-7).

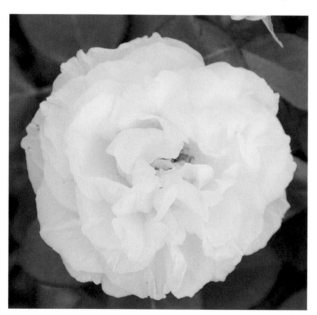

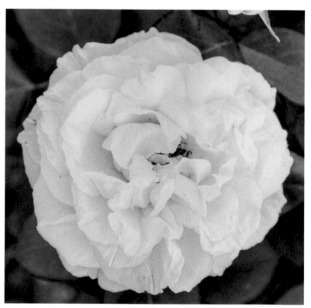

Figure 7-7: The source image: The individual petals are hardly discernible.

Figure 7-8: The image after processing using the settings shown in figure 7-9 and "Normal" blending mode.

Because the highlights are more important than the rest of the image, we adjust the *Highlights* value to 26 and reduce the standard *Lightness* value to 19, as we do not wish to increase the overall brightness of our image.

Because the initial result (generated with blending mode set to *Normal*) has drained too much color from the center of the rose (see figure 7-8), we switch to *Luminosity* blending mode. The new result is shown in figure 7-10. The contrast becomes even more pronounced if we use the *Multiply*

blending mode. This approach, however, makes the image generally too dark, so we also apply a Levels correction to brighten things up a little (see figure 7-12).

The fact that the leaves in the background remain dark doesn't bother us, especially as this reduces the noise effects that Enhancer produces in the green elements of the image. Figure 7-11 shows the final result.

Figure 7-9:
The Enhancer settings used for the image shown in figure 7-8.

The noise which became visible in figures 7-8 and 7-10 demonstrates a potential problem with this type of correction – namely, noise which is present but barely visible in the source image can become much more pronounced during processing.

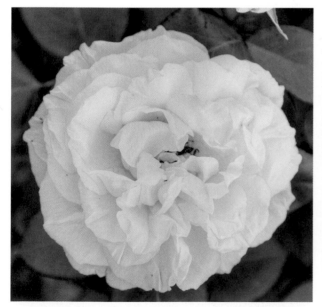

Figure 7-10: Our rose processed in "Luminance" blending mode. The yellow in the center of the bloom is accentuated.

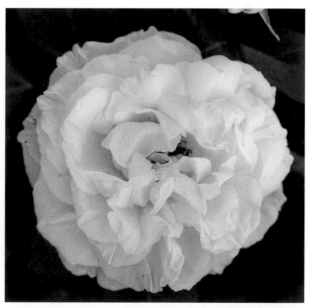

Figure 7-11: Here, we used "Multiply" blending mode, and the entire image was brightened using an adjustment layer.

For Enhancer, we can try to combat this effect by setting the *Lightness* value to below 50%.

However, as the example above shows, this is not always sufficient. Other solutions include either reducing noise before enhancing microcontrast, or simply shooting the source images using a lower ISO speed setting – which is, of course, not always possible in low light or for moving subjects.

Figure 7-12: The Enhancer effect is increased by using "Multiply" blending mode.

Enhancing Microcontrast Using DOP Detail Extractor

Uwe Steinmueller, co-author and occasional lead author of many Rocky Nook books, is well-known through his *Outbackphoto* web site (www. outbackphoto.com). He is also the creator of the *DOP Detail Extractor*[*] Photoshop plug-in – a tool for enhancing microcontrast. Once installed, the plug-in is made available under File ▸ Scripts.

Unlike the other filters we've worked with, *Detail Extractor* doesn't require you to create a duplicate layer manually – the plug-in automatically creates one and gives it a name which describes exactly the settings used for the layer in question (see figure 7-14). This new layer also appears automatically in the Layers palette. By default, Detail Extractor sets blending mode to *Luminosity* (see figure 7-19), in order to prevent image saturation from being affected by the process.

* *DOP stands for "Digital Outback Photo", the name of Uwe Steinmueller's company.*

Figure 7-13: The DOP Detail Extractor main dialog.

The plug-in's individual parameter settings function as follows:

Detail Size controls the pixel radius within which differences in contrast should be accentuated. You should set this value according to your subject, image resolution, and the size of your planned display format. Higher image resolution will require a slightly higher *Detail Size* value. The default value is 15 for images with a resolution of 8–12 megapixels. Smaller values will result in softer images, which can be an advantage for images with finely structured transitions (as long as you are not working with additional layer masks).

Boost is best described as a kind of "strength" setting, and should be used sparingly (usually with values between zero and 15). Any value above 50 will produce *grunging*-type effects. (There is an example of this type of effect later in the chapter.)

Extra Detail strengthens local contrast enhancement, especially in shadow areas.

Protect sets the degree to which shadows and highlights will be protected from being clipped. The default value is 50 – lower values increase detail contrast, but can lead to blocked-out shadows and washed-out highlights. Values above 50 protect shadows and highlights but can reduce highlight and shadow microcontrast.

Figure 7-14: DOP Detail Extractor automatically generates a new layer, where it places the processing results. The settings used are reflected in the name of the new layer.

Detail+ increases the detail enhancement, and has a similar effect to additional sharpening.

Clipping- Activating this option limits the dynamic range to between 10 and 245 (referring to the RGB luminance scale of 0–255). The

image will no longer include any absolute white or black pixels, and will appear to have slightly less contrast when viewed on a monitor. This effect helps in printing situations, as dark areas (with values below 10) usually block out, and it is generally not possible to differentiate visually between tonal values above 245 and virgin white paper (255) anyway.

The filter's default settings produce low-key but recognizable effects. In most images, the differences remain subtle.

Once you have found settings which work for your type of image and suit your personal style, you can save them by clicking Save, and recall them through the Settings menu. This is important, because Detail Extractor doesn't have a preview mode. It is only possible to make judgments about the effects of your settings once they have been applied to your image. Detail Extractor does, however, save the settings that are active at shutdown, and loads these automatically when the plug-in is restarted.

Remember to give your settings profiles names that describe precisely the settings you used. Older profiles that you no longer require can be deleted by selecting them (Settings) and clicking Delete. Figure figure 7-15 shows our initial image, which has already been slightly retouched and optimized. Although the blacks and the slight shimmer of oil contrast well with the dark red wheels, and although the steam escaping from the valve gives the image an air of authenticity, we still think our image could bear a little enhancement using Detail Extractor.

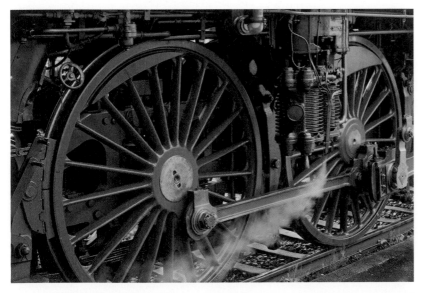

Figure 7-15:
This technology is more than 50 years old and is still truly impressive.

We set the *Detail Size* value to 17 pixels. This parameter should be set based on the resolution of your image – images with higher resolutions will sometimes need a higher value. For our image, we used a solid *Boost* factor of 57, which is close to the upper limit of values that can be usefully applied to

normal images. Anything more would bring us into *grunge* territory, which is simply not suitable for use with this subject.

We set *Extra Detail* to its maximum justifiable limit of 30, which is why we also set *Protect* to 63 in order to prevent the highlights already present in the image from washing out, and the shadows from blocking. Because we were processing this image for use with the offset printing process used for this book, we also activated the *Clipping* option to reduce the overall dynamic range, thus preserving shadow and highlight detail at the print stage.

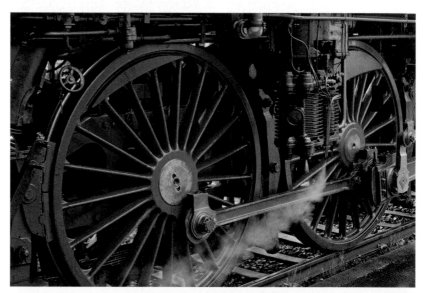

Figure 7-16:
The source image once again for reference.

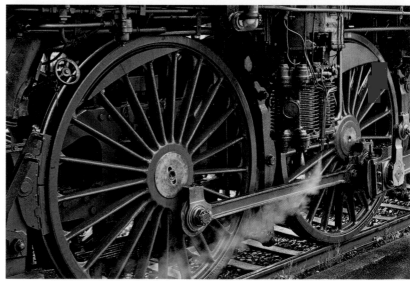

Figure 7-17:
Our image after processing with Detail
Extractor using the settings shown above.

Increasing microcontrast would have further accentuated some of the detail visible behind the locomotive, so we deliberately blurred those areas in

advance using Photoshop's Gaussian blur filter (Filters ▸ Gaussian Blur) and a layer mask. Enhancing microcontrast without this initial background softening made some of the brighter details in the image overbearing and distracting.

Figure 7-18:
The detail on the left is taken from the original image, while the detail on the right has been processed using "Detail Extractor". A close look at the details reveals that a "halo" effect is already visible in the form of individual white pixels and some white fringing.

Figure 7-18 shows an enlarged detail before and after Detail Extractor was applied. The processed version has a much more three-dimensional look and a crisp flair.

All of these new types of tools are still relatively sparsely documented, and DOP Extractor is no exception. You will need to experiment to develop a feel for the way the plug-in functions, and if and how to apply it to your particular type of image. The strength of the filters you apply remains a matter of personal taste, and is always a source of lively debate.

Figure 7-19: The Layers palette for our image. The filter automatically embeds abbreviated information about the settings used into the layer name.

"Grunging"

The term "grunging" is derived from the "grunge" rock music style. In the world of digital photography, it is used to describe an effect which sharpens tonal values in an image to a point where contrast is highly exaggerated and the entire image begins to look "super-real" and generally over-the-top. Detail Extractor can be effectively used to create this kind of effect by setting the base parameters to extremely high values. If a single application doesn't achieve the effect you are looking for, you can simply run your already-filtered image through the filter again. We have found that more than three consecutive runs produce results that are no longer usable.

Grunging is a specialized image effect which isn't suitable for all subjects or image types. Occasionally, however, it can turn a normal image into a real eye-catcher. Here is an example.

Figure 7-20: The source picture to be "grunged" already has fairly good microcontrast.

The source image is our simple rose from figure 7-20. The image already has fairly good texture, with a few bright spots caused by the original exposure being made in direct sunlight.

To create our grunge effect we run Detail Extractor twice, using high parameter values both times. Figure 7-22 shows the original image, in which we have already darkened the highlights to prevent them being washed out by the contrast enhancement process. Figure 7-23 shows the image after the first run and 7-24 after the second. Even with the *Protect* parameter set to 77, our highlights were further brightened and are almost burnt out.

To combat this, we used a 50% gray layer (in *Overlay* blending mode) to darken these sections using a soft, black brush. Figure 7-24 shows this gray layer.

Figure 7-21: Our "grunging" source image, already showing strong microcontrast.

Figure 7-22: The original pictures with slightly dodged highlights.

Figure 7-23: The rose after the first Detail Extractor run using the settings seen in figure 7-21.

Figure 7-24: The rose after the second Detail Extractor run, now showing a strong grunge effect.

The gray layer (in "Overlay" blending mode) used to darken the nearly washed-out image areas between runs.

Enhancing Microcontrast in Monochrome Images

Appealing tones and the contrast and transitions between them are the factors that bring monochrome (black-and-white) images to life. The techniques described above are therefore also highly applicable for monochrome images. If you are creating monochrome images by converting color originals, the tones in your monochrome image will only really become recognizable after conversion. For this reason, we recommend that you apply any global contrast adjustments (for example, using Curves), or local tonal value adjustments after you convert your image to black-and-white. You can make local corrections to tonal values using a gray layer set to *Overlay* blending mode. Use this layer to color in the areas you want to darken using a soft,* translucent black brush, and the areas you want to brighten using a white brush. As an alternative to the brush tools, you can also use Photoshop's *Burn* (⬤) and *Dodge* (🔍) tools to achieve the same effects.

Microcontrast correction is almost the last stage in the image correction process, but should take place before the post-processing steps described below. All three of the tools we have described work well in monochrome situations. For our example (an old steam engine) we will use *DOP Detail Extractor.* Figure 7-25 shows our source image.

** I.e., with hardness set to between 0–20%.*

→ As a rule, we use a brush with an opacity of 15–20%. This means we have to cover some areas multiple times, but it gives us more precise control over the final effect.

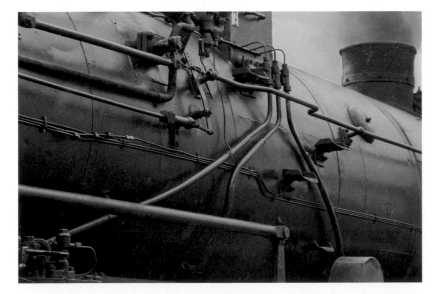

Figure 7-25:
Our source image of a steam locomotive. It has been lovingly restored and cared for.

We remove the colors from the image using the Photoshop Black & White command.** Because the source image is already nearly monochrome, we do not need to perform much optimization in the *Black & White* dialog box. The result of the conversion (shown in figure 7-27) is still an RGB image, which can be converted to grayscale via Image ▸ Mode ▸ Grayscale without any adverse effects. Conversion will also save some disk space. We tend to leave our monochrome images in RGB format so that we can tint or manipulate them more easily later (some Photoshop filters cannot be applied to grayscale images).

*** The Black & White command first became available in Photoshop CS3. It can be found under Layer ▸ New Adjustment Layer ▸ Black and White or under Image ▸ Adjustments ▸ Black and White.*

Figure 7-26: The Layers palette after we converted the picture to black and white.

Figure 7-27:
The locomotive after
conversion to black & white using the
Photoshop CS3 function. The image is slightly
dark and the near-white areas are almost
completely missing.

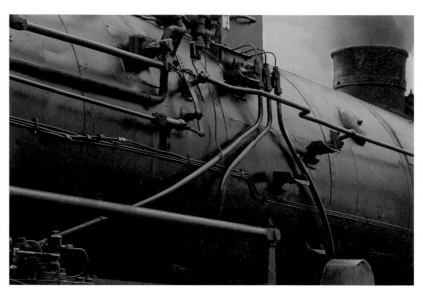

We use Levels to brighten the image a little, which uses some of the reserve tonal range that is present in the image highlights (see figure 7-28). In our next step, we slightly increase the mid-tone contrast using a classic s-formed Curve, as illustrated in figure 7-29.

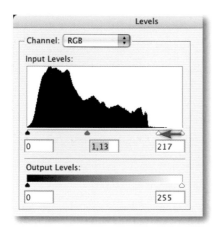

Figure 7-28:
We were able to brighten the image by
adjusting the white point.

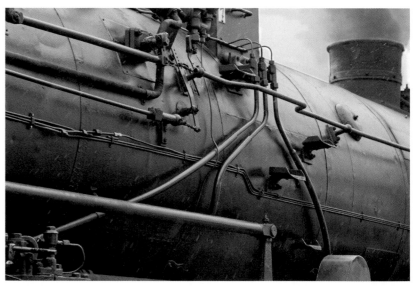

Wherever possible (using Curves, for instance), we use an adjustment layer for this type of correction. This allows us to fine-tune our image later without having to restart the entire correction process from scratch.

The final step in this workflow is to increase microcontrast using *DOP Detail Extractor* (File ▸ Scripts ▸ Detail Extractor). As we have already reached the practicable upper limits in the levels adjustment for the highlights, we activate the *Clipping* option and increase the *Protect* value to 65.

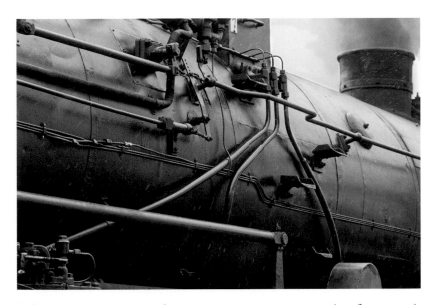

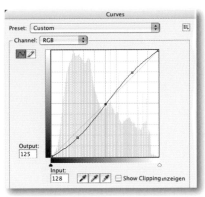

Figure 7-29:

After making the Curves correction shown above, the mid-tones have more contrast.

Otherwise, we use strong, but not overpowering settings (see figure 7-30). The result is a more vivid-looking locomotive, but the ash coming from the smokestack has also become more accentuated, especially around the boiler and its pipes.

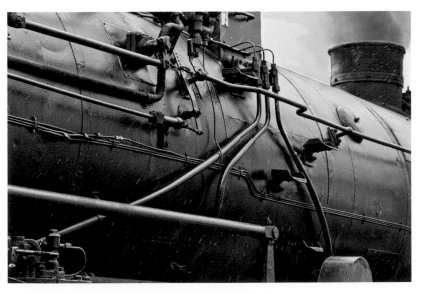

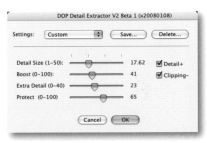

Figure 7-30:

Our image after running the Detail Extractor script with the settings shown above. Some particles of ash are still too prominent.

There are two possible solutions to this effect:

A. Use the Clone Stamp tool ⚒ or the Healing Brush tool ✎ on the uppermost layer. Under such circumstances, we always create a new layer and set the tool settings to *Sample All Layers*.

B. Create an adjustment layer directly above the background layer and make your corrections there using ⚒ or ✎.

Experience has shown this to be the better solution. It is also clear at this point that using adjustment layers is always preferable to making changes directly in the image layer. Because the corrections we have made are documented in the individual layers, we can note the settings before deleting or simply hiding the layers we do not currently need.

Figure 7-31: The Layers palette documents the individual steps we have taken. The second layer from the bottom is the clone stamp layer which we used to retouch some of the particles of ash.

The question of how much ash to remove is again a matter of taste and authenticity. We have taken a middle route by removing the ash where the well-defined pipes themselves are the subject, and where they appear in too stark a contrast against the darker parts of the boiler. Some of the more blurred particles were simply left as they were. Before starting *Detail Extractor* again, we need to reactivate the uppermost layer (by clicking on it) so that the plug-in's effect is applied to all layers.

Figure 7-32 shows the final image and figure 7-31 shows the Layers palette associated with it – the individual correction steps are clearly visible. We generally name our layers according to correction type, so we don't have to open each layer individually (by double clicking the ◑ icon) to see what corrections they contain.

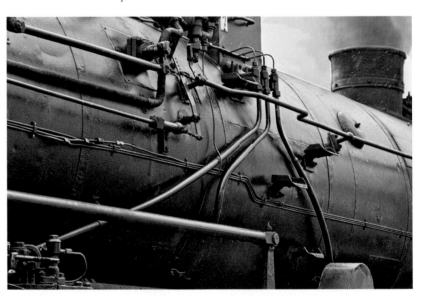

Figure 7-32:
The final image with some of the ash particles removed.

Although this is a complex workflow, it is nevertheless fairly typical. Additional dodging & burning or selective tonal correction are often necessary. We can't overemphasize the value of using adjustment layers and other duplicate layers for the individual processing steps. We usually keep all our layers separate (even if there are ten or more), as experience has shown that we return time and again to our individual layers for that "little extra" fine-tuning.

7.2 Post-Processing

All of the filters demonstrated here (*Unsharp Mask, Enhancer,* and *Detail Extractor*) should be applied exclusively to separate layers. The *Unsharp Mask* and *Enhancer* filters require the user to create the layer themselves, while *Detail Extractor* creates a new layer automatically. This way, Photoshop filter effects can be elegantly controlled in one of two separate ways.

Controlling Effect Strength

The *Opacity* slider in the Layers palette (see figure 7-33 Ⓐ) lets you set the strength of your chosen effect – 100% opacity means that your effect is completely visible, and 0% makes it entirely invisible. As a rule, we work with slightly over-strong effects and reduce the opacity of the effect layer later, if necessary. This often allows us to control the strength of our effects more precisely than we can by simply moving the filter sliders. This approach also allows us to make subsequent adjustments to the effect (within the limits of our original settings) without having to go back and perform the entire filter process a second time.

Figure 7-33: The opacity slider (A) allows you to reduce the effect of a filter at any time.

In the example in figure 7-34, the image on the far left has fairly bland microcontrast. The version in the middle shows the result of applying *Detail Extractor*. Here, the effect is somewhat exaggerated, but, instead of discarding the new image layer and running the filter again, we lessened the effect simply by reducing the opacity of the adjustment layer.

Figure 7-33 shows the Layers palette for this image. The source image is a detail of an altar at the Roggenburg monastery in Germany.

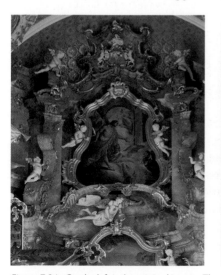
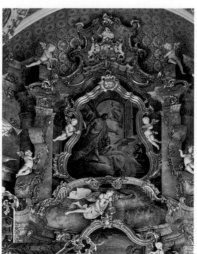
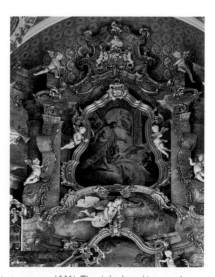

Figure 7-34: On the left is the original image. The center image shows the effect of applying Detail Extractor at 100%. The right-hand image shows the same image with the opacity of the filter layer reduced to 70%.

Limiting Effects Selectively

The method previously described applies to an entire image. You may find, however, that you want to protect certain parts of an image (such as soft transitions or skin-tones) from becoming too high-contrast. It is also not uncommon to use sharpening effects to attract the viewer to specific parts of an image while keeping the effects in the rest of the frame discreet. We use Photoshop layer masks to achieve this type of effect. If you have not yet created a layer mask, the layer mask symbol (⬛▢) will be missing from the layer entry in the Layers palette. Click on the ⬛ icon at the bottom of the palette to create an empty layer mask (signified by the ▢ icon). The Layers palette should now remain open during all of the following steps.*

* You can switch the Layers palette on and off using Window ▸ Layer or by pressing F7.

To be certain the mask is active, we click the ▢ icon and then select the Paintbrush tool 🖌. We use a soft brush (approximately 10% hardness) with a black foreground color and 100% opacity to roughly cover over the areas of the image we wanted to protect.

Using a brush in the mask

Using a brush in the image

Figure 7-35: The dotted line in a Layers palette entry signifies whether the layer itself or the layer mask is activated.

If you find yourself painting into the image itself, then you haven't activated the layer mask. Undo your brushstrokes using Ctrl/⌘-Z and click once again on the layer mask thumbnail in the Layers palette entry for your layer.

If we need to apply our effect more selectively and refine our mask, we reduce the opacity of the brush to 20% and reduce the brush size. The brighter a particular area of the mask is, the more the effect will be visible within that area. The layer effect will be 100% visible in white mask areas, weaker in gray areas, and invisible where the mask is black. If you find you have overdone the masking in a certain area, you can switch the brush to white (or use the Eraser tool 🩹) to correct your mask.

Figure 7-36: A very small view of the layer mask is visible within the layer mask icon.

It is often difficult to make out the exact form of the layer mask because it is displayed at a very reduced size (see figure 7-36), and is only displayed fully after a short delay. You can display the layer mask itself in the editing window by clicking on the layer mask thumbnail while holding down the Alt key (or the Mac ⌥ key). You can continue to work on the mask in this mode, but you will not be able to see the image beneath, making it difficult to judge the effect of your work. To return to standard mode, click the layer mask thumbnail while holding down the Alt or ⌥ key.

There is also a more useful alternative method for working directly in your layer mask. Click the layer mask thumbnail while holding down ⇧ and Alt (or ⇧ and ⌥ on a Mac). The layer mask will be displayed (in its default red color) superimposed on your image (see figure 7-38). The mask color can be changed in the Quick Mask Options dialog box (see figure 7-37) which you can reach by double-clicking the ⬛ toolbox icon. To return to a normal view, click the layer mask thumbnail a second time while holding down the same keystroke combination as described above.

Figure 7-37: The Quick Mask Options dialog, where you can redefine your mask's color.

Should you want to make corrections directly in the image layer, a click on the image thumbnail in the layer entry in the Layers palette activates the image layer.

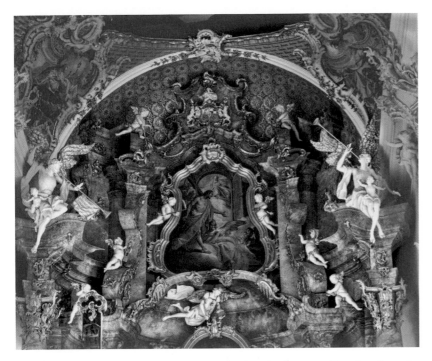

Figure 7-38:
This illustration shows the mask (in red)
superimposed on the image. You can reach
this view by clicking the mask thumbnail
in the Layers palette while pressing ⇧-Alt
(or ⇧-⌥ *on a Mac).*

Any changes you make now will be applied to the layer itself rather than the layer's mask. Photoshop outlines the currently active layer (or layer mask) with a dotted line, making it easy to see where you are actually working (see figure 7-35).

It is also possible to fill the entire layer mask with black using the Paint Bucket tool 🖤, or to create a black mask directly by holding down the Alt or ⌥ key) when clicking the create mask icon ◙. You can then use a white brush to "erase" the parts of the mask where you want your effect (in this case, microcontrast enhancement) to be visible. You can apply any of the normal painting and standard processing tools to a layer mask.

A click on the layer mask thumbnail while holding down ⇧* deactivates the layer mask but doesn't delete it (signified by a crossed-out mask symbol: ⊠). A second click on the thumbnail while holding down ⇧ will reactivate the mask.

** The shift key.*

Sharpening

Increasing microcontrast is a step that is generally carried out late in the image optimization cycle after corrections have been made to white balance, exposure, global and local color, and to lens and perspective distortion.

Traditionally, the very last step in the process is to scale the resulting master image copy for its intended output format, whether this be for web display or printing. If the image is to be converted to a different format, it will usually be sharpened beforehand.

Figure 7-39: If you increase microcontrast in advance, your image will require significantly less sharpening at the post-processing stage.

If you have already increased microcontrast, you will need to sharpen your final image less than you otherwise might. The appropriate degree of sharpening depends on the subject, the extent of any microcontrast enhancement you may have applied, and on the planned output medium. As a general reference point, we recommend halving the normal amount of sharpening you would apply to your images. You need to take special care if you are using semi-automatic sharpening tools such as Nik Software's *Nik Sharpener* [23], as these set sharpening levels based on the selected output size and output medium but without taking any manual presharpening into account.

As previously mentioned, most sharpening tools can only be applied directly to regular layers, so it is often necessary to create a subsidiary layer which merges all the layers beneath it into one, as described on page 200. You can create such a layer by pressing ⌂-Ctrl-Alt-E (or ⌂-⌥-⌘-E on a Mac). *Detail Extractor* automatically generates a regular top layer, but in order to avoid making unwanted changes to our already corrected image, we still duplicate this layer to apply sharpening. If necessary, we use layer masks to protect specific image areas from over-sharpening, as previously described.

In order to avoid color shifts or an increase in color noise when sharpening color photos, it is best to set the sharpening layer to *Luminosity* blending mode (see figure 7-31 on page 212). We especially recommend this course of action if microcontrast (and therefore detail color contrast) has already been increased in advance of further processing.

Using Filters with "Smart Objects"

If you are working in Photoshop CS3 (or later) and have a regular layer at the top of a layer stack – as is the case in our locomotive image in figure 7-32 – instead of duplicating this layer, you can turn it into a *Smart Object* using Convert to Smart Object (under the ▶ icon at the top right of the Layers palette or in the Photoshop Layer menu; see figure 7-40).

We then apply the filter to the Smart Object. Not all filters can be applied to Smart Objects, but in this case, the required Unsharp mask or Selective sharpening are both compatible. Our layer entry then appears as shown in figure 7-41.

Using this method, you can reactivate the sharpening filter and change its settings at any time without having to delete the top layer and start again. Here, double clicking the filter entry in the Layers palette opens the filter dialog box, allowing you to change the settings. This is called *Smart Filter* functionality.

Not all filters can be applied as Smart Filters. Tools such as *DOP Detail Extractor*, which are implemented as scripts rather than as standard Photoshop filters, cannot be applied this way. Some other, third-party filters, such as *Color Efex Pro 3* by Nik Software are now Smart

Figure 7-40: The Smart Object conversion function has been available in the Layer menu since Photoshop CS3.

Filter-compatible. There is also a work-around that we learned from Uwe Steinmueller:

Photoshop CS3 ships with a script called *EnableAllPluginsForSmart-Filters.jsx* included on the installation CD. Once installed, the script can be run by navigating to File ▸ Scripts ▸ EnableAllPluginsForSmartFilters.

Once you have run the script once, Photoshop remembers the settings it makes, and some filters which aren't usually Smart Filter-enabled (such as Akvis *Enhancer*) become functional. This is unfortuantely still not true for all major filters.

We have sometimes experienced Photoshop crashes when using filters in conjunction with Smart Objects. It is always worth taking the time to check for compatibility before you start work.

Figure 7-41: The Detail Extractor layer set as a Smart Object and sharpened using the USM filter.

Merging Layers into One – Flattening Your Image

If you want to publish your image on the web or have it printed using an online print service, you will need to merge the layers into one using the Photoshop Layer ▸ Flatten Image command. **Always flatten a copy, never your master image!**

There are, of course, other circumstances under which you no longer need certain layers, and these can then be merged with regular layers beneath them, or even right down to the background layer. Flattening your image this way can save disk space, although adjustment layers without layer masks are not particularly memory-hungry. Layer masks are also not too critical in this respect, as they consist of simple, 8-bit grayscale data. However, the first additional layer will double the original file size (in compatibility mode), as Photoshop here creates an additional, invisible preview layer which contains all visible layers merged into one.[*] Additional adjustment layers (after the first one) don't cost much.

** This preview layer allows programs which do not support Photoshop's layer format to display an accurate preview image.*

We almost never discard individual layers. Keeping all our layers gives us the flexibility to go back and make changes whenever we want, and the documented trail of corrections we have made is more valuable to us than disk space (which is, these days, cheap and easily available).

References and Links

Here you will find the references and links cited throughout the text. Please bear in mind that Internet articles are often moved to new URLs or are removed from their original site, and that sometimes websites are simply no longer available. Please let us know if you come across any omissions - this helps us to keep our information up to date for later editions of this book.

The ⊞ *icon denotes software which runs on Windows and the* 🍎 *icon denotes software designed to run on Mac OS X.*

The publisher's Internet link page to all the tools used in the book can be found at: www.rockynook.com/tools.php

A.1 Books

[1] *Take Your Photography to the Next Level: From Inspiration to Image.*
George Barr
Rocky Nook, Inc, Santa Barabara, CA, 2007
ISBN: 978-1-933952-21-5

[2] *Managing Your Photographic Workflow with Photoshop Lightroom.*
Uwe Steinmuller, Juergen Gulbins
Rocky Nook, Inc, Santa Barabara, CA, 2007
ISBN: 978-1-933952-20-8

[3] *Fine Art Printing for Photographers: Exhibition Quality Prints with Inkjet Printers.*
Uwe Steinmuller, Juergen Gulbins
Rocky Nook, Inc, Santa Barabara, CA, 2008
ISBN: 978-1-933952-31-4

[4] *The HDRI Handbook: High Dynamic Range Imaging for Photographers and CG Artists.*
Christian Bloch
Rocky Nook, Inc, Santa Barabara, CA, 2007
ISBN: 978-1-933952-05-5

[5] *Practical HDRI: High Dynamic Range Imaging for Photographers.*
Jack Howard
Rocky Nook, Inc, Santa Barabara, CA, 2008
ISBN: 978-1-933952-32-1

[6] *Closeup Shooting: A Guide to Closeup, Tabletop, and Macro Photography.*
Cyrill Harnischmacher:
Rocky Nook, Inc, Santa Barabara, CA, 2007
ISBN: 978-1-933952-09-3

[7] *Practical Digital Photomicrography: An Introduction to Photography Through the Microscope.*
Brian Matsumoto
Rocky Nook, Santa Barbara, 2009
ISBN: 978-1-933952-07-9

[8] *Photoshop CS4 Photographer's Handbook.*
Brad Hinkel
Rocky Nook, Inc, Santa Barabara, CA, 2009
ISBN: 978-1-933952-42-0

[9] *The Art of Black and White Photography: Techniques for Creating Superb Images in a Digital Workflow.*
Torsten Andreas Hoffmann
Rocky Nook, Inc, Santa Barabara, CA, 2008
ISBN: 978-1-933952-27-7

Further information about these books can be found at: www.rockynook.com.

A.2 Internet Resources

[10] *Outbackphoto.com*: This is Uwe Steinmueller's web site. It is entirely focused on digital photography, and includes many articles addressing related topics, including Photoshop, Lightroom, HDRI, and fine art printing:
www.outbackphoto.com

[11] *DOP Detail Extractor* is a Photoshop plug-in (⊞,) designed for increasing microcontrast in digital images. A free trial version can be downloaded at:
www.outbackphoto.com/filters/dopf005_detail_extractor/DOP_DetailExtractor.html.

[12] *FotoEspresso* is a photo newsletter, which includes extensive articles about many related topics. FotoEspresso is available at regular intervals as a downloadable PDF or as an e-mail attachment.
www.fotoespresso.com

[13] HDRSoft: *Photomatix* is a tool (⊞,) for creating High Dynamic Range images from several differently exposed source images. The program is more powerful than its Photoshop command-based counterpart. A good introduction to HDRI in general can be found at:
www.hdrsoft.com

[14] Lightcrafts: *LightZone* (⊞,) is a photo editor which supports Lightroom, RAW, TIFF, JPEG, and PSD file formats. LightZone is capable of selective correction to specific image areas, and functions non-destructively. It also offers very precise Tone Mapping functionality (⊞,):
www.lightcrafts.com

[15] *PTLens* is a Photoshop plug-in for making profile-based corrections to vignetting, distortion, and chromatic aberration errors. (⊞, , only Intel Macs):
http://epaperpress.com/ptlens/

[16] *LensFix* is a Photoshop plug-in for making profile-based corrections to lens errors ():
www.kekus.com

[17] HeliconSoft: *Helicon Focus* (⊞,) is a focus stacking program. It can be purchased in Lite or Pro versions:
www.heliconsoft.com

[18] Akvis: *Enhancer* is a Photoshop plug-in (⊞,), which has impressive microcontrast enhancement capabilities. It is one of the reasons we often use Photoshop to post-process Lightroom images:
www.akvis.com

[19] *PhotoAcute* (⊞,) is a stand-alone program with many functions, including focus stacking, super-resolution, HDRI, and lens corrections:
www.photoacute.com

[20] Adobe *DNG Converter* (⊞,) is a freely downloadable RAW-to-DNG converter. DNG is the best RAW format for use with PhotoAcute or Photomatix.
www.adobe.com/products/dng/

[21] Alan Hayley: *CombineZM* is a reliable, free focus stacking program (⊞):
http://hadleyweb.pwp.blueyonder.co.uk/CZM/News.htm

[22] The Yahoo *CombineZM* Group can be found at:
http://tech.groups.yahoo.com/group/combinez/

[23] Nik Software offers many filters and plug-ins for Photoshop, including the well-known *Nik Silver Efex* (⊞,) and *Nik Sharpener* (⊞,) packages:
www.niksoftware.com

[24] *FDRTools –Full Dynamic Range Tools*. Andreas Schoemann offers three tone mapping tools at his website: *FDRTools Basic* (free, ⊞,), *FDRTools Advanced,* and the *FDR Compressor* Photoshop plug-in (⊞,). The site also includes interesting articles and discussions relating to HDRI techniques:
www.fdrtools.com

[25] *OpenEXR Viewer* () is a free image viewer for OpenEXR HDR images:
www.mesadynamics.com/openexr.htm

[26] *HDRView* (⊞) is a fast HDR image viewer which supports Radiance, PFM, and floating-point TIFF formats:
www.debevec.org/FiatLux/hdrview/

[27] *XNView* is a universal, free image browser which can also display the Radiance HDR format and TIFF LogLuv files:
www.xnview.com

[28] *IrfanView* (⊞) is a fast, free image browser which includes support for several HDR formats:
http://www.irfanview.net

[29] *Hugin* (⊞,) is an easy to use, cross-platform panoramic imaging toolchain based on *Panorama Tools* (or *PanoTools*). *PanoTools* is an open source program designed to stitch individual images together to form panoramas. It is freeware and can be downloaded at:
http://hugin.sourceforge.net/

[30] *PanoTools* (⊞,) was originally created by Professor Helmut *Dersch*. It has since been turned into an open source project and is under continual development. It is a very powerful tool for creating panoramas and other stitched images. Because its user interface is somewhat sparse, there are a number of graphical front ends available for it (such as Hugin).
http://panotools.sourceforge.net/

[31] *Kekus digital* offers a number of tools for profile-based correction of lens errorss (*LensFix*,), and for panorama stitching (*PTMac*,) and (*PTBatch*,). These tools are only available for Mac OS X:
www.kekus.com

[32] *PTgui* and *PTgui Pro* (⊞,) are panorama-creation programs:
www.ptgui.com

[33] *Autopan Pro* (⊞,) is a fast, effective panorama stitcher from the Kolor company:
www.autopano.net

[34] *REALVIZ Stitcher Unlimted* (⊞,) is a versatile stitcher from REALVIZ – a division of Autodesk. The company offers an introductory version called Autodesk® Stitcher™ Express:
http://stitcher.realviz.com/

[35] *DXO Optics Pro* (⊞,) is designed to make profile-based lens corrections, including lens distortions, vignetting, and chromatic aberration. The program also includes its own RAW converter:
www.dxo.com

[36] *Neat Image* (⊞,) is a Photoshop plug-in used for noise reduction. It is profile-based:
www.neatimage.com

[37] *Noise Ninja* (⊞,) is a very powerful Photoshop noise reduction plug-in. It is somewhat complex to use:
www.picturecode.com

[38] *Noiseware* (⊞,) is a Photoshop plug-in which provides profile-based noise reduction functionality:
www.imagenomic.com

[39] *enblend* (⊞,) is a command-line-based add-in for Hugin and other similar programs. It is designed to merge pre-aligned images seamlessly. There are many GUI front-ends (such as *Xblend*) available for enblend:
http://enblend.sourceforge.net/

[40] *Novoflex* is a German manufacturer of camera accessories, including tripod heads, panorama heads, quick release plates, flash guns, mini studios, and macro-photographic equipment:
www.novoflex.com

[41] *Really Right Stuff* is an American company which manufactures practical, high-quality (and expensive) camera accessories including L-plates, quick-release plates, tripod heads, panorama heads, and tripods:
reallyrightstuff.com

[42] *Cambridge in Color* is a website hosted by the University of Cambridge in England which includes a number of objective, competent tutorials addressing digital photographic topics. The site is well laid out and (almost) completely ad-free: www.cambridgeincolour.com/tutorials.htm The article discussed in the book text "Diffraction & Photographs" can be found at: www.cambridgeincolour.com/tutorials/ diffraction-photography.htm In the "Advanced Topics" section you will also find some interesting articles relating to panorama photography and usable aperture.

[43] Bob Atkins: *Depth-of-Field Calculator*. This page is devoted to mathematics and photography, and includes an online calculator to help determine depth of field and optimum aperture: www.bobatkins.com/photography/technical/ dofcalc.html

[44] Thomas Halstein: *Outsight environmental photography*. Here, you will find a number of optical formulae to help you calculate – amongst other things – depth of field and optimum aperture: www.outsight.com/hyperfocal.html#math

[45] *Exifer* (⧉) is a useful, free tool which allows users to export, copy, transfer, overwrite, and edit EXIF and IPTC data: www.friedemann-schmidt.com/software/exifer/

[46] Phil Harvey: *ExifTool*. This tool helps you to copy EXIF and ITPC data from one image file to another: www.sno.phy.queensu.ca/~phil/exiftool/

[47] *EXIFUtils* is a group of command-line-based tools which allow you to save EXIF and IPTC data to text files, or to transfer it to other images: www.hugsan.com/EXIFutils/

[48] *Camera test charts*. There are many test charts available for determining the effective resolution of a camera. These include the standardized ISO test chart (ISO 12233 "Standard for measuring resolution of 'electronic still imaging' cameras".) Simple charts usually suffice for general use, and the following article includes a printable PDF designed for exactly that purpose: www.graphics.cornell.edu/~westin/misc/ res-chart.html

[49] *DOFMaster* is a web site which hosts a number of online calculators which can be used to calculate depth of field and hyperfocal distance. These can be downloaded for free for Windows or Palm OS at: www.dofmaster.com

[50] *Building a panorama head*: There are a number of guides to building your own low-cost panorama head (or L-plate) available online. Here are a few examples: www.sentex.net/~mwandel/photo/panos.html or www.chem.uky.edu/xray/people/Parkin/ panohead/panohead.html or www.wikihow.com/Build-a-Panoramic-Tripod-Head/

[51] *Nodal Ninja* is a series of relatively inexpensive but flexible panorama tripod heads: www.nodalninja.com

[52] *Manfrotto* is a manufacturer of high-quality photographic tripods, tripod heads, and specialized panorama heads. You can find Manfrotto products and dealers who carry them at: www.manfrotto.com

[53] *panoramas.dk* is a very informative internet site devoted to panorama photography. The site includes product information, links to tutorials, and other useful information: www.panoramas.dk/panorama/software.html

[54] *Panoguide* is an Internet site with a number of tutorials and other useful information relating to creating panoramas: www.panoguide.com

[55] *IVRPA – International VR Photography Association.* This web site includes information relating to the creation of interactive virtual reality images, including panoramas: http://ivrpa.org

[56] *Gigapxl Project* is a project devoted to creating images with extremely high resolutions – all the way up to the gigapixel range. The techniques involved are based on the use of film which is later scanned, rather than on the use of digital cameras: www.gigapxl.org

[57] *Bibble Labs* offer the Bibble RAW converter (⊞,). This tool supports a broad spectrum of RAW formats and profile-based lens error corrections, including distortion, chromatic aberration, and vignetting: www.bibblelabs.com

[58] *Pano Tools Wiki* shows you what you can do with the *Panorama Tools* and how to use them effectively: http://wiki.panotools.org/

Index

Juergen Gulbins
Digital Photography from the Ground Up
A Comprehensive Course

This "ground up" guide to digital photography will give the novice photographer a firm foundation in understanding the principles and techniques of modern photography. And, the more experienced photographer will be guided through the transition from analog to digital photography. In this book the reader will learn:

- How imaging occurs in digital cameras
- What to look for when buying a new camera
- An understanding of composition
- Digital shooting techniques
- Image editing, printing, and presentation
- How to archive and organize photographic images

This is not the book that explains which button to push. Rather, it is what the title promises: an in-depth course loaded with valuable information and tips. The author's goal is to share his own experience as a photographer, and to pass on the knowledge that will make photography an enjoyable and rewarding endeavor.

March 2008, 362 pages
978-1-933952-17-8
US $ 34.95, CAN $ 38.95

Rocky Nook, Inc.
26 West Mission St Ste 3
Santa Barbara, CA 93101-2432

Phone 1-805-687-8727
Toll-free 1-866-687-1118
Fax 1-805-687-2204

E-mail contact@rockynook.com
www.rockynook.com

"A good photograp
is one that
communicates a fa
touches the hear
leaves the viewer
a changed person
for having seen it

IRVING PENN

Uwe Steinmueller · Juergen Gulbins
Fine Art Printing for Photographers
Exhibition Quality Prints with Inkjet Printers
2nd Edition

Today's digital cameras continue to produce increasingly higher definition image data files making high resolution, large-format output possible. As printing technology moves forward at an equally fast pace, the new inkjet printers are capable of printing with great precision at a very fine resolution, providing an amazing tonal range and significantly superior image permanence at a more affordable price. In the hands of knowledgeable photographers, these printers are capable of producing prints that are comparable to the highest quality darkroom prints on photographic paper.

The second edition of this best selling book provides the necessary foundation for successful fine art printing: the understanding of color management, profiling, paper, and inks. It demonstrates how to set up the printing workflow, and guides the reader step-by-step through the process of converting an image file to an outstanding fine art print. This new edition covers the most recent lines of high-end inkjet printers.

May 2008, 298 pages
978-1-933952-31-4
US $ 44.95, CAN $ 49.95

Rocky Nook, Inc.
26 West Mission St Ste 3
Santa Barbara, CA 93101-2432

Phone 1-805-687-8727
Toll-free 1-866-687-1118
Fax 1-805-687-2204

E-mail contact@rockynook.com
www.rockynook.com